POPULAR CULTURE AND
THE EXPANDING CONSCIOUSNESS

PROBLEMS IN AMERICAN HISTORY

EDITOR

LOREN BARITZ

State University of New York, Albany

POPULAR CULTURE AND THE EXPANDING CONSCIOUSNESS

EDITED BY

Ray B. Browne

Center for the Study of Popular Culture
Bowling Green University

John Wiley & Sons, Inc.
New York • London • Sydney •Toronto

Library of Congress Cataloging in Publication Data:
Browne, Ray Broadus, comp.
 Popular culture and the expanding consciousness.

 (Problems in American history)
 CONTENTS: Old attitudes: Kirk, R. Anti-culture at public expense. Browne, R. B. Popular culture: notes toward a definition.—Changing concepts: Sontag, S. One culture and the new sensibility. Fishwick, M. Confessions of an ex-elitist.—Expanding awareness: Cawelti, J. G. Notes toward an aesthetic of popular culture. [etc.]
 1. United States—Popular culture—Addresses, essays, lectures. 2. The arts, Modern—20th century—United States—Addresses, essays, lectures. I. Title.

NX504.B67 700.973 72–8867
ISBN 0–471–11322–0
ISBN 0–471–11323–9 (pbk.)

Printed in the United States of America

10 9 8 7 6 5 4 3 2 1

SERIES PREFACE

This series is an introduction to the most important problems in the writing and study of American history. Some of these problems have been the subject of debate and argument for a long time, although others only recently have been recognized as controversial. However, in every case, the student will find a vital topic, an understanding of which will deepen his knowledge of social change in America.

The scholars who introduce and edit the books in this series are teaching historians who have written history in the same general area as their individual books. Many of them are leading scholars in their fields, and all have done important work in the collective search for better historical understanding.

Because of the talent and the specialized knowledge of the individual editors, a rigid editorial format has not been imposed on them. For example, some of the editors believe that primary source material is necessary to their subjects. Some believe that their material should be arranged to show conflicting interpretations. Others have decided to use the selected materials as evidence for their own interpretations. The individual editors have been given the freedom to handle their books in the way that their own experience and knowledge indicate is best. The overall result is a series built up from the individual decisions of working scholars in the various fields, rather than one that conforms to a uniform editorial decision.

A common goal (rather than a shared technique) is the bridge of this series. There is always the desire to bring the reader as close to these problems as possible. One result of this objective is an emphasis on the nature and consequences of problems and events, with a de-emphasis of the more purely historiographical issues. The goal is to involve the student in the reality of crisis, the inevitability of ambiguity, and the excitement of finding a way through the historical maze.

Above all, this series is designed to show students how experienced historians read and reason. Although health is not contagious, intellectual engagement may be. If we show students something significant in a phrase or a passage that they otherwise may have missed, we will have accomplished part of our objective. When students see something that passed us by, then the process will have been made whole. This active and mutual involvement of editor and reader with a significant human problem will rescue the study of history from the smell and feel of dust.

Loren Baritz

v

CONTENTS

Introduction

Many old ideas—even in the academic community, which presumably is always open to new thoughts—seem never to die; they are kept around until they become aphorisms, then are elevated to truth, and are finally enshrined in the museum of holies and from there cast their awful spell apparently forever because they have been placed above serious examination. This seeming sanctification has been especially real in the arts and with "truth." Both have been held to be universal and eternal and therefore separated from and superior to everyday life. "Truth and beauty," we are taught, do not change—the past is always with us.

Even in America, where we like to believe we are a forward-looking and realistic society, we are often taught by act if not in theory to over-respect the teachings of the past. Although many people might silently agree with Henry Ford's attitude that history is bunk, a large number—academics especially—believe so strongly in Santayana's injunction that if we forget the past we will be forced to relive it that they do not want to release it or depart from its lessons. Both attitudes are extreme. Emerson recognized the power the past holds over us ("Books are the best type of the influence of the past") but he also feared its heavy hand ("Books are the best of things, well used; abused, among the worst"). As Emerson realized, much of the influence the past exerts derives from our timidity and fear, and a great deal springs from and is fed by snobbishness.

But no matter how slow the infusion, how great the obstacles, new concepts have in fact over the years seeped into our ideas of the nature of "beauty and truth." "The struggle of the gen-

1

erations," Theodore Roszak says in *The Making of a Counter Culture*, "is one of the obvious constants of human affairs." But the struggle has accelerated recently. In the past five years this seepage has become a torrent, driving the young to new ways of viewing the phenomena of life and even influencing the thinking of many intellectual oldtimers, sweeping away much of their timidity and snobbishness, infusing new concepts of the nature of education, the arts and "truth" in general, even the real values of life. The history of the acceptance of this new way of looking at things, this new awareness and expanding consciousness reminds one of the observation of William James: "First, you know, a new theory is attacked as absurd; then it is admitted to be true, but obvious and insignificant; finally it is seen to be so important that its adversaries claim that they themselves discovered it." We are now in the latter half of the second phase of this trilogy, and the third seems well on its way.

One of the significant new realizations is that there is no real distinction between "elite" and "popular" art, that all aesthetics are on one horizontal continuum—there are no such distinctions as "high" and "low" art—the difference being one of degree, not kind. One powerful argument in favor of this attitude is the evidence presented by Alan Gowans in his persuasive book *The Unchanging Arts*, in which he contends and demonstrates that all art—and by extension "philosophy" and "truth"—springs from utilitarianism, definite purposes. Once you separate art from the useful purpose it was designed to serve and put it in a museum, it becomes dead, and adoration of it is worship of a stuffed animal, a corpse.

To a large extent this over-respect for the elite and the past results from a massive con game which derives from our educational system and the result it achieves whether it teaches it or not. That is, many—one is inclined to say most—scholars and critics, no matter what areas they address themselves to, are not really out to improve the tastes of people. They want to impress others with how much they themselves know and to keep this knowledge hidden. Carrying on this game forces the invention and elaboration of greater and greater complexities and theories. Critics and scholars must have reasons for existing, which are explaining "elite" art and "great" ideas.

Most scholars and critics are not interested in creating new concepts and new beauties. Most are not thinkers, not creators. They are transmitters of old notions. They are not, what Emerson called for so desperately in America, Man thinking; instead they are Man remembering. Incapable of discovering new truths, they content themselves with disseminating old ones. Scholar-critic Frederick Crews speaks fearfully of the dangers inherent in the indifference of the scholarly mind to new ideas. He insists that the base of college and university education must be broadened to make it more inclusive and more democratic and therefore more viable.

Such persons defend their attitudes in many ways, of course. Among them are two that seem compelling. One is that art is long and life is short. Art is indeed long and life short—too short in fact to waste on learning only the "truths" that everybody else studies. Abraham Kaplan, the philosopher, observes that incessant study about the generally accepted "good" is "not only boring but usually inconsequential as well." And Susan Sontag, the brilliant critic, insists that, "One cheats himself as a human being, if one has respect only for the style of high culture."

This point of view is demonstrated by the talented young stylist Tom Wolfe, who, perhaps writing more viscerally than intellectually, thumbs his nose at the prejudice and snobbery that has always held at arm's length all claims of validity if not esthetic accomplishment of the culture of the masses.

A second way such persons defend their position is by use of the feeling that the ultimate purpose of education and thinking is for an individual to know himself or herself. But the old socratic injunction "Know thyself," is no longer acceptable, if indeed it ever was. Now it must read, "Know yourself in your surroundings," for the world we live in whips us with such force that for an individual to pull back into the presumed safety of his psyche is to engage in the worst kind of intellectual and social irresponsibility.

Harold Howe, then Commissioner of the U.S. Office of Education, attributed most of students' unrest in the late 60's to their professors' indifference to the real world:

"Students are disaffected and disgruntled with what is going on in the universities; and they cannot understand why university professors who are responsible for the reach into space, for splitting the atom, and for the interpretation of man's journey on earth seem unable to find a way to make the university pertinent to their lives."

Mr. Howe insisted that young people are justly demanding that their education prepare them for "an incredibly complex world that makes tremendous new demands on the citizenry of a democracy." "Poverty, integration, defense, transportation, space exploration, economic development, and deterioration of the cities cry out for creative, interdisciplinary thinking," he affirmed. McGeorge Bundy has unequivocally stated the same position: ". . . The American university curriculum and the American pattern of the organization of courses is badly out of date and is the product of custom and inertia much more than of rational examination of the learning process, and I think that great improvement can be made."

Other perceptive thinkers these days are increasingly insisting on a fuller and richer use of the academic institution. In his incisive book *The Transformations of Man,* Lewis Mumford wrote that education should be "looked upon as a lifelong transformation of the human personality, in which every aspect of life plays a part." And Richard Altick, in his delightful book *The Art of Literary Research* insists: "The three disciplines—the history of literature, of ideas, and of the conditions and habits that set the tone of everyday life in any given period—are inseparable."

Yet the slowness with which academia has recognized this need is sometimes appalling. The American Anthropological Association is a good case in point. Although Anthropology—the study of man—has always had champions for engagement in society, the discipline as a whole has tended to remain speculative and abstract. In his 1967 B. B. C. Reith Lectures, Edmund Leach, taking "an evolutionary humanist" stance argued against the old attitude and for more engagement:

"By participating in history instead of standing by to watch we shall at least be able to enjoy the present. The cult of scientific detachment and the orderly fragmented way of living that goes

with it, serve only to isolate the human individual from his environment, and from his neighbors—they reduce him to a lonely, impotent and terrified observer of a runaway world. A more positive attitude to change will not mean that you will always feel secure, it will give you a sense of purpose."

The astonishing thing is that the American Anthropological Association did not officially recognize until 1969 that "anthropological studies of contemporary American society are essential to the advancement of anthropology as a science and to the well being of the society." This approval had to be made by official resolution.

American education, like life in general, is at a crisis. But the great need is for understanding and action rather than for fear. As the acute British critic Raymond Williams has observed:

"The human crisis is always a crisis of understanding; what we genuinely understand we can do. . . . There are ideas, and ways of thinking, with the seeds of life in them, and there are others, perhaps deep in our minds, with the seeds of general death. Our measure of success in recognizing these kinds, and in naming them making possible their common recognition, may be literally the measure of our future."

Although society has always exerted some influence on artistic consciousness, this influence has obviously grown much more rapidly than ever since the Industrial Revolution. In the last two decades, however, with the increased proliferation and power of the mass media, the compelling force has reached strengths never dreamed of before and to some people almost too powerful to resist. The result has been for some people to try ostrich-like to ignore the new culture (popular culture) that has resulted. Most, however, are being more realistic. To a large extent the new thrust in awareness has come from youth, who always have been more willing to tear down the old castles and erect new ones, thus are receptive to new ideas. The young in mind and spirit of all ages have lead the fight. In speaking of the counter culture, Roszak says, "It is the young, arriving with eyes that can see the obvious, who must remake the lethal culture of their elders, and who must remake it in desperate haste." But youth are not alone

in the expanding consciousness and new awareness. Their ideas have both sparked and found receptivity with older people, who, realizing that there has always been something wrong with the old ideas, have welcomed the opportunities presented in the new awareness.

Contrary to what many people feel, this expanding consciousness does not polarize the cultures, does not further separate the elite from the common. Nor does it dilute the elite and therefore threaten to destroy it. Surely it does not reduce all culture to the lowest common denominator, a threat preached by many jeremiahs for years. On the contrary, it places all culture on the largest common denominator, and by so doing brings back conditions that formerly existed: it is drawing the several cultures together again as they once were. The new awareness of and understanding of the Popular Culture—by which is meant, roughly, all the experiences in life shared by people in common, generally though not necessarily disseminated by the mass media—is merely a recognition of the fact that all culture—or cultures—is one continuum, with differing emphases, but not with breaks between. The best symbol is perhaps the CBS logo—the eyeball. On one end is folk culture, on the other elite culture; in the middle, constituting by far the largest portion, is the iris in which rests the pupil—popular culture—ever expanding, ever growing, and always seeing more widely and deeply, becoming aware of more and more aspects of life and an appreciation of the full experience. But the eyeball is horizontal, not vertical. It is inappropriate to think that one culture is "high" and another "low."

Popular Culture provides a kind of audio-video profile of a nation. It pictures the smiles and it echoes the sighs of contentment. It also points to the locations of fissures in the crust of society through which seethes and explodes the lava of public discontent. To the critics Hall and Whannell this is possibly one of the most important aspects of popular culture:

"Perhaps the most significant connection between popular art and high art is to be seen in the way popular work helps the serious artist to focus the actual world, to draw upon common types, to sharpen his observations and to detach the large but hidden movements of society. New art forms frequently arise when pro-

found modifications are taking place in social life and in the 'structure of feeling' in the society. Often this change is first recorded in popular work, and new popular themes and conventions are devised to deal with them, or to express them."

This volume of essays catalogues the expansion of the growing awareness, what obstacles it had to overcome, rationalization for the expansion and the areas of the new sensitivity.

The old attitude—that of the elitists—could scarcely be more succinctly or more extremely presented than in the essay by Russell Kirk, in Section One, "Old Attitudes."

The thrust of the new ideas is manifest clearly in the section called "Changing Concepts." The essay by Susan Sontag delineates clearly her notion, and that of an increasing number of people, that all cultures are one and are not to be feared but welcomed.

Section Three, "Expanding Awareness," develops the new concepts about the most important genres or types of popular culture: the Western, detective story, gangster, the study of history and by extension other disciplines, comics, science fiction, literary fiction, poetry, and the really important media of our time, music, television, and the movies.

In all the sections, the conclusion is inevitable. A new awareness is developing, expanding, becoming more encompassing and more pervasive. All aspects of life—education, philosophy, "truth," art, esthetics, etc.—can only be the richer for it.

PART ONE

Old Attitudes

1 FROM

Russell Kirk
Anti-Culture at Public Expense

Mr. Kirk, a political conservative, brings to his attitude about Popular Culture his political bias. To him people in general are, to use his favorite echoing of Edmund Burke, the "swinish multitude." Kirk's charges against the study of Popular Culture are the usual two charges of opponents: that studying it in academic institutions (1) lowers standards and (2) misuses money.

FROM THE ACADEMY

As Mr. Irving Kristol points out, what most rebellious students demand by way of university reform is not culture, but anti-culture. Real reform and reinvigoration of the higher learning are desperately needed in this land, Lord knows; yet (with some honorable exceptions) that is not at all the sort of change the intemperate student desires.

Finding genuine humane studies and pure science too rigorous for his undisciplined and uninquisitive intellect, the student rebel shrieks "Give Me Relevance!"—by which he means trivia and ephemera requiring no painful thought.

SOURCE. Russell Kirk, "Anti-Culture at Public Expense." Reprinted by permission of the publisher *National Review,* 150 East 35th St., New York, New York 10016, #37, Sept. 23, 1969, p. 962.

On many campuses, defenders of real culture are enfeebled. Not a few professors and administrators are themselves anticultural; many others supinely acquiesce in the clamor for a "relevance" signifying hostility to the works of the mind. In the present struggle over what a college or university should teach, one recalls the lines from Yeats:

"The best lack all conviction, while the worst
Are full of passionate intensity."

In every age, the majority of young people have felt no strong desire for attainment of high culture. Only in our time, however, have great masses of ineducable folk, positively hostile to culture, penetrated within the Academy. The extracurricular life of the campus possessing its attractions, nevertheless, and enrollment being a means for escaping the draft, and a college degree having become essential to social status and many forms of employment —why, this mass of "students" remaining undesirous of cultural attainment, anti-cultural boondoggles must be created to occupy their time.

Some of the boondoggles are harmless enough, and for people who like that sort of thing, that is the sort of thing they like. If a young person can abide only trivia and ephemera, and his parents concur in his taste—well, supposing that such "students" or their parents pay their own bills, at least four awkward postadolescent and pre-employment years are filled for those to whom thought is unbearably painful.

Providing anti-culture at public expense, however, is something else. Even in this country, public funds for the higher learning are limited: what is appropriated for anti-culture must be deducted from culture. Worse still, students capable of something better are thrust or enticed into educational boondoggles, supported by public revenues, on the tacit principle that what the masses relish ought to be good enough for anybody.

Consider the plight of a kinswoman of mine, a good schoolteacher, required to obtain two credits in education this summer, that she may be officially certified as competent in a specialized discipline which she already has taught with distinction for several years. Of the hollow courses offered by the anti-cultural department of education at the university where she endures this summer servitude, the most promising is entitled "Creativity."

This course is taught (or monitored, rather) by the dullest dog in the department, into whose brain no creative impulse ever has entered. Mercifully, perhaps, the professor never lectures: he merely beams while the captive teacher-students in search of two credits lackadaisically discuss among themselves whatever vagrant notion may be offered by one of their number. The slim textbook, written by some obscure educationist, is calculated to make any decent student abjure creativity forevermore.

Oh, there are "workbooks," too, that the students are supposed to submit—the sort of thing they pasted together in the sixth grade. On most days, class is dismissed early, inspiration having flagged. A grade of A minus—at worst—is virtually automatic in this course.

More bluntly anti-cultural programs of study, stripped of the last stitch of moral imagination, are taking shape on other campuses. Michigan State has its course in "detective fiction," which does not have room enough for a third of the students who would like to enroll. Ohio State has its course in "drugstore literature," no less popular with Burke's swinish multitude.

Bowling Green State University, in Ohio, is the proudest pioneer—or sapper—in the demolition of culture and the erection of anti-culture in the shadow of the Ivory Tower. At that former normal school, there has been founded a Center for the Study of Popular Culture, with 35,000 recordings, twenty thousand books, a grand collection of underground newspapers and of posters, etc., etc. All this is supposed "to make education more meaningful to a mobile society." (No society ever was more mobile than that of the Huns.) The director of this Center sneers at the "solemnity" of traditional courses; he means that his charges shall study menus, cigar bands and baseball picture cards—really and truly. Soon, he hopes, the University will offer a bachelor's degree in popular culture.

Actually, Bowling Green is no more anti-cultural than a good many other former teachers' colleges converted into universities by act of legislature. Bowling Green State's general library, let it be said, is a distinctly superior collection, carefully if voraciously enlarged over the past quarter of a century.

But for some notion of students' interests at Bowling Green, walk through the university bookstore. That shop sells enormous stacks of girlie magazines and worse, though it is difficult to find

any serious periodical. "Drugstore literature" is the literature of the Bowling Green undergraduate. And Pop Culture endowed by the state, rapidly devours the remains of civilization.

2 FROM *Ray B. Browne*
Popular Culture: Notes Toward a Definition

In the last five years, great strides have been made in the under-standing of exactly what Popular Culture is, what it is worth, and why it should be studied. The academic discipline is still new and many persons worry about whether defining the area of study will not in fact codify and restrict it. Others feel that it must be de-fined to be understood. Perhaps, at this point, a loose and fluid definition, with no restrictions imposed against expansion, is best.

"Popular Culture" is an indistinct term whose edges blur into imprecision. Scarcely any two commentators who try to define it agree in all aspects of what popular culture really is. Most critics, in fact, do not attempt to define it; instead, after distinguishing between it and the mass media, and between it and "high" culture, most assume that everybody knows that whatever is widely disseminated and experienced is "popular culture."

Some observers divide the total culture of a people into "minority" and "majority" categories. Other observers classify culture into High-Cult, Mid-Cult and Low-Cult, or High-Brow, Mid-Brow and Low-Brow, leaving out, apparently, the level that would perhaps be called Folk-Cult or Folk-Brow, though Folk culture is now taking on, even among the severest critics of popular culture a high class and achievement unique unto itself. Most of the discriminating observers agree, in fact, that there are per-

SOURCE. Reprinted with the permission of Bowling Green University Pop-ular Press from *Popular Culture and Curricula* by Ray B. Browne and Ron-ald Ambrosetti. Copyright © 1970 by the Bowling Green University Popular Press, pp. 3–11.

haps actually four areas of culture: Elite, Popular, Mass and Folk, with the understanding that none is a discrete unity standing apart and unaffected by the others.

One reason for the lack of a precise definition is that the serious study of "popular culture" has been neglected in American colleges and universities. Elitist critics of our culture—notably such persons as Dwight Macdonald and Edmund Wilson—have always insisted that whatever was widespread was artistically and esthetically deficient, therefore unworthy of study. They have taught that "culture" to be worthwhile must necessarily be limited to the elite, aristocratic, and the minority. They felt that mass or popular culture—especially as it appeared in the mass media—would vitiate real culture. This attitude persists today among some of the younger critics. William Gass, for example, the esthetician and critic, takes the extreme position that "the products of popular culture, by and large, have no more esthetic quality than a brick in the street. . . . Any esthetic intention is entirely absent, and because it is desired to manipulate consciousness directly, achieve one's effect there, no mind is paid to the intrinsic nature of its objects; they lack finish, complexity, stasis, individuality, coherence, depth, and endurance."

Such an attitude as Gass' is perhaps an extreme statement of the elitist critic's point of view. Luckily the force of numerous critics' arguments is weakening such attitudes. Popular Culture has a dimension, a thrust and—most important—a reality that has nothing to do with its esthetic accomplishment, though that has more merit than is often given to it.

This point of view is demonstrated by the talented young stylist Tom Wolfe, who, perhaps writing more viscerally than intellectually, thumbs his nose at the prejudice and snobbery that has always held at arm's length all claims of validity if not esthetic accomplishment of the "culture" of the masses.

Susan Sontag, a brilliant young critic and esthetician, is more effective in bludgeoning the old point of view. Far from alarmed at the apparent new esthetic, she sees that it is merely a change in attitude, not a death's blow to culture and art:

"What we are getting is not the demise of art, but a transformation of the function of art. Art, which arose in human society as

magical-religious operation, and passed over into a technique for
depicting and commenting on secular reality, has in our own time
arrogated to itself a new function—neither religious, nor serving
a secularized religious function, nor merely secular or profane. . . .
Art today is a new kind of instrument, an instrument for modify-
ing consciousness and organizing new modes of sensibility."

To Sontag the unprecedented complexity of the world has
made inevitable and very necessary this change in the function
of art. This is virtually the same attitude held by Marshall
McLuhan:

"A technological extension of our bodies designed to alleviate
physical stress can bring on psychic stress that may be much
worse. . . . Art is exact information of how to rearrange one's psyche
to anticipate the next blow from our own extended psyches
In experimental art, men are given the exact specifications of com-
ing violence to their own psyche from their own counter-irritants
or technology. For those parts of ourselves that we thrust out in
the form of new inventions are attempts to counter or neutralize
collective pressures and irritations. But the counter-irritant usu-
ally proves a greater plague than the initial irritant like a drug
habit. And it is here that the artist can show us how to 'ride with
the punch,' instead of 'taking it on the chin.' "

An equally important aspect of popular culture as index and
corrector is its role as comic voice. Popular humor provides a
healthy element in a nation's life. It pricks the pompous, devalu-
ates the inflated, and snipes at the overly solemn. For example,
such organs of popular culture as the magazines spoofed Henry
James' pomposity during his lifetime, spoofed his "high" serious-
ness and in general tended to humanize him.

A more reasonable attitude than Gass' and one that is becoming
increasingly acceptable is that held by the philosopher Abraham
Kaplan: That popular culture has considerable accomplishment
and even more real possibilities and it is developing but has not
realized its full potential. All areas draw from one another. The
Mass area being largely imitative, draws from the others without
altering much. Elite art draws heavily from both folk and, per-
haps to a slightly lesser degree, popular arts. Popular art draws

from Elite and Mass, and Folk, but does not take any without subjecting it to a greater or lesser amount of creative change. That popular culture has "no more esthetic quality than a brick in the street" or at least no more esthetic potential is a contention refuted by America's greatest writers—Hawthorne, Melville, Whitman, Twain, to name only four—as well as the greatest writers of all times and countries—Homer, Shakespeare, Dickens, Dostoevski, Tolstoi, for example.

Melville provides an excellent case in point. *Moby Dick* is the greatest creative book written in America and one of the half dozen greatest ever written anywhere. Its greatness derives from the sum total of its many parts. It is a blend of nearly all elements of all cultures of mid-nineteenth century America. Melville took all the culture around him—trivial and profound—Transcendentalism and the plumbing of the depths of the human experience, but also demonism, popular theater, the shanghai gesture, jokes about pills and gas on the stomach, etc., and boiled them in the tryworks of his fiery genius into the highest art.

Many definitions of popular culture turn on methods of dissemination. Those elements which are too sophisticated for the mass media are generally called Elite culture, those distributed through these media that are something less than "mass"—that is such things as the smaller magazines and newspapers, the less widely distributed books, museums and less sophisticated galleries, so-called clothes line art exhibits, and the like—are called in the narrow sense of the term "popular," those elements that are distributed through the mass media are "mass" culture, and those which are or were at one time disseminated by oral and non-oral methods—on levels "lower" than the mass media—are called "folk."

All definitions of such a complex matter, though containing a certain amount of validity and usefulness, are bound to be to a certain extent inadequate or incorrect. Perhaps a workable definition can best be arrived at by looking at one of the culture's most salient and quintessential aspects—its artistic creations—because the artist perhaps more than any one else draws from the totality of experience and best reflects it.

Shakespeare and his works are an excellent example. When he was producing his plays at the Globe Theater, Shakespeare was

surely a "popular" author and his works were elements of "popular" culture, though they were at the same time also High or Elite culture, for they were very much part of the lives of both the groundlings and the nobles. Later, in America, especially during the nineteenth century, all of his works were well known, his name was commonplace, and he was at the same time still High art, Popular (even mass) art and Folk art. In the twentieth century, however, his works are more distinguishable as parts of various levels. *Hamlet* is still a play of both High and Popular art. The most sophisticated and scholarly people still praise it. But *Hamlet* is also widely distributed on TV, radio and through the movies. It is a commonplace on all levels of society and is therefore a part of "popular culture" in the broadest sense of the term. Other plays by Shakespeare, however, have not become a part of "popular" culture. *Titus Andronicus,* for example, for any of several reasons, is not widely known by the general public. It remains, thus, Elite culture.

Wideness of distribution and popularity in this sense are one major aspect of popular culture. But there are others. Many writers would be automatically a part of popular culture if their works sold only a few copies—Frank G. Slaughter and Frank Yerby, for example. Louis Auchincloss also, though his works are of a different kind than Slaughter's and Yerby's, because his subject is Wall Street and high finance, and these are subjects of popular culture.

Aside from distribution another major difference between high and popular culture, and among popular culture, mass culture and folk culture, is the motivation of the persons contributing, the makers and shapers of culture. On the Elite or sophisticated level, the creators value individualism, individual expression, the exploration and discovery of new art forms, of new ways of stating, the exploration and discovery of new depths in life's experiences.

On the other levels of culture there is usually less emphasis placed upon, and less accomplishment reached in, this plumbing of reality. Generally speaking, both popular and mass artists are less interested in the experimental and searching than in the restatement of the old and accepted. But there are actually vast differences in the esthetic achievements attained in the works

from these two levels, and different aspirations and goals, even within these somewhat limited objectives. As Hall and Whannel have pointed out:

"In mass art the formula is everything—an escape from, rather than a means to, originality. The popular artist may use the conventions to select, emphasize and stress (or alter the emphasis and stress) so as to delight the audience with a kind of creative surprise. Mass art uses the stereotypes and formulae to simplify the experience, to mobilize stock feelings and to 'get them going.' "

The popular artist is superior to the mass artist because for him "stylization is necessary, and the conventions provide an agreed base from which true creative invention springs." It is a serious error therefore to agree with Dwight Macdonald (in *Against the American Grain*) that all popular art "includes the spectator's reactions in the work itself instead of forcing him to make his own responses." Consider, for example, the reactions of two carriers of non-Elite culture, the first of popular culture, the banjo player Johnny St. Cyr. He always felt that the creative impulses of the average person and his responses in a creative situation were immense:

"You see, the average man is very musical. Playing music for him is just relaxing. He gets as much kick out of playing as other folks get out of dancing. The more enthusiastic his audience is, why the more spirit the working man's got to play. And with your natural feelings that way you never make the same thing twice. Every time you play a tune new ideas come to mind and you slip that one in."

Compare that true artist's philosophy with that of Liberace, to whom the "whole trick is to keep the tune well out in front," to play "the melodies" and skip the "spiritual struggles." He always knows "just how many notes (his) audience will stand for," and if he has time left over he fills in "with a lot of runs up and down the keyboard."

Here in condensed form is the difference between popular and mass art and popular and mass artists. Both aim for different goals. St. Cyr is a truly creative artist in both intent and accomplishment. His credentials are not invalidated merely by the fact

that he works in essentially a popular idiom. Given the limita-
tions of his medium—if indeed these limitations are real—he can
still be just as great a creator as—perhaps greater than—Ruben-
stein. It is incorrect to pit jazz against classical music, the popular
against the elite. They are not in competition. Each has its own
purposes, techniques and accomplishments. They complement
each other rather than compete.

Another fine example can be found among the youth of today
and their rebellion against what they consider the establishment.
They are obviously not a part of the static mass, to whom escape
is everything. Instead they are vigorously active, and in their
action create dynamic and fine works of art, as examination of
their songs, their art, their movies, etc., dramatically demonstrates.

It is also unfair to give blanket condemnation to mass art,
though obviously the accomplishments of mass art are less than
those of "higher" forms. Liberace does not aspire to much, and
perhaps reaches even less. His purposes and techniques are in-
ferior, but not all his, or the many other workers' in the level, are
completely without value.

All levels of culture, it must never be forgotten, are distorted
by the lenses of snobbery and prejudice which the observers wear.
There are no hard and fast lines separating one level from
another.

Popular culture also includes folk culture. The relationship
between folk culture and popular and elite cultures is still de-
batable. In many ways folk culture borrows from and imitates
both.

Historically folk art has come more from the hall than from the
novel, has depended more upon the truly creative—though un-
sophisticated—spirit than the mediocre imitator. "Sir Patrick
Spens," one of the greatest songs (poems) ever written, was origi-
nally the product of a single creative genius. Today's best folklore-
to-be, that is the most esthetically satisfying folklore which is
working into tradition today, is that of such people as Woody
Guthrie, Larry Gorman and such individual artists.

To a large number of observers, however, folklore is felt to be
the same as popular culture. To another large number folklore
derives directly from popular culture, with only a slight time lag.

To them, today's popular culture is tomorrow's folklore. Both notions are gross and out of line.

Esthetically folk culture has two levels. There is superb folk art and deficient, mediocre folk art. Esthetically folk art is more nearly akin to Elite art, despite the lack of sophistication that much folk art has, than to popular. Elite art has much that is inferior, as even the most prejudiced critic must admit. In motivation of artist, also, folk art is close to Elite, for like the Elite artist the truly accomplished folk artist values individualism and personal expression, he explores new forms and seeks new depths in expression and feeling. But there are at the same time workers in folklore who are mere imitators, just trying to get along— exactly like their counterparts in mass culture.

Thus all elements in our culture (or cultures) are closely related and are not mutually exclusive one from another. They constitute one long continuum. Perhaps the best metaphorical figure for all is that of a flattened ellipsis, or a lens. In the center, largest in bulk and easiest seen through is Popular Culture, which includes Mass Culture.

On either end of the lens are High and Folk Cultures, both looking fundamentally alike in many respects and both having a great deal in common, for both have keen direct vision and extensive peripheral insight and acumen. All four derive in many ways and to many degrees from one another, and the lines of demarcations between any two are indistinct and mobile.

Despite the obvious difficulty of arriving at a hard and fast definition of popular culture, it will probably be to our advantage—and a comfort to many who need one—to arrive at some viable though tentative understanding of how popular culture can be defined.

Two scholars who do attempt a definition, following George Santayana's broad distinctions between work and play, believe that "Popular Culture is really what people do when they are not working." This definition is both excessively general and overly exclusive, for it includes much that is "high" culture and leaves out many aspects which obviously belong to popular culture.

One serious scholar defines a total culture as "The body of in-

tellectual and imaginative work which each generation receives"
as its tradition. Basing our conclusion on this one, a viable defi-
nition for Popular Culture is all those elements of life which are
not narrowly intellectual or creatively elitist and which are gen-
erally though not necessarily disseminated through the mass
media. Popular Culture consists of the spoken and printed word,
sounds, pictures, objects and artifacts. "Popular Culture" thus
embraces all levels of our society and culture other than the
Elite—the "popular," "mass" and "folk." It includes most of
the bewildering aspects of life which hammer us daily.

Such a definition, though perhaps umbrella-like in its com-
prehensiveness, provides the latitude needed at this point, it
seems, for the serious scholar to study the world around him.
Later, definitions may need to pare edges and change lighting
and emphasis. But for the moment, inclusiveness is perhaps bet-
ter than exclusiveness.

PART TWO

Changing Concepts

.

3 FROM *Susan Sontag*
One Culture and the New Sensibility

Susan Sontag's essay, which represents the swing in attitude from the "elitist" point of view to a more open-minded appreciation of all things in general, underscores the point that a person, in order to comprehend life, must be able to get outside the skin of his training, biases, loves, and hates, and give other person's experiences a fair hearing.

In the last few years there has been a good deal of discussion of a purported chasm which opened up some two centuries ago, with the advent of the Industrial Revolution, between "two cultures," the literary-artistic and the scientific. According to this diagnosis, any intelligent and articulate modern person is likely to inhabit one culture to the exclusion of the other. He will be concerned with different documents, different techniques, different problems; he will speak a different language. Most important, the type of effort required for the mastery of these two cultures will differ vastly. For the literary-artistic culture is understood as a general culture. It is addressed to man insofar as

SOURCE. Reprinted with the permission of Farrar, Straus & Giroux, Inc. from *Against Interpretation* by Susan Sontag. Copyright © 1965, 1966 by Susan Sontag.

he is man; it is culture or, rather, it promotes culture, in the sense of culture defined by Ortega y Gasset: that which a man has in his possession when he has forgotten everything that he has read. The scientific culture, in contrast, is a culture for specialists; it is founded on remembering and is set down in ways that require complete dedication of the effort to comprehend. While the literary-artistic culture aims at internalization, ingestion—in other words, cultivation—the scientific culture aims at accumulation and externalization in complex instruments for problem-solving and specific techniques for mastery.

Though T. S. Eliot derived the chasm between the two cultures from a period more remote in modern history, speaking in a famous essay of a "dissociation of sensibility" which opened up in the 17th century, the connection of the problem with the Industrial Revolution seems well taken. There is a historic antipathy on the part of many literary intellectuals and artists to those changes which characterize modern society—above all, industrialization and those of its effects which everyone has experienced, such as the proliferation of huge impersonal cities and the predominance of the anonymous style of urban life. It has mattered little whether industrialization, the creature of modern "science," is seen on the 19th and early 20th century model, as noisy smoky artificial processes which defile nature and standardize culture, or on the newer model, the clean automated technology that is coming into being in the second half of the 20th century. The judgment has been mostly the same. Literary men, feeling that the status of humanity itself was being challenged by the new science and the new technology, abhorred and deplored the change. But the literary men, whether one thinks of Emerson and Thoreau and Ruskin in the 19th century, or of 20th century intellectuals who talk of modern society as being in some new way incomprehensible, "alienated," are inevitably on the defensive. They know that the scientific culture, the coming of the machine, cannot be stopped.

The standard response to the problem of "the two cultures" —and the issue long antedates by many decades the crude and philistine statement of the problem by C. P. Snow in a famous lecture some years ago—has been a facile defense of the function of the arts (in terms of an ever vaguer ideology of "humanism")

or a premature surrender of the function of the arts to science. By the second response, I am not referring to the philistinism of scientists (and those of their party among artists and philosophers) who dismiss the arts as imprecise, untrue, at best mere toys. I am speaking of serious doubts which have arisen among those who are passionately engaged in the arts. The role of the individual artist, in the business of making unique objects for the purpose of giving pleasure and educating conscience and sensibility, has repeatedly been called into question. Some literary intellectuals and artists have gone so far as to prophesy the ultimate demise of the art-making activity of man. Art, in an automated scientific society, would be unfunctional, useless.

But this conclusion, I should argue, is plainly unwarranted. Indeed, the whole issue seems to me crudely put. For the question of "the two cultures" assumes that science and technology are changing, in motion, while the arts are static, fulfilling some perennial generic human function (consolation? edification? diversion?). Only on the basis of this false assumption would anyone reason that the arts might be in danger of becoming obsolete.

Art does not progress, in the sense that science and technology do. But the arts do develop and change. For instance, in our own time, art is becoming increasingly the terrain of specialists. The most interesting and creative art of our time is *not* open to the generally educated; it demands special effort; it speaks a specialized language. The music of Milton Babbitt and Morton Feldman, the painting of Mark Rothko and Frank Stella, the dance of Merce Cunningham and James Waring demand an education of sensibility whose difficulties and length of apprenticeship are at least comparable to the difficulties of mastering physics or engineering. (Only the novel, among the arts, at least in America, fails to provide similar examples.) The parallel between the abstruseness of contemporary art and that of modern science is too obvious to be missed. Another likeness to the scientific culture is the history-mindedness of contemporary art. The most interesting works of contemporary art are full of references to the history of the medium; so far as they comment on past art, they demand a knowledge of at least the recent past. As Harold Rosenberg has pointed out, contemporary paintings are themselves acts of criticism as much as of creation. The point could be made as

well of much recent work in the films, music, the dance, poetry, and (in Europe) literature. Again, a similarity with the style of science—this time, with the accumulative aspect of science—can be discerned.

The conflict between "the two cultures" is in fact an illusion, a temporary phenomenon born of a period of profound and bewildering historical change. What we are witnessing is not so much a conflict of cultures as the creation of a new (potentially unitary) kind of sensibility. This new sensibility is rooted, as it must be, in *our* experience, experiences which are new in the history of humanity—in extreme social and physical mobility; in the crowdedness of the human scene (both people and material commodities multiplying at a dizzying rate); in the availability of new sensations such as speed (physical speed, as in airplane travel; speed of images, as in the cinema); and in the pan-cultural perspective on the arts that is possible through the mass reproduction of art objects.

What we are getting is not the demise of art, but a transformation of the function of art. Art, which arose in human society as a magical-religious operation, and passed over into a technique for depicting and commenting on secular reality, has in our own time arrogated to itself a new function—neither religious, nor serving a secularized religious function, nor merely secular or profane (a notion which breaks down when its opposite, the "religious" or "sacred," becomes obsolescent). Art today is a new kind of instrument, an instrument for modifying consciousness and organizing new modes of sensibility. And the means for practicing art have been radically extended. Indeed, in response to this new function (more felt than clearly articulated), artists have had to become self-conscious aestheticians: continually challenging their means, their materials and methods. Often, the conquest and exploitation of new materials and methods drawn from the world of "non-art"—for example, from industrial technology, from commercial processes and imagery, from purely private and subjective fantasies and dreams—seems to be the principal effort of many artists. Painters no longer feel themselves confined to canvas and paint, but employ hair, photographs, wax, sand, bicycle tires, their own toothbrushes and socks. Musicians have reached beyond the sounds of the tradi-

tional instruments to use tampered instruments and (usually on tape) synthetic sounds and industrial noises.

All kinds of conventionally accepted boundaries have thereby been challenged: not just the one between the "scientific" and the "literary-artistic" cultures, or the one between "art" and "non-art"; but also many established distinctions within the world of culture itself—that between form and content, the frivolous and the serious, and (a favorite of literary intellectuals) "high" and "low" culture.

The distinction between "high" and "low" (or "mass" or "popular") culture is based partly on an evaluation of the difference between unique and mass-produced objects. In an era of mass technological reproduction, the work of the serious artist had a special value simply because it was unique, because it bore his personal, individual signature. The works of popular culture (and even films were for a long time included in this category) were seen as having little value because they were manufactured objects, bearing no individual stamp—group concoctions made for an undifferentiated audience. But in the light of contemporary practice in the arts, this distinction appears extremely shallow. Many of the serious works of art of recent decades have a decidedly impersonal character. The work of art is reasserting its existence as "object" (even as manufactured or mass-produced object, drawing on the popular arts) rather than as "individual personal expression."

The exploration of the impersonal (and trans-personal) in contemporary art is the new classicism; at least, a reaction against what is understood as the romantic spirit dominates most of the interesting art of today. Today's art, with its insistence on coolness, its refusal of what it considers to be sentimentality, its spirit of exactness, its sense of "research" and "problems," is closer to the spirit of science than of art in the old-fashioned sense. Often, the artist's work is only his idea, his concept. This is a familiar practice in architecture, of course. And one remembers that painters in the Renaissance often left parts of their canvases to be worked out by students, and that in the flourishing period of the concerto the cadenza at the end of the first movement was left to the inventiveness and discretion of the performing soloist. But similar practices have a different, more polemical meaning to-

day, in the present post-romantic era of the arts. When painters such as Joseph Albers, Ellsworth Kelly, and Andy Warhol assign portions of the work, say, the painting in of the colors themselves, to a friend or the local gardener; when musicians such as Stockhausen, John Cage, and Luigi Nono invite collaboration from performers by leaving opportunities for random effects, switching around the order of the score, and improvisations— they are changing the ground rules which most of us employ to recognize a work of art. They are saying what art need not be. At least, not necessarily.

The primary feature of the new sensibility is that its model product is not the literary work, above all, the novel. A new non-literary culture exists today, of whose very existence, not to mention significance, most literary intellectuals are entirely unaware. This new establishment includes certain painters, sculptors, architects, social planners, film-makers, TV technicians, neurologists, musicians, electronics engineers, dancers, philosophers, and sociologists. (A few poets and prose writers can be included.) Some of the basic texts for this new cultural alignment are to be found in the writings of Nietzsche, Wittgenstein, Antonin Artaud, C. S. Sherrington, Buckminster Fuller, Marshall McLuhan, John Cage, André Breton, Roland Barthes, Claude Lévi-Strauss, Siegfried Gidieon, Norman O. Brown, and Gyorgy Kepes.

Those who worry about the gap between "the two cultures," and this means virtually all literary intellectuals in England and America, take for granted a notion of culture which decidedly needs reexamining. It is the notion perhaps best expressed by Matthew Arnold (in which the central cultural act is the making of literature, which is itself understood as the criticism of culture). Simply ignorant of the vital and enthralling (so called "avant-garde") developments in the other arts, and blinded by their personal investment in the perpetuation of the older notion of culture, they continue to cling to literature as the model for creative statement.

What gives literature its preeminence is its heavy burden of "content," both reportage and moral judgment. (This makes it possible for most English and American literary critics to use literary works mainly as texts, or even pretexts, for social and cultural diagnosis—rather than concentrating on the properties

of, say, a given novel or a play, as an art work.) But the model arts of our time are actually those with much less content, and a much cooler mode of moral judgment—like music, films, dance, architecture, painting, sculpture. The practice of these arts—all of which draw profusely, naturally, and without embarrassment, upon science and technology—are the locus of the new sensibility.

The problem of "the two cultures," in short, rests upon an uneducated, uncontemporary grasp of our present cultural situation. It arises from the ignorance of literary intellectuals (and of scientists with a shallow knowledge of the arts, like the scientist-novelist C. P. Snow himself) of a new culture, and its emerging sensibility. In fact, there can be no divorce between science and technology, on the one hand, and art, on the other, any more than there can be a divorce between art and the forms of social life. Works of art, psychological forms, and social forms all reflect each other, and change with each other. But, of course, most people are slow to come to terms with such changes—especially today, when the changes are occurring with an unprecedented rapidity. Marshall McLuhan has described human history as a succession of acts of technological extension of human capacity, each of which works a radical change upon our environment and our ways of thinking, feeling, and valuing. The tendency, he remarks, is to upgrade the old environment into art form (thus Nature became a vessel of aesthetic and spiritual values in the new industrial environment) "while the new conditions are regarded as corrupt and degrading." Typically, it is only certain artists in any given era who "have the resources and temerity to live in immediate contact with the environment of their age . . . That is why they may seem to be 'ahead of their time' . . . More timid people prefer to accept the . . . previous environment's values as the continuing reality of their time. Our natural bias is to accept the new gimmick (automation, say) as a thing that can be accommodated in the old ethical order." Only in the terms of what McLuhan calls the old ethical order does the problem of "the two cultures" appear to be a genuine problem. It is not a problem for most of the creative artists of our time (among whom one could include very few novelists) because most of these artists have broken, whether they know it or not, with the

Matthew Arnold notion of culture, finding it historically and humanly obsolescent.

The Matthew Arnold notion of culture defines art as the criticism of life—this being understood as the propounding of moral, social, and political ideas. The new sensibility understands art as the extension of life—this being understood as the representation of (new) modes of vivacity. There is no necessary denial of the role of moral evaluation here. Only the scale has changed; it has become less gross, and what it sacrifices in discursive explicitness it gains in accuracy and subliminal power. For we are what we are able to see (hear, taste, smell, feel) even more powerfully and profoundly than we are what furniture of ideas we have stocked in our heads. Of course, the proponents of "the two cultures" crisis continue to observe a desperate contrast between unintelligible, morally neutral science and technology, on the one hand, and morally committed, human-scale art on the other. But matters are not that simple, and never were. A great work of art is never simply (or even mainly) a vehicle of ideas or of moral sentiments. It is, first of all, an object modifying our consciousness and sensibility, changing the composition, however slightly, of the humus that nourishes all specific ideas and sentiments. Outraged humanists, please note. There is no need for alarm. A work of art does not cease being a moment in the conscience of mankind, when moral conscience is understood as only one of the functions of consciousness.

Sensations, feelings, the abstract forms and styles of sensibility count. It is to these that contemporary art addresses itself. The basic unit for contemporary art is not the idea, but the analysis of and extension of sensations. (Or if it is an "idea," it is about the form of sensibility.) Rilke described the artist as someone who works "toward an extension of the regions of the individual senses"; McLuhan calls artists "experts in sensory awareness." And the most interesting works of contemporary art (one can begin at least as far back as French symbolist poetry) are adventures in sensation, new "sensory mixes." Such art is, in principle, experimental—not out of an elitist disdain for what is accessible to the majority, but precisely in the sense that science is experimental. Such an art is also notably apolitical and undidactic, or, rather, infradidactic.

When Ortega y Gasset wrote his famous essay *The Dehumanization of Art* in the early 1920s, he ascribed the qualities of modern art (such as impersonality, the ban on pathos, hostility to the past, playfulness, willful stylization, absence of ethical and political commitment) to the spirit of youth which he thought dominated our age.[1] In retrospect, it seems this "dehumanization" did not signify the recovery of childlike innocence, but was rather a very adult, knowing response. What other response than anguish, followed by anesthesia and then by wit and the elevating of intelligence over sentiment, is possible as a response to the social disorder and mass atrocities of our time, and—equally important for our sensibilities, but less often remarked on—to the unprecedented change in what rules our environment from the intelligible and visible to that which is only with difficulty intelligible, and is invisible? Art, which I have characterized as an instrument for modifying and educating sensibility and consciousness, now operates in an environment which cannot be grasped by the senses.

Buckminster Fuller has written:

"In World War I industry suddenly went from the visible to the invisible base, from the track to the trackless, from the wire to the wireless, from visible structuring to invisible structuring in alloys. The big thing about World War I is that *man went off the sensorial spectrum forever* as the prime criterion of accrediting innovations . . . All major advances since World War I have been in the *infra* and the *ultra*sensorial frequencies of the electromagnetic spectrum. All the important technical affairs of men today are invisible . . . The old masters, who were sensorialists, have unleashed a Pandora's box of non-sensorially controllable phenomena, which they had avoided accrediting up to that time . . . Suddenly they lost their true mastery, because from then on they didn't personally understand what was going on. If you don't understand you cannot master . . . Since World War I, the old masters have been extinct . . ."

But, of course, art remains permanently tied to the senses. Just

[1] Ortega remarks, in this essay: "Were art to redeem man, it could do so only by saving him from the seriousness of life and restoring him to an unexpected boyishness."

as one cannot float colors in space (a painter needs some sort of surface, like a canvas, however neutral and textureless), one cannot have a work of art that does not impinge upon the human sensorium. But it is important to realize that human sensory awareness has not merely a biology but a specific history, each culture placing a premium on certain senses and inhibiting others. (The same is true for the range of primary human emotions.) Here is where art (among other things) enters, and why the interesting art of our time has such a feeling of anguish and crisis about it, however playful and abstract and ostensibly neutral morally it may appear. Western man may be said to have been undergoing a massive sensory anesthesia (a concomitant of the process that Max Weber calls "bureaucratic rationalization") at least since the Industrial Revolution, with modern art functioning as a kind of shock therapy for both confounding and unclosing our senses.

One important consequence of the new sensibility (with its abandonment of the Matthew Arnold idea of culture) has already been alluded to—namely, that the distinction between "high" and "low" culture seems less and less meaningful. For such a distinction—inseparable from the Matthew Arnold apparatus—simply does not make sense for a creative community of artists and scientists engaged in programming sensations, uninterested in art as a species of moral journalism. Art has always been more than that, anyway.

Another way of characterizing the present cultural situation, in its most creative aspects, would be to speak of a new attitude toward pleasure. In one sense, the new art and the new sensibility take a rather dim view of pleasure. (The great contemporary French composer, Pierre Boulez, entitled an important essay of his twelve years ago, "Against Hedonism in Music.") The seriousness of modern art precludes pleasure in the familiar sense—the pleasure of a melody that one can hum after leaving the concert hall, of characters in a novel or play whom one can recognize, identify with, and dissect in terms of realistic psychological motives, of a beautiful landscape or a dramatic moment represented on a canvas. If hedonism means sustaining the old ways in which we have found pleasure in art (the old sensory and psychic modalities), then the new art is anti-hedonistic. Having

one's sensorium challenged or stretched hurts. The new serious music hurts one's ears, the new painting does not graciously reward one's sight, the new films and the few interesting new prose works do not go down easily. The commonest complaint about the films of Antonioni or the narratives of Beckett or Burroughs is that they are hard to look at or to read, that they are "boring." But the charge of boredom is really hypocritical. There is, in a sense, no such thing as boredom. Boredom is only another name for a certain species of frustration. And the new languages which the interesting art of our time speaks are frustrating to the sensibilities of most educated people.

But the purpose of art is always, ultimately, to give pleasure—though our sensibilities may take time to catch up with the forms of pleasure that art in a given time may offer. And, one can also say that, balancing the ostensible anti-hedonism of serious contemporary art, the modern sensibility is more involved with pleasure in the familiar sense than ever. Because the new sensibility demands less "content" in art, and is more open to the pleasures of "form" and style, it is also less snobbish, less moralistic—in that it does not demand that pleasure in art necessarily be associated with edification. If art is understood as a form of discipline of the feelings and a programming of sensations, then the feeling (or sensation) given off by a Rauschenberg painting might be like that of a song by the Supremes. The brio and elegance of Budd Boetticher's *The Rise and Fall of Legs Diamond* or the singing style of Dionne Warwick can be appreciated as a complex and pleasurable event. They are experienced without condescension.

This last point seems to me worth underscoring. For it is important to understand that the affection which many younger artists and intellectuals feel for the popular arts is not a new philistinism (as has so often been charged) or a species of anti-intellectualism or some kind of abdication from culture. The fact that many of the most serious American painters, for example, are also fans of "the new sound" in popular music is *not* the result of the search for mere diversion or relaxation; it is not, say, like Schoenberg also playing tennis. It reflects a new, more open way of looking at the world and at things in the world, our world. It does not mean the renunciation of all standards:

there is plenty of stupid popular music, as well as inferior and pretentious "avant-garde" paintings, films, and music. The point is that there *are* new standards, new standards of beauty and style and taste. The new sensibility is defiantly pluralistic; it is dedicated both to an excruciating seriousness and to fun and wit and nostalgia. It is also extremely history-conscious; and the voracity of its enthusiasms (and of the supercession of these enthusiasms) is very high-speed and hectic. From the vantage point of this new sensibility, the beauty of a machine or of the solution to a mathematical problem, of a painting by Jasper Johns, of a film by Jean-Luc Godard, and of the personalities and music of the Beatles is equally accessible.

4 FROM *Marshall Fishwick*
Confessions of an Ex-Elitist

Perhaps no more candid expression of how a person changes his attitude toward "elite" and "Popular" culture need be made than Marshall Fishwick's. Though an account of a personal change, the essay undoubtedly charts the alteration in attitude of many of us.

"One cheats himself, as a human being, if one has respect only for the style of high culture."

Susan Sontag

Pooh-Bah was born sneering. Unlike Gilbert's famous snob, most of us must acquire the habit. It begins when we learn there are "better" toys, playmates, words; "superior" schools on the "right side of the track." On then to Ivy U., where Matthew Arnold's shadow still haunts the cloisters. Exposed to "the best

SOURCE. Reprinted with the permission of Marshall Fishwick from a pamphlet *Confessions of an Ex-Elitist* published by the Popular Culture Association and the American Studies Institute, Lincoln University.

that has been thought and said," at least in Western Europe, one burns with a gem-like flame: this is Higher Education. Up up he goes, until

> *"Established in his eminence of taste*
> *This little man has little time to waste;*
> *And so the only books at which he looks*
> *Are books on books, or books on books*
> *on books."*

One finds himself wearing the robes of Platonism—that *haute couture* of the academic establishment. He analyzes the realm of value by looking chiefly at ideal embodiments, seeking the un-blemished display of perfection. Intent on the True and the Beautiful, Plato labeled democracy the worst form of govern-ment, and wanted to exile artists in his Republic, since they worked with cheap copies of reality. Believing this, scorning the vulgar and the low, I became, at an early age, an elitist.

Other acceptable labels were aristocratic, purist, highbrow, cognoscenti, sophisticated. Little magazines and big words were *de rigeur*. So was the first editon and the last word.

I turned my back on Parmenides: "The time will come when philosophy will not despite even the meanest things, even those of which the mention may provoke a smile." My mentors were Ortaga Y. Gassett, warning that "the masses not only vulgarize and dehumanize but actually destroy art"; T. S. Eliot, whose *Defi-nition of Culture* was narrow enough to exclude even Pooh-Bah; and Ezra Pound, hooked on Chinese ideograms and Mussolini. There was too that haughty English don, F. R. Leavis, who would later be echoed by Denys Thompson and Oxford dons. Closer to home, elitist Dwight McDonald insisted that homog-enized popular art did not even have the theoretical possibility of being good. *Against the American Grain* enunciated his Law of Raspberry Jam—unless checked, the tepid ooze of Midcult will contaminate all civilization.

"Unremitting talk about the good is not only boring but usu-ally inconsequential as well," Abraham Kaplan wrote in 1966. "Aesthetic theory that is preoccupied with artistic virtue is largely irrelevant both to artistic experience and to critical practice, confronted as they are with so much vice."[1] But 20 years sepa-

rated my college days and Kaplan's observation. During that time I concealed my interest in radio, movies, comics, and other items dear to the *hoi polloi*. When I boarded my first navy ship my duffel bag contained not only a copy of the *Bluejacket's Manual*, but the *Poems of Milton*—and Tillyard's comments on them. Those buffeting war years did bring me into contact with American poets for the first time. One of them, in fact, inspired me to espouse American Studies. I wanted to answer the questions Walt Whitman raises in "By Blue Ontario's Shore":

> *"Who are you indeed who would talk or sing to America?*
> *Have you studied out the land, its idiom and men?*
> *Are you really of the whole People?*
> *Have you vivified yourself from the maternity of these*
> *States?"*

So off to graduate school. Little did I dream that I would "vivify myself" by studying Old Norse, German grammar, and amply footnoted monographs in *PMLA* and other scholarly journals. Instead of bringing me closer to "the whole People," the doctorate strengthened my elitist philosophy and Platonism. Outside the Yale Tower was a city that would soon seethe with violence and revolution; of that I knew and thought nothing. The America we studied was safely locked up in the stacks.

Teaching in a "good" (i.e., elite) small college, I found a cordial reception for such Higher Learning. A moment of crisis came when we received our first TV set from a well-meaning relative. This was quickly consigned upstairs, to a back bedroom. The Dean was known to be unalterably opposed to the boob tube; and after all, with promotions coming up in the spring . . .

Then I met Marshall McLuhan. His elitist credentials were impeccable—he had even studied in Mother England. But when he confronted classes of freshman, McLuhan admitted, he was incapable of understanding them. "I felt an urgent need to study their popular culture," he later wrote, "advertising, games, movies. It was pedagogy, part of my teaching program."[2]

No need to summarize here the controversial dicta the scholar Harold Rosenberg calls "a belated Whitman singing the body electric with Thomas Edison as accompanist." And no use denying that telling criticisms have been leveled against the King

of Popthink. His message, Benjamin DeMott warns, is relax; go soft and complacent; accept subliminal perfectibility—a new form of Platonism? "How much can be said for an intellectual vision whose effect is to encourage abdication from all responsibility of mind?" DeMott asks.[3] Those of us who have left the elitist camp to assume rather than abdicate responsibility must not only hear but answer such questions. We must explain why we take great risks to avoid what Norman Podhoretz calls "an eternal isolation . . . which ends finally in sterility, disassociation, and mandarinism."

This means serious and significant study of popular culture, which is not yet a discipline but a series of related subjects neglected or slighted by established disciplines. Instead of lauding the cheap and inferior, a new breed of scholar would study those things (some inferior, some superior, some extraordinary) cherished and supported by ordinary men. Nobody likes popular culture *per se*, but many like certain specific popular works. "Contemporary democracy and mass culture are two sides of the same coin," H. Stuart Hughes observes.[4] The real meaning of popular culture lies not in some definable area or method, but in an attempt to find new apparatus to study and understand the world people inhabit and relish.

Pioneers launched that effort half a century ago. Van Wyck Brooks made his highbrow-lowbrow distinctions in 1915. Shortly afterwards Gilbert Seldes began collecting material on the *Seven Lively Arts,* restoring a good conscience to people who were enjoying silent movies and "Gasoline Alley"—"but with an uneasy feeling that they ought to be hearing Puccini and looking at the murals of Puvis deChavennes." Folklorists collected nonelite material, but generally got a mere toehold in universities. Edmund Wilson, Lewis Mumford, and John Kouwenhoven probed new areas, centering on "the unselfconscious efforts of common people to create satisfying patterns, not inspired by ancient tradition, but imposed by the driving energies of an unprecedented social structure."[5] Siegfried Giedion showed that molded plywood forms which revolutionized 20th century elite art were conventional material for ferryboat seats in the 1870's; and that certain highly acclaimed Bauhaus designs had been standard equipment on American reapers and mowers since the 1850's.

The most vigorous art movement since World War II—pop art
—draws much of its material from super markets, filling stations,
and neon-lighted streets on which Everyman makes his contem-
porary pilgrimage.

Most interdisciplinary scholarship of this type met with icy
disdain. The Big Thaw got underway in the Kennedy Years,
affecting films, literature, politics, journalism, and finally the
academic establishment itself. Significantly, the heading "Popular
Culture" didn't appear in *Reader's Guide* until 1960. The days
of the "silent generation" and the boot-licking "organization
man" passed. The emphasis moved from silence to uproar; from
negative to positive values; from turned off to tuned in. This
recognition of inescapability, on a private and public level,
moved modern thought from existentialism to social realism.
(What ever happened to David Riesmann's *Lonely Crowd?*)

More and more scholars have come to recognize popular cul-
ture as a barometer, mirror, and monument of the world around
them. It is the cutting edge of American Studies expanding fur-
ther the inquiry into and between subjects that began a genera-
tion ago. Those of us over 30 must acquire its idiom and flavor;
those under have been unable to avoid it, since it is the *lingua
franca* of their generation. Popular culture is their culture, norm,
mode. Perhaps, they are saying, we are not *ex*-elitists but *post*-
elitists. Neat categories and barriers are disappearing. Hard be-
comes soft, drama becomes audience, small becomes large, silence
becomes music. Men like John Cawelti are both fascinated and
frightened by the new radical cultural transformations. "At
times they seem to hold out the promise of a revitalization of our
culture," he writes. "At other times I wonder whether it is not
simply an evasion of cultural responsibility."[6] Meanwhile Peter
Haertling, viewing the 1970 international Book Fair in Frank-
furt, reports: "This has been a fair of pop singers, famous fliers,
and obsolete comic strips. I suppose great novels are a thing of
the past."[7]

It was to assume and meet such new conditions that popular
culture courses centering on nonelite groups (especially Afro-
American) came into being. A 1969 survey by the Popular Studies
Association commented on this:

"The evolution of the Black culture course is a good illustration of some general trends in popular culture studies. Originally, Black culture was studied primarily in sociology and history courses which tried to define, analyze, and prescribe remedies for the deviant and negative aspects of Black culture. Recently, however, a quite different kind of course has developed which is more humanistic in its approach and tries to define the uniquely positive values of Black culture by studying the creative ways in which Black people have responded to their cultural predicament."

That same survey showed that 56% of them offered specific courses in popular culture (exclusive of vocational or professional courses in TV, film, journalism, etc.) Others outside the universities noticed the dramatic changes, too. The Nov. 21, 1970 issue of *Saturday Review* headlined "The Apotheosis of Masscult."

Susan Sontag, who is *Against Interpretation*, argues that the novel is dead and says that interpretation is the revenge of the intellect upon art. "Even more, it is the revenge of the intellect upon the world." There are new standards of beauty, style, taste: pluralistic, high-speed, hectic. "From the vantage point of this new sensibility, the beauty of a machine, of a painting, of a film, and of the personalities and music of the Beatles is equally accessible."[8]

When a field of study comes of age, it produces major synthetic studies that show how the jigsaw puzzle can be assembled. Such a book was published in 1970—Russel B. Nye's 500-page volume (in Dial's "Two Centuries of American Life" series) *The Unembarrassed Muse: The Popular Arts in America*. Dealing with popular fiction, poetry, theater, art, heroes, music, and media, Nye sets a new standard for comprehensiveness. He documents the gradual improvement over the years of popular standards of performance. The simple literalness of Tom Mix and Edward G. Robinson has become the symbolic, multileveled popular art of *High Noon* and *Bonnie and Clyde*.

Nye, who helped create some of the elite studies and attitudes which he now examines, spearheads the reevaluation of the position of popular culture in modern critical thought. "To erase

the boundaries created by snobbery and cultism," he writes in the final chapter, "that have so long divided the arts means, in the long run, greater understanding of them."

Though we meet it everywhere, popular culture is still a vast and unknown terrain. Ahead lies not only new media and messages, but a cosmos, society, and ontology which even our parents could not have imagined. Because popular culture is built on now, and the instant, it reflects that search, with the dramatic breakthroughs, first and most vividly. (For example, we *saw* the first man step on the moon, at the very instant he stepped out. We *saw* Oswald assassinated, Cambodia invaded, Nasser buried.) "There are many misguided attempts to mold synthetic demigods," John Lahr points out in *Up Against the Fourth Wall*. "But through all of it, American mythology is being reassessed."

I confess I find that very exciting.

REFERENCES

1. Abraham Kaplan, "The Aesthetics of the Popular Arts," *Journal of Aesthetics and Art Criticism*, XXXIV (Spring, 1966), p. 351.
2. Gerald E. Stearn, editor, *McLuhan Hot and Cool* (New York, 1967), p. 268.
3. *Ibid.*, p. 252.
4. "Mass Culture and Social Criticism," *Daedalus* (Spring, 1960), p. 388.
5. John Kouwenhoven, *Made in America* (New York, 1948), p. 125.
6. "Beatles, Batman, and the New Aesthetic," *Midway* (Autumn, 1966), p. 68.
7. *New York Times,* Oct. 11, 1970, p. 88.
8. *Against Interpretation* (New York, 1961), p. 12.

PART THREE

Expanding Awareness

5 FROM *John G. Cawelti*
Notes Toward an Aesthetic of Popular Culture

John Cawelti's essay points out that the traditional ways of viewing art—with the "high-low" dichotomy—are too simplistic and depend upon too few variables. "Truth" or actuality involves many more aspects that must be considered, if one is to understand the continuum of art.

Whenever criticism feels the impact of an expanded sensibility, it becomes shot through with ideological dispute. In quieter, more stable artistic times, the critic, unburdened by the clash of methods and criteria, can focus his attention on his real task, the exploration and interpretation of individual works of art. But before he can do so with any hope of being understood and accepted by others, he must share with them at least a basic core of assumptions about the nature and value of artistic work. For almost three decades now, the criticism of literature, despite a variety of tangential currents, has flowed fairly smoothly from certain key assumptions of the "new criticism": the integrity and

SOURCE. John Cawelti, *Notes Toward an Aesthetic of Popular Culture,* pp. 255–268. Reprinted with the permission of the *Journal of Popular Culture* from the *Journal of Popular Culture,* Volume V:2, Fall 1971. Copyright © 1971 by Ray B. Browne.

unity of the individual work, the intricate analysis of structure as the key to meaning and value, the central value of complexity of expression as manifested in artistic devices like tension, irony, ambiguity, etc.

But the impact of the new media, the growth of a new pop culture, and the widening range of artistic interests and tasks have opened again the Pandora's box of aesthetic controversy. The resultant confusion is most apparent in film criticism—at present the most highly developed though most pungently polemical area of criticism involving modern popular forms. Compared to film criticism, other modes of popular art such as pop music, comedy, and formula literature like detective stories, have remained critically inarticulate, except for the work of reviewers. To a considerable extent these modes of popular art still bear the lingering stigma of cultural inferiority which long prevented film criticism from coming into its own. Indeed, the problem of the relationship between popular art and so-called "high" or "serious" art has always been the crux of any attempt to create a popular aesthetic. In this paper, I would like to explore this difficulty and to suggest how some of the recent concepts of film criticism have made possible a better approach to the analysis and criticism of the popular arts.

The traditional way of treating the popular arts has been in effect to deny that they are arts at all, or at least not arts in the same sense as the high arts. This practice has age-old authority since it was first and most compellingly set forth by no less a critic than Plato. In the *Gorgias*, Socrates arrives at a fundamental distinction between "arts" which are rational methods for using true knowledge to good ends and non-arts or "knacks" as Socrates calls them which are capable of moving the mind through pleasure. However, these "knacks" are irrational because they concern not truth, but what pleases. Thus they are practised by a combination of instinct and trial and error and cannot, like arts, be taught or meaningfully discussed. As examples of knacks as opposed to arts, Socrates distinguishes cookery from medicine and make-up from gymnastics. Cookery and medicine both concern themselves with diet. However, where medicine prescribes not what pleases, but what the doctor's knowledge tells him is best for the body to eat, the cook seeks

primarily to please, irrespective of the consequences for health. Similarly, the gymnast prescribes exercises aimed at the creation of a healthy body, while the make-up man has the knack of creating a beautiful appearance without concern for the actual state of the body. In the same way, rhetoric, Socrates argues, is not an art based on true ends, but a knack for creating the appearance of conviction: its true and rational counterpart is legislation, the art of prescribing what is right for the health of the state.

Many modern critics have used the Platonic distinction between art and knack to distinguish "high" or "serious" art from the popular or mass arts; in contemporary parlance the Platonic notion of knack has been replaced by such terms as entertainment or "kitsch." But the basic idea remains the same; arts dedicated to higher purposes are opposed to arts that have simple pleasure or an appeal to the baser emotions as their primary goal.

Today, though many critics have consciously abandoned the negative, pejorative approach that long dominated the discussion of popular culture, the traditional Platonic distinction between art and non-art has a way of lingering on in more positive forms. Much current critical treatment of such film directors as Alfred Hitchcock reflects this tendency. O. B. Hardison, for instance, completely retains the traditional Platonic distinction, but he believes that the rhetorical knacks which Plato condemns are significant arts, which have their own meaningful purposes and are highly valuable in their own way. Thus, for him, Hitchcock is not an artist in the true sense, but a high quality professional creator of entertaining melodrama.

"Nobody would seriously compare Hitchcock to a dozen directors and producers who have used the film medium as an art form. Eisenstein, Chaplin, Ford, Bergman, Olivier, Fellini—the list could be expanded—have qualities undreamed of in the world of cops and robbers and pseudo-Freudian melodrama, which is the world where Hitchcock reigns supreme."[1]

In explaining and defining his distinction between "professional" and "artist" Hardison goes on to create a superb contemporary formulation of Plato's *Gorgias* distinction:

"Consider the professional a rhetorician. The purpose of art, says Aristotle, is to give pleasure. Not any kind of pleasure, but the sort that comes from learning. The experience of art is an insight, an illumination of the action being imitated. Rhetoric, on the other hand, is oriented toward the market place. Its purpose is not illumination but persuasion, and its governing concept is that the work produced must be adjusted to the mind of the audience. Rhetorical art succeeds by saying what the audience has secretly known (or wanted to know) all along. Its language is disguised flattery, its norm fantasy, and its symbols surrogates for unconscious cravings. Given the passionate desire that everyone has to suspend disbelief, almost anything works, as witness the comic book and the exploits of Mike Hammer and James Bond; but some kinds of rhetoric work better than others. [and here Hardison departs sharply from Plato] Just as there is good and bad art, there is good and bad rhetoric."[2]

Hardison's essay is somewhat ambiguous on the relative value of art and rhetoric. At times he seems to be saying, like Socrates, that rhetoric is an inferior mode of creation: ("Nobody would seriously compare Hitchcock to a dozen directors and producers who have used the film medium as an art form"). But, on the other hand he seems to suggest that rhetoric, though different from art is equally valid: "If [Hitchcock's thrillers] are rhetoric and shaped by the needs of the audience, they are just as significant as art and just as necessary."[3] This uncertainty about the aesthetic value of Hitchcock's work leads Hardison to a particular mode of analysis of his films. Instead of treating them as independent works, Hardison examines Hitchcock's thrillers as embodiments of the middle-class mind of the twentieth century. "Because Hitchcock has continued to produce successful thrillers for over thirty years, his films are a kind of contour map of the middle-class mind during this period."[4]

This approach implies that the work of "rhetorical" or popular artists like Hitchcock is successful because it embodies or expresses the values of the popular mind in a particularly effective or direct fashion. This assumption, shared by many scholars and critics of the popular arts has made social and psychological analysis the dominant mode of interpretation and analysis in

dealing with this kind of material. Thus, the distinction between high art and popular art has led to two quite different modes of discussion: high art is commonly treated as aesthetic structure or individual vision; the popular arts are studied as social and psychological data.

There is certainly some validity to this practice if we assume that what is popular embodies cultural attitudes to a greater extent than that which is not. However, such an approach does have some problems. First of all, what is popular at any given time is not all "rhetorical" art. Indeed, as Frank Luther Mott's study of best-sellers has shown, many novels which we would call high art have over a longer period of years sold as well as many ephemeral best-sellers.[5] This is perhaps not as clear in the case of the newer media of film and TV. Nonetheless, films which belong unquestionably to the category of high art—e.g., the works of Bergman, Fellini, Antonioni and Godard—have been quite popular. Correspondingly, many films clearly designed solely for rhetorical purposes, have not been successful. Thus, there is no necessary connection between popularity and those qualities of a work which Hardison designates as rhetorical. The fact that a work is designed to please the audience, clearly does not mean that it will become popular. Otherwise, most Hollywood films and pulp novels would achieve the popularity of Hitchcock at his best, and works created primarily with a view to an artistic expression of the creator's vision would inevitably fail.

A second difficult question is what psychological process or mechanism makes the expression of commonly held values popular with the public. Is it simply that we find comfort in repetitions of received opinions? But if this is the case, why go to all the trouble of constructing a fiction; if this theory of popularity is correct we should all be satisfied with Fourth of July Speeches and sermons from the church of our choice. Moreover, if we look at some of the most successful popular works, they seem as much to contradict popular views as to affirm them. One of the strongest middle-class values is a respect for law and order and a high valuation of stability and respectable enterprise. Yet in Hitchcock's thrillers, respectable citizens become involved in situations of peril and intrigue where the established machinery of law and

order is helpless. Perhaps this is vicarious adventure which springs from the impulse to escape an overly stable and restrictive life. Then Hitchcock is successful because he reflects basic conflicts in the middle-class mind. This is essentially the way Hardison views Hitchcock: his films embody the subconscious need to engage in adventures without destroying the framework of reason and stability:

"No matter how we may plot our situation on the charts of reason, the subconscious needs to view life as an epic quest through alien territories and the domains of strange gods, underwritten by providence and with the payoff guaranteed. Hitchcock's thrillers present this fantasy in palatable modern guise."[6]

But if this means that Hitchcock's thrillers constitute an exploration and resolution of the complex conflicts between the conscious mind and the devious subconscious, how do we differentiate this from art? Why is the insight into human life produced by such a work of art any less than that of say, Dostoyevsky's *Crime and Punishment?* Hardison would reply, I think, that Hitchcock's exploration and resolution is more formulaic, more stereotyped than Dostoyevsky's. But, if this is the case, are we not just saying that Hitchcock is an inferior artist? In these terms is not the distinction between high art and popular art simply a means of evading the obvious conclusion that most popular artists are inferior artists, no matter how much pleasure they may give.

Several other difficulties attend the definition of the popular arts along the Platonic lines of truth vs. rhetoric. Are we then to say that high art is not rhetorical, does not depend for much of its effectiveness on a skillful manipulation of audience attitudes and feelings. If all art depends on emotional effect to some extent just where do we draw the line between rhetoric and art? To some extent this depends on the audience and not on the innate character of the work. To a person without much education or sophistication, a soap opera may well be an important source of truths about life. Is it then entirely rhetorical for such a person? Moreover, it is a notorious fact that the popular art of one century often becomes the high art of another. Shakespeare and Dickens certainly thought of themselves as popular artists writing for a heterogeneous public and the media in which they worked

were the mass media of their day. Today their status as classics is unchallenged. Does this mean that *Hamlet* and *Bleak House* have been transmuted by some mysterious process from rhetoric into art? From audience flattery into illumination?

I find it impossible to answer these questions very satisfactorily and I invariably run into such mare's nests whenever I try to separate the high arts and the popular arts in this fashion. I recommend that we turn our attention to the work of a different school of film critics, who have managed to surmount this problem. This group is known as the *auteur* critics after a term first given wide currency in an essay by the French critic and director Francois Truffaut.[7] To understand the particular emphases of *auteur* criticism one must grasp certain aspects of the critical background against which it developed. For many years serious film criticism followed the model of literary criticism by concentrating most of its attention on films which could unmistakably be conceived as total works of art. This meant in practice films which were controlled from inception to final editing by a single artist and which could be viewed as original creations with serious rather than entertaining intentions. Naturally such criticism largely rejected the output of the American film industry where, with the exception of a few rare films like Welles' *Citizen Kane,* the product was the result of many conflicting judgments and the criteria of entertainment commonly played a greater part than the ideals of art. The *auteur* critics, finding artistic value and interest in the Hollywood film, have created a new mode of analysis based on the individual stylistic characteristics and thematic interests of the director. Their criticism has demonstrated that despite the commercial orientation and artistic limitations of the American film industry, certain directors of great ability—men like Hitchcock, Welles, Renoir, Lang, Ford, Hawks and Cukor—have been able to make significant individual artistic statements. The crucial difference in the approach of the *auteur* critics from that of contemporary critics of literature lies in the way the artistic statement is defined.[8] Where the new critic defines the artistic statement in terms of the total unity and power of the individual work, the essential reference of the *auteur* critic is to the *auteur's* complete work; the artistic statement is sought not in the complex totality of the individual work, but in those aspects

of the individual film which are clearly related to the overall stylistic or thematic preoccupation of the *auteur*. Indeed, for the *auteur* critic, many elements of the work, including some of its most obvious characteristics, may have to be set aside in order to discover the *auteur's* statement:

"One essential corollary of the theory as it has been developed is the discovery that the defining characteristics of an author's [*auteur's*] work are not necessarily those which are most readily apparent. The purpose of criticism thus becomes to uncover behind the superficial contrasts of subject and treatment a hard core of basic and often recondite motifs. The pattern formed by these motifs . . . is what gives an [*auteur's*] work its particular structure, both defining it internally and distinguishing one body of work from another."[9]

An example will clarify what these somewhat enigmatic statements mean. The most obvious defining characteristic of most of the films of Hitchcock is their thrilling, frequently melodramatic, plots presenting situations of international intrigue and crime. These plots are, for the most part, derived from the work of others —many of Hitchcock's films have been based on novels by such writers as John Buchan, Somerset Maugham, Daphne du Maurier, Patricia Highsmith, Cornell Woolrich and even Joseph Conrad. In turn many aspects of the way these stories are realized in Hitchcock's films relate to popular traditions of the thriller and the romance. Yet, despite all these limitations on his originality, limitations typical of those imposed on any director working in Hollywood, Hitchcock remains a highly distinctive and unique director. In what consists this uniqueness? According to the *auteur* critics the answer to this question lies along two lines: a) the special technical cinematic competence and unique mastery of visual style and editing which Hitchcock brings to his work and b) the way in which he is able to use conventional materials of many different kinds to explore certain moral and artistic themes which have always fascinated him. Anyone who has seen a Hitchcock film is probably at least unconsciously aware of one recurrent motif: the peculiar intensity of attention which is focussed on particular details or objects. Hitchcock's settings are commonly rather austere; even when they represent lavish ballrooms or

luxury hotels, they are almost never cluttered with objects or rich with decor. But within this general austerity certain small details and objects, usually very ordinary things, become highly charged with significance and ambiguity: a glass of milk which may or may not be poisoned, a key, a newspaper, a man's hand, these ordinary objects have a way of suddenly becoming symbols of something sinister and terrible. This pattern of the innocent becoming sinister or evil is clearly a basic form of Hitchcock's imagination and few of his most successful films fail to embody it both in detail and in the larger patterns of the story. Film after film is based on the plight of an ordinary person suddenly caught up in a web of intrigue and crime and forced to undergo the experiences of guilt and terror. Those incidents from Hitchcock's films which haunt the mind invariably bear this quality of the sudden transformation of the ordinary into the terrifying: the shower murder in *Psycho* where a ghastly murderous figure suddenly turns up in the most banal and ordinary motel bathroom; the crop-dusting plane in *North by Northwest* which suddenly becomes a murderous instrument, or to take a much earlier example, the tweedy country gentleman in *The 39 Steps* who is suddenly revealed as the leader of the enemy spies when the hero notices that he has a portion of one finger missing. Or think what Hitchcock has so often made of train journeys, commonly experiences of mild boredom and relaxation. Such examples could be multiplied indefinitely, but these should be enough to suggest the presence of basic patterns derived from stylistic and thematic preoccupations which Hitchcock is able to impose on the most diverse and conventional kind of story material.

Because it is concerned not with the unity of the total work, but with those elements which show the individual mark of the director, auteur criticism has been very fruitful in dealing with those films which have been created as part of a mass entertainment industry. The *auteur* approach also has the value of ducking the problematic art-rhetoric distinction by simply ignoring those aspects of films which aim at manipulating audience emotions and attitudes and concentrating on the director's style and themes. Far from distinguishing between "rhetorical" film-makers like Hitchcock and serious artists, the *auteur* critics like to insist on the authentic artistry of a Hitchcock and frequently remind us of

the analogy between the "commercial" Hollywood cinema and the equally "popular" Elizabethan theater. Robin Wood draws out this comparison in a statement which directly opposes Hardison's comments on the nature of Hitchcock's films:

"Hitchcock's films are—usually—popular: indeed some of his best films . . . are among his *most* popular. From this arises a widespread assumption that, however 'clever,' 'technically brilliant,' 'amusing,' 'gripping,' etc. they may be, they can't be taken seriously. They *must* be, if not absolutely bad, at least fatally flawed from a serious standpoint. And it is easy enough for those who take this line to point to all manner of 'concessions to the box office,' fatal compromises with a debased popular taste: Hitchcock returns repeatedly to the suspense-thriller for his material; he generally uses established stars who are 'personalities' first and actors second; there is a strong element of humour in his work, 'gags' and 'comic relief' which effectively undermine any pretensions to sustained seriousness of tone. To one whose training has been primarily literary, these objections have a decidedly familiar ring. One recalls that 'commercial'—and at the same time intellectually disreputable—medium the Elizabethan drama; one thinks of those editors who have wished to remove the Porter scene from *Macbeth* because its tone of bawdy comedy is incompatible with the tragic atmosphere. . . . What one does not want either Shakespeare or Hitchcock deprived of is precisely the richness their work derives from the sense of living contact with a wide popular audience. To wish that Hitchcock's films were like those of Bergman or Antonioni is like wishing that Shakespeare had been like Corneille."[10]

Like many new, partly developed critical methods, the *auteur* approach has been highly susceptible to faddism. Some of its judgments can leave those outside the magic circle of conviction gasping: "Charlton Heston is an axiom of the cinema." Apart from its occasional excesses, however, the *auteur* approach has produced the most interesting and systematic body of film criticism being written today and therefore merits our attention as a possible model for the analysis and interpretation of popular culture generally.

Auteur criticism has effectively widened our range of awareness

in the film, because the *auteur* critic's concept of artistry corresponds with the kind of creativity most successful under the circumstances of popular culture. If we look a little more closely at the concept of the *auteur*, we will see how this is the case.

According to most proponents of the theory the *auteur* is not one of those few film directors who insist upon absolute originality, who create their own material, write their own scripts and thus create total works of art without any compromises for the sake of commercial success or mass audience tastes. On the other hand, the *auteur* is not a mere technician who simply transmits to film the script which an omnipotent producer hands him. Instead, the *auteur* is an individual creator who works within a framework of existing materials, conventional structures, and commercial imperatives, but who nonetheless has the imagination, the integrity, and the skill to express his own artistic personality in the way he sets forth the conventional material he works with. In other words, the successful *auteur* lies somewhere along the continuum between original creation and performance. He is not an original artist because he is an interpreter of materials or of conventional structures largely created by others, but he is more than a performer because he recreates these conventions to the point that they manifest at least in part the patterns of his own style and vision.

Thus, the analogy between Shakespeare and a film *auteur* like Hitchcock is not totally absurd. Like Hitchcock, Shakespeare worked in a popular, commercial medium and accepted the limitations of that medium. He, too, made extensive use of conventional material; as we know from the many studies of his sources, most of Shakespeare's plays were adaptations of existing stories. His work is full of the stage conventions of his time and emphasizes many of the same popular elements on which Hitchcock has fastened: sensational crimes and international intrigues, madness and violence, mystery and romance. Moreover, it is not inconceivable that like Shakespeare's plays, Hitchcock's films will make the transition from the popular art of one century to the high art of another. Still, I find it a little hard to accept the Shakespeare-Hitchcock analogy with the same conviction as a good *auteur* critic like Robin Wood. Wood, I think, might agree that Shakespeare does far more to transform his materials and thus to create

totally unique works of art than Hitchcock does. But, it seems to me there is also something of a theoretic as well as a qualitative distinction here. The distinction I have in mind is a result of the difference between contemporary popular dramatic conventions, and those of the Elizabethan stage. The tradition of the contemporary thriller, which Hitchcock operates within is a far more specialized and restrictive tradition than that of the Elizabethan tragedy. For one thing, the thriller is the result of a longer process of cultural evolution and is consequently more rigid and refined in its conventional limits. In addition, the thriller is generally conceived of as a form which, for purposes of entertainment, restricts the depth and range of emotion which it arouses. While the Elizabethan theater was also devoted to entertainment, it is evident from the plays themselves—and not just Shakespeare's—that the nature and kind of emotion which could be represented was richer and more complex. Elizabethan tragedy arouses pity and fear and brings them to their fullest expression before dismissing them; the thriller arouses these emotions, but never fully because it restricts their expression by relief when we see that the hero and heroine will be saved from a terrible fate and by a displacement of pity and fear into terror and suspense. Even in a film which verges on tragedy like *Psycho,* Hitchcock is very careful to restrict our sense of identification with the heroine by showing her yielding to a temptation so petty that the viewer pities her plight, but does not feel the tragic sense of identification. Then, in the murder scene our emotion is displaced from a specific feeling for the heroine to a more generalized sense of terror and the uncanny, a feeling which is immediately powerful but less deep and lasting in its impact. This is, of course, a function of the conception of entertainment as a highly controlled experience which puts us through an intense series of emotions which immediately dissipate upon conclusion of the performance. Working within the limitations of contemporary conceptions of entertainment, Hitchcock must strive for an artistic effect which is less rich and deep but more tightly focused and controlled than that cultivated by the Elizabethan dramatists.

Thus, there is some validity to the kind of distinction O. B. Hardison makes between Hitchcock and directors like Eisenstein, Bergman and Fellini. But this is not a contrast between art and

rhetoric, but between different kinds of art. The art of the free creator is the making of a unique and integrated work which in its totality embodies a new conception of art and of the world. The art of the *auteur* is that of turning a conventional and generally known and appreciated artistic formula into a medium of personal expression while at the same time giving us a version of the formula which is satisfying because it fulfills our basic expectations. As noted earlier, the art of the *auteur* lies somewhere between creation and performance. It differs from original creation not in being more rhetorical, but in sharing certain of the characteristics of performance. It is this aspect which relates it to popular or mass culture.

Hall and Whannel point out in their interesting book on the popular arts that these are above all arts in which performance plays a central role. They ascribe this fact to two conditions of popular art: first, the essential conventionality which makes it widely understood and appreciated by places stressing the repetition or performance of something already known rather than the creation of something new; second the need for a quality of personal style, since among essentially similar versions of a formula that one that manifests most clearly a sense of individual style will be most attractive and gratifying:

"Popular art is essentially a conventional art which restates in an intense form, values and attitudes already known; which reassures and reaffirms, but brings to this something of the surprise of art as well as the shock of recognition. Such art has in common with folk art the genuine contact between audience and performer: but it differs from folk art in that it is an individualized art, the art of the known performer. The audience-as-community has come to depend on the performer's skills, and on the force of a personal style, to articulate its common values and interpret its experience."[11]

The concept of the *auteur* has made available to us, at least in terms of the art of film, an effective means of discussing the kind of art which Hall and Whannel describe in the passage just quoted. Though it is just beginning to develop an articulated method, *auteur* criticism has already given valuable examples of how to define and analyze the personal within the conventional

in the work of such directors as Hitchcock, Howard Hawks, John Ford, George Cukor, and many others. It seems to me that with some changes for the different artistic media, the *auteur* approach should be a profitable one for other areas of popular culture. In popular music, for example, one can see the difference between pop groups which simply perform without creating that personal statement which marks the *auteur*, and highly creative groups like the Beatles who make of their performances a complex work of art. The methods of the *auteur* approach—examination of the entire body of work for recurrent stylistic and thematic patterns rather than the isolated analysis of the individual work in its unique totality—should prove a fruitful method for defining those patterns which mark the Beatles as *auteurs* and thereby make more articulate for us the special values of their art. The same method should prove useful in the analysis of highly conventionalized types of popular literature like the detective story, the Western, or the spy thriller. These literary types like films, are dominantly repetitions of conventional formulas which have a simple entertainment function but little lasting interest or value. However, there are always a few writers who, without losing sight of the conventional structures of the story type they work within, still manage to create a distinctive personal art. These are the *auteurs* of popular literature; writers like Raymond Chandler, Ross Macdonald, Dorothy Sayers, and even Ian Fleming, whose personal performances stand out from the mass of mystery fiction. As in the case of pop music and the conventional film, it is not so much the unique totality of the individual work, but the artistic dialectic between *auteur* and convention, the drama of how the convention is shaped to manifest the auteur's intention, that excites our interest and admiration.

NOTES

1. O. B. Hardison, "The Rhetoric of Hitchcock's Thrillers" in W. R. Robinson (ed.) *Man and the Movies* (Baltimore, Md.: Penguin Books, 1969), pp. 137–138.
2. Hardison, p. 138.
3. Hardison, p. 152.
4. Hardison, p. 150.

5. Cf. Frank Luther Mott, *Golden Multitudes*.

6. Hardison, p. 152.

7. Of the various general accounts of the *auteur* theory, the most useful are those in Peter Wollen, *Signs and Meaning in the Cinema* and Raymond Durgnat, *Films and Feeling*. The reader should also consult the criticism of Andre Bazin in *What Is Cinema?* and Andrew Sarris in *American Cinema* for discussions of the *auteur* approach. I have also been helped in my understanding of the subject by unpublished papers by Charles Flynn and Christian Koch.

8. Of the *auteur* critics who have written full-length studies of major directors, I have found the work of Robin Wood, who has written substantial monographs on Hitchcock, Howard Hawks and Arthur Penn most interesting. Some of the best *auteur* criticism remains unfortunately untranslated from the French such as the excellent study of John Ford by Jean Mitry.

9. Geoffrey Nowell-Smith quoted in Peter Wollen, *Signs and Meaning in the Cinema* (Bloomington: Indiana University Press, 1969), p. 80.

10. Robin Wood, *Hitchcock's Films* (New York: A. S. Barnes Co., 1969), pp. 9–10.

11. Stuart Hall and Paddy Whannel, *The Popular Arts* (New York: Panthcon Books, 1965), p. 66.

THE WESTERN

6 FROM *Richard Etulain*
Origins of the Western[1]

*The Western— as novel, movie, TV show—has long been with
us and its impact has been and continues to be immense, one of
the most powerful in American society. The far reaches and im-
pact of the genre are sketched deftly in the following article by
Richard Etulain.*

In the first quarter of the present century, a new American
literary type— the Western—arose. Because until recently histo-
rians and literary critics have paid scant attention to popular
literature, the Western has received little notice. Those who have
chosen to discuss this popular genre have usually dismissed it as
literary trash or as a species of sub-literature.[2] This being the case,
no one has undertaken a study of the origins of the Western. This
paper is a very brief and tentative treatment of the rise of the
Western and why it arose when it did.

Some students of popular culture contend that the roots of the
Western can be traced back to Homer and other writers of the
epic. Others suggest that it owes most of its ingredients to medi-

SOURCE. Richard Etulain, "Origins of the Western." Reprinted with the
permission of the *Journal of Popular Culture* from the *Journal of Popular
Culture,* Volume V:4, Spring 1972. Copyright © 1972 by Ray B. Browne.

eval romances and morality plays. And still others argue that Sir Walter Scott, Robert Louis Stevenson, and other writers of historical adventure influenced the shape and content of the Western more than any other source. Each of these arguments has its validity, but the major reasons for the rise of the Western are found in more recent trends in American cultural history. More than anything else the genre owes its appearance to the combined influence of a number of occurrences in the years surrounding 1900. Each of these events or cultural changes may have been largely independent of the rest, but all shared in giving rise to an indigenous literary type.[3]

The appearance of a new hero in American literature—the cowboy—offered distinctive experiences for the author of the Western to portray. As Warren French and Mody Boatright have pointed out, the cowboy appeared earlier in a few dime novels but nearly always as a minor figure and frequently in an ungallant role. By 1890, however, the cowboy was beginning to move to the forefront as a western fictional hero. Commencing with the writings of Owen Wister he received a new emphasis. This newly-refurbished hero aided greatly the rise of the Western.[4]

Also, about 1900 there was a revival of interest in the historical novel—one of three such periods in American literary history. Americans turned to historical fiction as one possible formula for recapturing a past that they were reluctant to lose. Because the Western was to be historical or pseudo-historical, it benefitted from the revival of interest in the historical novel.[5]

Moreover, there was an increased interest in the West during the last two decades of the nineteenth century. A series of critical economic problems brought to mind a sobering truth: the West was filling up; its wide open spaces would soon be gone. Tourists flocked west, and a number published their reactions to the region in such influential eastern magazines as *Outlook, Harper's, Scribner's,* and *Atlantic.* These same periodicals took more western fiction in the 1880s, and the western pieces became so popular by the middle 1890s that Henry Alden, an editor of *Harper's Monthly,* did his best to keep all of Owen Wister's work in his magazine. Several editors wanted Wister's fiction, and only higher prices kept him in the *Harper's* fold.[6]

The era from 1890 to 1910 has frequently been termed "the

strenuous age." The fiction of Jack London, Harold Bell Wright, Stewart Edward White, Rex Beach, and other writings of the rough, virile, and out-of-doors type speak for the age. It was the period of the Spanish American War generation, of Teddy Roosevelt, of militant Anglo-Saxonism. This spirit is found in the Western, particularly in its portrayal of the gallant hero who is always eager to combat any foe, regardless of the odds.

By the early 1890s interest in the dime novel was diminishing. Shortly after its inception during the Civil War, this popular type had turned to the West for several of its heroes—Buffalo Bill, Deadeye Dick, Old Scout, and other frontier worthies. As the dime novel began to disappear, the popularity of its hero fell rapidly. Readers undoubtedly were dissatisfied with a continuous line of heroes who fought off twenty Indians and rescued the heroine, even with one arm badly wounded. They wanted a gallant and strong protagonist but one that was, nonetheless, believable. Eventually, the hero of the Western satisfied both of these desires.[7]

The Western also continued an American melodramatic tradition that had appeared earlier in such sources as the writings of James Fenimore Cooper, the dime novel, and the works of the sentimental novelists. In the post-Civil War period western literature became a recognizable current in the stream of melodrama. The work of Bret Harte, the dime novelists, and the story paper writers firmly established the melodramatic tradition in the literature of the West. As one study of the western periodical literature of the late nineteenth century points out, western writers increasingly utilized vague western settings and general descriptions. And a nostalgic tone crept into western literature. It was as if those who had lived through the previous years were, by 1890 and afterward, looking back and trying to recapture some of their past glory.[8]

Finally, the most important reason for the rise of the Western is the most difficult to describe with precision. This factor is what historian Carl Becker calls the "climate of opinion" of an era. In this case, it is the predominant mentality of the progressive period in American history.

Several interpreters have described the Progressive Era as a watershed period in the American mind. From the 1890s until

World War I a new urban, industrial thrust in American society challenged the older mentality of a rural, agricultural America. For Americans who became Progressives, or who shared the moods and feelings of the Progressives, this conflict between the old and the new was a traumatic experience that was not easily resolved.

Many Progressives were forward-looking. Like Theodore Roosevelt, they accepted the new urban-industrial force and advocated a federal government strong enough to deal with the powerful forces that the cities and industrial capitalists had unleashed. These New Nationationists, as they were called, were optimistic reformers and called for strong, new leadership to deal with recent problems.

Another strain of the progressive mind that owed much to Populism is evident in the early ideas of Woodrow Wilson. He too thought that the rise of an urban-industrial America necessitated changes in the forms of government and society. But Wilson and his followers thought the necessary reform was that of breaking up large corporations and of returning to a pre-industrial America, of recapturing Jefferson's agrarian dream. If these advocates of New Freedom allowed themselves to do so, they easily slipped into a nostalgic longing for pre-Rockefeller, Carnegie, and Vanderbilt days.

The same nostalgia that was apparent among proponents of New Freedom was also evident among followers of New Nationalism. In several ways Roosevelt stands as a Janus figure: the venturesome technocrat and yet the advocate of individualism, the product of an eastern-Harvard gentility and yet the westerner and Rough Rider. Other Americans of the era shared Roosevelt's feelings: the desire to hold on to the fruits of industrialism without losing, at the same time, individual freedom. For these persons, the American West was the last frontier of freedom and individualism, and it had to be preserved as a sacred bulwark against profane industrialism.

And thus the West as a physical and spiritual frontier was an important symbol for Americans during the Progressive Era. To lose it or the idyllic existence that it represented was to lose part of their past and the bargain away their future. It is not difficult to perceive how this psychological necessity encouraged authors

to devote more attention to the West in their writings. The need and mood were apparent, and writers who were a part of this identity crisis—or at least sensed it—could assure themselves a larger audience if they portrayed the West romantically. So the conflict between industrial and agricultural America and the resultant nostalgia for the past were large encouragements for the rise of the Western.[9]

These trends were John the Baptists in preparing the way for the Western. Such writers as Owen Wister, Zane Grey, and Frederick Faust (Max Brand), sometimes working within the limits of these trends and sometimes pressured into new directions by them, did much to establish the dimensions of Western. Wister, for example, utilized the new comboy hero and the Wyoming past and blended them with the necessary ingredients of adventure fiction—love, action, and good versus evil—to produce the first Western in *The Virginian* (1902). He was, in short, the synthesizer of the elements that make up the Western. Following the pattern that Wister introduced, Grey and Brand, though men of lesser writing talents, turned out dozens of Westerns by the end of the 1920s. The roots of the Western, then, were nourished by cultural and intellectual currents that rippled through American experience between the end of the nineteenth century and the Depression.

Roderick Nash, who examines this era's need for wilderness symbols, expresses as well as anyone the cultural-intellectual matrix that helped spawn the Western. He says:

"America was ripe for the widespread appeal of the uncivilized. The cult had several facets. In the first place, there was a growing tendency to associate wilderness with America's frontier and pioneer past that was believed responsible for many unique and desirable national characteristics. Wilderness also acquired importance as a source of virility, toughness, and savagery—qualities that defined fitness in Darwinian terms. Finally, an increasing number of Americans invested wild places with aesthetic and ethical values, emphasizing the opportunity they afforded for contemplation and worship."[10]

What Nash points out—and this is a point that students of American popular culture must keep in mind—is that the ori-

gins of a new popular idea or genre are usually tied to specific occurrences in the mind and experience of the era that produces them. So it was with the beginnings of the Western.

NOTES

1. This essay is a portion of a paper presented at the meeting of the Popular Culture Association, East Lansing, Michigan, April 1971. I use the term *Western* in a narrower sense than most do who invoke the term. By a *Western*, I mean novel about the West that follows a recognizable formula—most often that of action, romance, and stock characters. Thus, most of the novels of Zane Grey, Max Brand, Ernest Haycox, and Luke Short are Westerns; but the works of western writers like Willa Cather, John Steinbeck, and Walter Van Tilburg Clark are not.

2. For an example of this negative attitude: "It has been the fate of the American West to beget stereotypes that belong to pseudo art before it has yielded up the individual types that belong to art proper." Robert B. Heilman, "The Western Theme: Exploiters and Explorers." *Partisan Review*, XXVIII (March–April 1961), 286.

3. Four books have been especially helpful for the remarks in this paragraph and the paragraphs that follow: Henry Nash Smith, *Virgin Land: The American West as Symbol and Myth* (New York: Vintage Books, 1957), 88–137; E. Douglas Branch, *The Cowboy and His Interpreters* (New York: Cooper Square Publishers, 1960), 180–270; Joe B. Frantz and Julian E. Choate, *The American Cowboy: Myth and Reality* (London: Thames and Hudson, 1956), 140–79; and G. Edward White, *The Eastern Establishment and the Western Experience: The West of Frederic Remington, Theodore Roosevelt, and Owen Wister* (New Haven: Yale University Press, 1968), especially pp. 31–51. Since this essay was first written, Russel B. Nye's superb *The Unembarrassed Muse: The Popular Arts in America* (New York: Dial Press, 1970), has appeared. The section in his book dealing with the rise of the Western agrees with several of my contentions and adds other helpful information on the nineteenth-century backgrounds of the Western. See pp. 280–304.

4. Warren French, "The Cowboy in the Dime Novel." *Texas Studies in English*, XXX (1951), 219–34; Mody C. Boatright, "The Beginning of Cowboy Fiction." *Southwest Review*, LI (Winter 1966), 11–28.

5. Willard Thorp, *American Writing in the Twentieth Century* (Cambridge: Harvard University Press, 1960), 1–11; Ernest E. Leisy, *The American Historical Novel* (Norman: University of Oklahoma Press, 1950), 9–17.

6. Earl Pomeroy, *In Search of the Golden West: The Tourist in Western America* (New York: Alfred A. Knopf, 1957), 73–111; L. J. Shaul, "Treat-

ment of the West in Selected Magazine Fiction, 1870–1910—An Annotated Bibliography." Unpublished master's thesis, University of Wyoming, 1954, pp. 50–2. The Alden-Wister relationship and other details about readers' interests in western fiction published during the 1890s is exhibited in the Owen Wister Papers, Library of Congress.

7. Wallace Stegner, "Western Record and Romance." *Literary History of the United States,* ed. Robert Spiller and others (New York: The Macmillan Company, 1960), 862–4, 872. For the influences of Buffalo Bill and his Wild West shows, see Don Russell, *The Lives and Legends of Buffalo Bill* (Norman: University of Oklahoma Press, 1960); and Joseph Schwartz, "The Wild West Show: 'Everything Genuine.' " *Journal of Popular Culture,* III (Spring 1970), 656–66.

8. Smith, *Virgin Land,* 88–137; Mary Noel, *Villains Galore* (New York: The Macmillan Company, 1954), 131–2, 149–59; Shaul, "Treatment of the West," 51–2.

9. The previous paragraphs are a product of several sources. The split between past and present that plagued many Progressives is abundantly documented in important books on this era by such writers as Richard Hofstadter, George Mowry, and Arthur Link. I am also indebted to W. H. Hutchinson for suggesting to me several years ago the close relationship between the rise of the Western and the traumas of the progressive period. More recently, this relationship is dealt with in White's *The Eastern Establishment and the Western Experience;* and in David Noble's several books on the Progressives, particularly in his latest book, *The Progressive Mind, 1890–1917* (Chicago: Rand McNally, 1970). Peter Schmitt adds another dimension in his stimulating monograph *Back to Nature: The Arcadian Myth in Urban America* (New York: Oxford University Press, 1969).

Finally, Roderick Nash and John William Ward suggest that the clash between past and present was a pivotal tension in the twenties. See Nash's *The Nervous Generation: American Thought, 1917–1930* (Chicago: Rand McNally, 1970) and Ward's "The Meaning of Lindbergh's Flight." *American Quarterly,* X (Spring 1958), 3–16.

10. Roderick Nash, *Wilderness and the American Mind* (New Haven: Yale University Press, 1967), p. 145.

THE DETECTIVE STORY

7 FROM *Frank D. McSherry, Jr.*
 The Shape of Crimes to Come

The future of crime fiction and the shape of crimes and their impact, are clearheadedly outlined in the following essay. Mr. McSherry covers science and society and how both are affected by and affect crime fiction.

Are you doing anything today that may be declared a crime tomorrow?

The detective-crime story deals with the commission and detection of criminal acts and with the circumstances surrounding such acts. A criminal act is any act that any society decides to call criminal. Under this empirical and pragmatic definition, we need not bother our heads about the fact that what may be branded a crime at one time and place may not be so labelled at another. Detective-crime stories set in the Roaring Twenties and dealing with the crime of bootlegging are still detective-crime stories despite the fact that the open sale and use of intoxicants is not now a crime and was not before Prohibition.

SOURCE. Frank D. McSherry, Jr., "The Shape of Crimes to Come," pp. 326–338. Reprinted with the permission of Bowling Green University Popular Press from *The Mystery Writer's Art* edited by Francis M. Nevins, Jr. Copyright 1971 by the Bowling Green University Popular Press.

The category of detective-crime story therefore includes stories in which the crime involved is not a crime now, and may even be an admirable moral act now, but is a crime in the imagined future in which a given story is set. The stories which fall within this description are completely new to most mystery readers, who have tended to classify such tales (correctly) as science fiction and (incorrectly) as science fiction only. But it would be unfortunate if lovers of mystery fiction continued to overlook these works; for, quite apart from their often high qualities as fiction, they offer more food for thought than do most detective-crime stories, especially about the legal, social and philosophical problems that are marching toward us from the future with a grim inevitability. The sooner we begin thinking about some of these problems the better; and if we get a first-rate story thrown into the bargain as well, we are that much better off.

Of all the situations approaching us in the future with which society may attempt to deal by imposing criminal sanctions, first and foremost is the population explosion.

Daniel Boone left his Kentucky valley home in disgust because another family moved into the other end of the valley twenty miles away: by God, it's gitting so a feller can't sit on his own front porch no more without a whole passel of people breathing down the back of his neck! That wasn't so long ago, either, as time goes in the life of nations; but things have changed immensely in the short time since then.

Tried to cross the street—or highway—lately? It takes longer with every year that goes by. Every year there are more cars, because every year there are more people to be transported and supplied.

Have your taxes gone up lately? There are many reasons why, but one of them is the rising number of people. Twice as many people in a given area need twice as many schools, hospitals, policemen, etc.

Have prices gone up at the supermarket lately? If you have twice as many people, you need twice as many trucks to supply them with food. Twice as many trucks means so much more traffic (and traffic jams), and so many more man-hours required to deliver the food, which means that the distributor must increase his prices proportionally or go out of business.

The problems created by the population explosion seem to be increasing all over the world. If the trend continues society may decide to deal with it by passing new criminal laws. The imposition of birth control by law is a controversial subject as every newspaper reader knows. Does any government have the right to tell you how many children you can have? Should it be given that right? Several authors have written stories postulating that government will be given or take upon itself such a power.

In Harry Harrison's "A Criminal Act" (*Analog,* January 1967), our society takes a fairly simple and obvious course. The Criminal Birth Act of 1993 forbids married couples to have more than the legal limit of two children per couple. Though the law and the crime are new, the punishment is a secular version of an old one: excommunication. The police power of the state will no longer protect Benedict Vernall, criminal, whose wife is going to have a third child. Any public-spirited citizen who volunteers to kill Vernall will be given a license and twenty-four hours in which to do so without fear of punishment. However, since the purpose of the law is to limit the population, the charge against Vernall will be dropped if he can kill his assassin. Harrison's story tells excitingly of the twenty-four hours during which Vernall is hunted down in his own apartment by an experienced professional killer-for-thrills.

Editor John W. Campbell's introduction to the story is sharply pointed and thought-provoking, especially for those who take a blindly literal view of law-and-order. "A criminal act is, by definition, something that's against the law. George Washington was a criminal, Hitler was not . . . because he passed laws before he acted. That a thing is legal doesn't guarantee that it's good or evil." It is true that Vernall is fighting for his new baby's right to survive, but what about the right of us others to survive? There's only so much food, water and land available. Which side are you on?

Harrison's method may be accused of giving an unfair edge to any criminal who is fast with a gun. A more democratic method of solving the population problem is presented in Frederik Pohl's "The Census Takers" (*The Magazine of Fantasy and Science Fiction,* February 1956). The titular officials count the population once a year; all people over the count of 300 found in any census

team's area are executed by the team on the spot. "Jumping"—
that is, packing with intent to move when a census team is in
the area—is a capital crime in this society. Encountering a fam-
ily of five that is guilty of this offense, the Enumerator mercifully
has only the father executed.

Where the supply of food has not increased and the supply of
people has, intense emotions can be generated. As Pohl's nar-
rator recounts: ". . . I couldn't help telling him: 'I've met your
kind before, mister. Five kids! If it wasn't for people like you we
wouldn't *have* any Overs, did you ever think of that? Sure you
didn't—you people never think of anything but yourself! Five
kids, and then when the Census comes around, you think you
can get smart and Jump.' I tell you, I was shaking."

Society devises a third method of dealing with the conse-
quences of a shortage of food and a surplus of people in H. Ken
Bulmer's novelette "Sunset," published in the now-deceased Scot-
tish magazine *Nebula Science Fiction* (November 1955). In this
world, not too long from now, it is a capital crime to be too ill
or old to work. Society simply does not have the surplus of goods
to support any person who cannot support himself. Any person
who fails to pass the periodic medical checkup required of every-
one is given three days' warning by the State so that he may hold
and attend his own funeral, at the conclusion of which he is
tastefully and painlessly put to death. Those who attempt to
evade this law and practice are criminals to be executed by the
police on sight and without trial.

Anton Rand, foreman at Interplanetary Shipbuilders and help-
ing the firm to finish a new automatic rocketship for travel to
settlements on Mars and Venus, has been brought up under this
system and approves of it. "I don't remember the old days. . . .
It must have been rather terrible to see cripples and old helpless
people on the streets, and to know that somewhere in the world
other people were starving for the food those useless mouths were
eating. We do things decently today." He approves of the sys-
tem, that is, until his father fails to pass the routine checkup and
is given the customary three days' warning. Rand then turns
criminal and plots to smuggle his sick father aboard the new
rocket to safety on another world.

Though its writing is generally undistinguished, the story is

memorable for its point of view. With grim and realistic honesty, Bulmer points out that Rand is not a hero but a villain. In the future society Bulmer postulates, Rand's attempt to save his sick father from execution is not just a technical crime but a genuinely criminal act, injurious to other human beings and to society in general. In a world so short of food that no one gets more than the bare minimum necessary to survive, the feeding of any extra person means that the amount available for the rest of us must be cut below subsistence level by just that much. Rand's act would today be admirable and moral, not criminal; but in the society of tomorrow that we are fast approaching—a society of too many people and too little food that we with our overproduction of people and our waste of natural resources are even now creating—Rand's act is, unpleasant though the fact may be to a reader of today, both illegal and immoral. Or do you prefer to defend him?

An ingenious new law that not only keeps the population down but solves the problem of the Generation Gap at the same time is shown in operation in William F. Nolan and George Clayton Johnson's novel *Logan's Run* (Dial Press, 1968). In this future world it is a capital crime to be over twenty-one.

A colored flower is indelibly imprinted on the palm of every child at birth. The color automatically changes every five years, and flickers throughout the day preceding one's twenty-first birthday. The citizen must then report promptly to the Deep Sleep factories, where he will be painlessly killed. On his twenty-first birthday the flower turns black, automatically alerting the Sandmen, or Deep Sleep police, that someone has not reported to the factories and is trying to run for his life. The police will then hunt the hated Runner down. Locating him through their many TV spy eyes throughout the city, they will kill him on sight. It is rumored, however, that some Runners have succeeded in escaping the Sandmen, that there is an underground route to safety and to the man rumored to be the oldest human now alive, almost forty years old.

Sandman Logan supports the system, hunting and killing the criminal Runners with ruthless efficiency, until the flower on his own palm begins to flicker. He fails to report to the Deep Sleep factories, telling himself he is doing so only in order to locate

and destroy the underground route and die in a blaze of suicidal glory while doing his duty. Logan begins his run from the police, using his thorough knowledge of their own techniques against them.

Logan's run takes him through a world of nightmarish garishness, a world slowly breaking down and incapable of progress, since no one lives long enough to acquire the experience needed to make advances in any area of endeavor. There is time only to perform an insufficient number of repairs on the old machines. From a dying city miles under the sea, from state-owned nurseries where children are brought up entirely by machines, to the giant computer that governs the world though its parts are slowly running down and its lights slowly going out as no one comes to repair it, and to the jungle growing over the ruins of atom-bombed Washington, Logan runs into and from a nightmare world devoted entirely to the young.

Nolan and Johnson do not say that these things will happen, let alone that they ought to happen; the legal and moral problems they raise are kept in the background and implied rather than expressly dealt with. Their primary concern is to write a suspenseful chase story, filled with images of beauty and horror. *Logan's Run* is intense, almost poetic, and hard to forget. But again, whose side are you on?

Charles Beaumont provides an even more nightmarish answer to the population problem in his well-known "The Crooked Man" (*Playboy*, August 1955; *The Hunger and Other Stories*, Putnam 1957). Here society attempts to control the phenomenon of heterosexual attraction and its resultant overabundance of babies (the story was of course written before the Pill) by structuring its legal and educational system so as to turn its citizens into sexual perverts and making heterosexual relations a crime. Adding to the grim force of this memorable and horrifying tale is the reader's feeling that, in view of what atrocities governments have committed within our lifetime, Beaumont's nightmare vision is far from impossible.

Another method of keeping the population low is adopted by the future society of Philip K. Dick's novelette "Time Pawn" (*Thrilling Wonder Stories*, Summer 1954; later revised and expanded into a novel, *Dr. Futurity*, Ace 1960). When some strange

force hurls young Dr. Parsons from his safe world of 1998 onto a night hillside, one look at the changed shapes of the stars tells him he has been thrown into the far future. But Parsons, an intelligent man, isn't especially worried. He is a trained doctor, his brain full of the race's most advanced medical knowledge, his bag full of the most advanced medical discoveries science has yet made. Surely he will be able to get along wherever he is; every society needs doctors.

Entering a city, he finds a girl dying after a vicious and unprovoked attack by a band of armed, uniformed and apparently government-supported band of juveniles. Parsons confidently goes to work, performing major surgery in a hotel lobby, removing the girl's damaged heart and replacing it with a mechanical one operated by an atomic battery. For a doctor of 1998 this is a routine and almost boring operation; the girl lives—and Parsons is promptly arrested by horrified onlookers. The charges: saving a human life and practicing medicine, both capital crimes. The next morning the girl herself signs the charges against him, then commits suicide.

Society's way of controlling the number of people is to make the teaching and practice of medicine illegal, and to authorize extra-legal killings by armed juvenile gangs. Every male is sterilized at puberty and samples of his gametes are kept in frozen form in sperm banks. The only ones allowed to reproduce are those few who win the world-wide games and tests society has devised to locate superior specimens of humanity. The death of one person automatically authorizes the birth of another from the frozen sperm of the ideal specimens, so that each newborn baby is far superior to the dead person he replaces; a man's death does not diminish mankind but advances and improves it. Naturally, therefore, a doctor, a man whose vocation is to prevent death, is a criminal.

The court mercifully takes cognizance of Parsons' unusual background and sentences him not to death but to life-long exile on Mars. But in every society there are groups that can use the services of a professional criminal. Indeed, it is one such group, armed with an imperfect knowledge of time travel, that brought Parsons to the future in the first place. For reasons of their own, they need a doctor badly; so they rescue Parsons. The plots and

counterplots thus set in motion keep Parsons on the run, taking him far forward in time to a deserted Earth where he finds a giant stone monolith with his name carved in it; back to the past to see Sir Francis Drake and his *Golden Hind* stop over in California on a round-the-world trip; and back to the world he was thrust into, where he becomes involved with a radical student society that advocates the open teaching of medicine and is viciously hunted by the police as a consequence.

Dr. Futurity is a fine fast-moving novel, full of action and counterplots. It is interesting to note that in the novel one side wins whereas in the earlier short version "Time Pawn" the other side comes out on top. You pays your money, you takes your pick.

In our own time we have seen medical science improve to the point where successful transplants of the heart and other vital organs have been accomplished. As long as man can replace his worn-out organs with brand-new ones in fine condition, he may live virtually forever. In his short novel "The Organleggers" (*Galaxy*, January 1969), Larry Niven points out some unpleasant legal and social consequences of this new scientific advance.

Since there are many more people with damaged organs needing to be replaced than there are people with good organs they are willing to part with, the demand for hearts and limbs and so on will inevitably exceed the supply. How can the supply be increased? Niven suggests two ways. One is legal: society restores the death penalty, applies it to more and more offenses, and finally imposes it automatically on anyone found guilty of exceeding the speed limit three times. A surgical team carries out the sentence, removing the victim's vital organs and quick-freezing them for storage in organ banks until they are called for. (Doubtless you believe yourself to be a kindly person, but would you vote to abolish the death penalty, even for such an offense as speeding, if it meant that you might lose your chance for centuries of extra life?)

The second way is illegal. New scientific advances often bring new crimes with them. Where demand of a commodity exceeds supply, as in Prohibition, criminal organizations arise to fill that demand, as in Prohibition. The new criminal, the organlegger, supplies hearts, legs, lungs etc. in brand-new condition to those

who are rich enough to pay his fees and desperate enough not to care whether those organs were given up willingly and legally. The protagonist in Niven's story is Gil Hamilton, a member of ARM, which is a branch of the UN Police Force organized expressly to track down this new breed of criminal. For some time Gil has been trying to nail a new group of organleggers who somewhere have found a large supply of untraceable victims. When a friend of his dies in a particularly gruesome way, Gil slowly realizes that the man was murdered and that the organlegger group is involved.

Another problem area with which the law may attempt to deal in the future is the prevention of nuclear war. In John Wyndham's short story "The Wheel" (*Startling Stories,* January 1952), a five-year-old boy commits a capital crime: he rediscovers the wheel. In the wake of an all-out atomic war, the terrified few survivors had outlawed all discovery. They have made science the scapegoat for their own failures, and the wheel the symbol of science. Wyndham's point of course is that it is not knowledge, but what man does with his knowledge, that is good or evil.

Even in the Dark Ages some research went on, though only in narrowly circumscribed areas. In Lewis Padgett's (Henry Kuttner's) "Tomorrow and Tomorrow" (*Astounding Science Fiction,* January–February 1947; *Tomorrow and Tomorrow and the Fairy Chessmen,* Gnome Press, 1951), all scientific research is made illegal. In this future, an appalling third world war has been stopped before it has killed more than a few million people. Riots of unparalleled violence break out, for "When a man is in an ammunition dump that is on fire, he will have less hesitancy in firing a gun." No government survives the riots, and the UN's successor, the Global Peace Commission, takes over control of the world by default. Its solution to the problem of war is to make any scientific advance in any field illegal. Dedicated fanatically to the status quo, it places a murderous stranglehold on human progress for a hundred years. No one starves, no one is fired, but there is no cure for cancer or any other yet-uncured disease, nor will there be as long as that stranglehold exists.

It is not surprising that a criminal group arises that wants to restart World War III and play it through to the finish, believing

that full-scale nuclear war is preferable to the slow death by strangulation that the GPC is imposing on the human race. The malcontents feel that the GPC's grip is so strong that only an atomic war can break it. They ask atomic physicist Joseph Breden, monitor of Uranium Pile One, to join them. In addition to deciding whether to join the revolutionaries, Breden has personal problems to wrestle with: lately he has been having bad dreams in which he cuts off all protective devices against sabotage on the pile, pulls out the cadmium control rods and detonates the pile, setting off an atomic explosion that will destroy not only the pile but civilization as well.

Kuttner's story, full of excitement and suspense, poses a problem not only for its protagonist but for the reader as well. Would you prefer a society where perfect safety and security is achieved for you at the price of permanent stagnation and the almost certain death of the whole race centuries later, or a society that achieves constant progress in all areas though it runs a risk of destruction in atomic holocaust?

We have seen that new advances in science may bring new crimes with them. Let us assume that psychology and genetics will have developed so far in a future time that inheritable diseases such as color-blindness, bad eyesight and rheumatic hearts can be bred out of the race entirely if its members will marry only people with the correct genes, and that one can be psychologically treated so that he will fall genuinely in love with another who possesses the proper genes. In such a world it will be a crime to marry anyone whose genes combined with yours will produce a physically or mentally defective child. Do you have the right to marry whom you please, if it can be scientifically proved that the children of that union will be defective? Should you have such a right? And when a characteristic is judged "defective," how do you judge that judgment?

The Population Control Board tells artist Aies Marlan on her twenty-first birthday whom she will marry, so that she and her chosen husband will be certain to produce children without defects. But Aies is in love with Paul, whose genes are not right for her. To escape the psychological conditioning that will destroy her love for Paul and force her to love the man the Board has chosen for her, Aies steals a plane and with Paul beside her

attempts "The Escape" in John W. Campbell's short story (*Astounding Science Fiction*, May 1935; in book form, *Cloak of Aesir*, Shasta Press, 1952).

We today would tend to regard Aies and Paul as heroic revolutionaries against a vicious tyranny; but, given the advances in psychology and genetics that Campbell postulates, the reader must consider the painful question whether they are not in reality a pair of selfish, antisocial immoralists. Behind its excellent writing and action and suspense, the story poses two basic questions. One, how much power should the government have over you? Two, may not the advance of science make the right answer to question one today a wrong answer tomorrow?

A society that has solved all its problems may well be in trouble just as deep as one with too many problems, as the British author S. Fowler Wright suggests in his novel *The Adventure of Wyndham Smith* (London: Jenkins, 1938), in which the protagonists commit the capital crime of failing to commit suicide.

A scientific experiment sends Wyndham Smith into a far distant future where the human race has solved all the problems facing us now. It is a quiet and peaceful world, without war, want or crime. And that is the ironic catch: having solved all problems, the people have nothing left to do, and are bored to death. The governing council decides that the only logical solution to the quandary is mass suicide. The people agree, and happily go off one by one to a painless death in the great suicide chambers; that is, all but Smith, the man from the past, and the beautiful girl he has fallen in love with. They become criminals, evading the mass-suicide law, and thus become the last people alive. But the dead are not fools; they have made provision for the contingency that someone, somewhere, might actually wish to go on living. They have designed and left behind them a deadly mechanical bloodhound, like a small tank, that is set to find any living thing and kill it on sight. Smith and the girl flee for their lives through an abandoned world whose superscientific devices have been permanently turned off, a world sunk in a moment to the level of the stone age.

Wright's grim, slow-moving novel asks: What is the goal of human life; and what happens after that goal is achieved? What can the human race do after all its problems are solved, all its

passions spent, the Utopia it claims to want made real at last? Where can you go from the top? The novel is written in a dry, matter-of-fact pedestrian style which would kill most stories but which surprisingly makes this one immensely convincing. Incidentally, Wright used the same concept a little later for his short story "Original Sin," published in England in his collection *The Witchfinder* (Books of Today Ltd., n.d.) and in the United States in *The Throne of Saturn* (Arkham House, 1949). Again two criminals disobey the law of mass suicide. The story has a sting at the end that remains in the mind long after.

Most of the stories dealing with crimes of the future are fast-moving and full of action and suspense. Their authors are writers first, intent on telling a good story well. They do not suggest that the events, laws and solutions in their stories will happen or should happen. They are aware of the many moral, philosophical and legal problems they are raising, but they use these problems to forward the plot and make the story interesting, to provide a background for the action in the foreground. Nevertheless, they do raise the problems. Someday you and I will have to decide these problems, perhaps sooner than we wish to; and the earlier we begin to think about them the more time we will have to consider our decisions. If we are spurred to hard thinking on these topics, we will have derived more than the excitement of a rousing good story from these tales of the shape of crimes to come.

COMICS

8 FROM *Saul Braun*
Shazam! Here Comes Captain Relevant

Readers of comics have always been able to justify their inter-est, even against intense criticism. In the last few years, however, reading comics has become easily justifiable, and to an ever-ex-panding group of persons. In order to keep up with their read-ers, creators of comics have had to become more and more timely and relevant. The following article is an excellent study of the timeliness of comics.

Envision a scene in a comic book:

In Panel 1, two New York City policemen are pointing sky-ward with their jaws hanging open and one is saying, "Wha . . . ?" They are looking at four or five men and women, shown in Panel 2 plummeting through the air feet first, as though riding surf-boards. The dominant figure has a black long coat thrown over his shoulders, wears a peaked, flat-brim hat and carries a cane. As the group lands on the street and enters the "Vision Build-ing," Panel 3, a hairy hip figure on the sidewalk observes to a friend: "Fellini's in town."

SOURCE. Braun, Saul, "Shazam! Here Comes Captain Relevant." reprinted by permission of William Morris Agency, Inc., *The New York Times Maga-zine*, May 2, 1971, Copyright © 1971.

In Panel 4, an office interior, the man with the cape is saying to the secretary, "I am Federico Fellini, come to pay his respects to . . ." Turn the page and there is the Fellini figure in the background finishing his balloon: ". . . the amazing Stan Lee." In the foreground is a tall, skinny man with a black D. H. Lawrence beard, wearing bathing trunks, longsleeved turtleneck sweater and misshapen sailor hat. Stan Lee stands alongside a table that has been piled on another table, and on top of that is a typewriter with a manuscript page inserted in it that reads: "The Amazing Spiderman. In the Grip of the Goblin! It's happening again. As we saw last. . . ."

This visit, in more mundane fashion, actually took place. Stan Lee has been writing comic books for 30 years and is now editor-in-chief of the Marvel Comics line. His reputation with *cognoscenti* is very, very high.

Alain Resnais is also a Lee fan and the two are now working together on a movie. Lee has succeeded so well with his art that he has spent a good deal of his time traveling around the country speaking at colleges. In his office at home—which is currently a Manhattan apartment in the East 60's—he has several shelves filled with tapes of his college talks. An Ivy League student was once quoted as telling him, "We think of Marvel Comics as the 20th century mythology and you as this generation's Homer."

Lee's comic antiheroes (Spiderman, Fantastic Four, Submariner, Thor, Captain America) have revolutionized an industry that took a beating from its critics and from TV in the nineteen-fifties. For decades, comic book writers and artists were considered little more than production workers, virtually interchangeable. Now Lee and his former collaborator, artist Jack Kirby of National Comics, Marvel's principal rival, are considered superstars—and their work reflects a growing sophistication in the industry that has attracted both young and old readers.

"We're in a renaissance," says Carmine Infantino, editorial director at National Comics, and he offers as proof the fact that at Brown University in Providence, R.I., they have a course, proposed by the students, called "Comparative Comics." A prospectus for the course sets out the case for comic books as Native Art:

"Comics, long scorned by parents, educators, psychologists,

lawmakers, American Legionnaires, moral crusaders, civic groups and J. Edgar Hoover, have developed into a new and interesting art form. Combining 'new journalism' with greater illustrative realism, comics are a reflection of both real society and personal fantasy. No longer restricted to simple, good vs. evil plot lines and unimaginative, sticklike figures, comics can now be read at several different levels by various age groups. There are still heroes for the younger readers, but now the heroes are different —they ponder moral questions, have emotional differences, and are just as neurotic as real people. Captain America openly sympathizes with campus radicals, the Black Widow fights side by side with the Young Lords, Lois Lane apes John Howard Griffin and turns herself black to study racism, and everybody battles to save the environment."

As for Fellini, his interest in American comic books, and Stan Lee's work in particular, is no passing fancy. For an introduction to Jim Steranko's "History of the Comics," he wrote the following lines:

"Not satisfied being heroes, but becoming even more heroic, the characters in the Marvel group know how to laugh at themselves. Their adventures are offered publicly like a larger-than-life spectacle, each searching masochistically within himself to find a sort of maturity, yet the results are nothing to be avoided: it is a brilliant tale, aggressive and retaliatory, a tale that continues to be reborn for eternity, without fear of obstacles or paradoxes. We cannot die from obstacles and paradoxes, if we face them with laughter. Only of boredom might we perish. And from boredom, fortunately, the comics keep a distance."

For an industry that wields considerable influence, comic-book publishing has only a small fraternity of workers. There are something like 200 million comic books sold each year, a volume produced by less than 200 people, including writers, artists and letterers. The artists fall into two categories, pencilers and inkers. Pencilers are slightly more highly reputed than inkers but, with few exceptions, nobody in the business has much of a public reputation, and most are poorly compensated. Most are freelancers, paid at a page rate that the various publishers prefer not to divulge. A rate of $15 a page, however, is said to be not uncommon.

"This is a fiercely competitive business," says Infantino. "After Superman clicked in 1935 everybody jumped in; there were millions of outfits. Then one by one they all slipped away. When World War II ended, then came survival of the fittest and, boom, they died by the wayside."

As in other industries, power gradually became concentrated during the nineteen-fifties and sixties, and now the industry consists of perhaps half a dozen companies with annual sales of about 200 million. National, the leader, sells about 70 million. Marvel sells 40 million, Archie 35 million, and the next three firms—Charleton (Yogi Bear, Beetle Bailey, Flintstones), Gold Key (Bugs Bunny, Donald Duck, Mickey Mouse) and Harvey (Caspar the Friendly Ghost, Richie Rich, Sad Sack) each sell about 25 million. That is a great many copies, but doesn't necessarily reflect profitability. The index of profit and loss is not sales but the percentage of published copies that are returned unsold from the store racks. A book that suffers returns of more than 50 per cent is in trouble.

Martin Goodman, president of the Magazine Management Company, which puts out the Marvel line, recalls that the golden age of comics was the war years and immediately afterwards. By the late forties, he says, "everything began to collapse. TV was kicking the hell out of a great number of comics. A book like Donald Duck went from 2¼ million monthly sale to about 200,000. You couldn't give the animated stuff away, the Disney stuff, because of TV. TV murdered it. Because if a kid spends Saturday morning looking at the stuff, what parent is going to give the kid another couple of dimes to buy the same thing again?

"Industrywide," says Goodman sorrowfully, "the volume is not going up. I think the comic-book field suffers from the same thing TV does. After a few years, an erosion sets in. You still maintain loyal readers, but you lose a lot more readers than you're picking up. That's why we have so many superhero characters, and run superheroes together. Even if you take two characters that are weak sellers and run them together in the same book, somehow, psychologically, the reader feels he's getting more. You get the Avenger follower and the Submariner follower. Often you see a new title do great on the first issue and then it begins to slide off . . ."

Goodman recalls with avuncular diffidence the arrival of Stan
Lee at Marvel, then called Timely Comics. "Stan started as a kid
here; he's my wife's cousin. That was in 1941, something like that.
He came in as an apprentice, to learn the business. He had a
talent for writing. I think when Stan developed the Marvel super-
heroes he did a very good job, and he got a lot of college kids
reading us. They make up a segment of our readership, but when
you play it to them you lose the very young kids who just can't
follow the whole damn thing. We try to keep a balance. Because
I read some stories sometimes and I can't even understand them.
I really can't!"

Today's superhero is about as much like his predecessors as
today's child is like his parents. My recollection of the typical pre-
World War II child (me) is of a sensitive, lonely kid full of fanta
sies of power and experiencing, at the same time, a life of endless
frustration and powerlessness. Nobody knew, of course, about the
hidden power, the supermuscles rippling beneath the coarse
woolen suits I had to wear that itched like crazy. How I longed to
rip off that suit. Shaz . . .

Comic book buffs will not need to be reminded that Shazam is
the magic name of a mysterious bald gentleman with a white
beard down to his waist, which, when spoken by newsboy Billy
Batson, turns Billy into Captain Marvel. The book didn't last
long, due to the swift, self-righteous reprisals of National Comics,
which took Captain Marvel to court for impersonating Superman.
It lasted long enough to impress upon my memory, however, that
"S" stood for Solomon's wisdom, "H" for Hercules's strength,
"A" for Atlas's stamina, "Z" for Zeus's power, "A" for Achilles's
courage and "M" for Mercury's speed. I always had trouble re-
membering the last two; like many another man, I have gone
through life saying "Shaz" to myself and getting nowhere.

So my childhood was one of repressed anger and sullen obedi-
ence and scratching all winter long, together with an iron will
that kept me from lifting my all-powerful fist and destroying those
who threatened me: Nazis, Japs, Polish kids (mostly at Easter
time), older kids, teachers and parents. My personal favorite was
Submariner. He hated everybody.

Actually, all of the early comic-book heroes perfectly mirrored
my own condition, and even provided pertinent psychological
details. The parents of superheroes were always being killed by

bad men or cataclysmic upheavals over which the heroes—let me make this one thing perfectly clear—had absolutely no control. However, they then embarked on a guilty, relentless, lifelong pursuit of evildoers. So many villains in so many bizarre guises only attested to the elusiveness and prevalence of—and persistence of—superhero complicity.

Secretly powerful people, like the superheroes and me, always assumed the guise of meekness; yet even the "real" identities were only symbols. All-powerful Superman equaled all-powerful father. Batman's costume disguise, like the typical parental bluster of the time, was intended to "strike terror into their hearts." For "their" read not only criminal but child.

Infantino, whose National Comics publishes, among others, the long-run superhit of the comic-book industry, Superman, believes that power is the industry's main motif:

"The theme of comic books is power. The villain wants power. He wants to take over the world. Take over the other person's mind. There's something about sitting in the car with the motorcycles flanking you back and front and the world at your feet. It motivates all of us."

For three decades, the social setting was an America more or less continuously at war. At war with poverty in the thirties, with Fascism in the early forties, and with the International Red Conspiracy in the late forties and in the fifties. During these years there existed simultaneously, if uneasily, in our consciousness the belief that we were uniquely strong and that nothing would avail except the unrelenting exercise of that strength. From wanting or being forced to take the law into our own hands during the thirties, we moved swiftly towards believing that our security depended on taking the whole world into our hands. That carried us from the Depression to Korea and, eventually, in the sixties, to a confused war in which it was impossible to tell whether we were strong or weak, in which irresponsible complacency existed comfortably with political and social atrocities that could spring only from secret weakness masquerading as strength.

It is not irrelevant to note that the Vietnamese war developed without hindrance—with some few exceptions—from a generation of men flying around the world on a fantasy-power trip, and was resisted in the main by their sons, the generation that began

rejecting the comic books of the fifties with their sanitized, censored, surreal images of the world: a world in which "we" were good and "they" were bad, in which lawlessness masqueraded as heroism, in which blacks were invisible, in which, according to a survey taken in 1953 by University of California professors, men led "active lives" but women were interested mainly in "romantic love" and only villainous women "try to gain power and status." A world in which no superhero, whatever his excesses, ever doubted that he was using his powers wisely and morally.

During this time the industry was adopting a self-censorship code of ethics in response to the hue and cry raised by a Congressional look into the industry's excesses of gore and by the appearance of "Seduction of the Innocent," a shrill piece of psycho-criticism by a psychiatrist named Fredric Wertham, who supported his view that the comics were a pernicious influence on children with stories like: "A boy of 13 committed a 'lust murder' of a girl of 6. Arrested and jailed, he asked only for comic books."

While it is true some publishers were printing stories with grisly and violent elements, I must confess that I to this day find myself unable to believe that the worst comic books could have corrupted the child's mind as much as the knowledge that in his own world, the world he was being educated to join, 6 million men, women and children had only recently been killed in gas ovens for no very good reason, and large numbers of others had died at Hiroshima and Dresden, for only slightly better reasons. Two of my own strongest memories of the time are of my father, who owned a candy store, denying me the treasure trove of comics ("They'll ruin your mind"), and of my father, after receiving a telegram telling him that his family had been wiped out in some concentration camp somewhere, turning ashen and falling to his knees. So, Superman, where were you when we needed you? My mind was corrupted, yes, and so were those of countless other children of the forties and fifties.

During this time, the only comic that held its own commercially was none other than William M. Gaines's "MAD." Gaines's defense of one of his horror comics was the high point at hearings of the Senate subcommittee on juvenile delinquency. The cover, depicting the severed head of a blonde, said Gaines, would have

been in bad taste "if the head were held a little higher so the neck would show the blood dripping out."

The industry response was the comics code, including provisions forbidding horror, excessive bloodshed, gory or gruesome crimes, depravity, lust, sadism and masochism; an authority to administer the code was created, with power to deny the industry seal of approval to any comic book violating its provisions. This satisfied parents and educators, but only intensified the sales slide for seal-of-approval comic books. The turnabout came in 1961, when Stan Lee metamorphosed the Marvel line and very likely saved comic books from an untimely death.

"Our competitors couldn't understand why our stuff was selling," Lee recalls. "They would have a superhero see a monster in the street and he'd say, 'Oh, a creature, I must destroy him before he crushes the world.' And they'd have another superhero in another book see a monster and he'd say, 'Oh, a creature, I must destroy him before he crushes the world.' It was so formularized. I said to my writers, 'Is that what you'd say in real life? If you saw a monster coming down the street, you'd say, "Gee, there must be a masquerade party going on."

"Because sales were down and out of sheer boredom, I changed the whole line around. New ways of talking, hangups, introspection and brooding. I brought out a new magazine called 'The Fantastic Four,' in 1961. Goodman came to me with sales figures. The competitors were doing well with a superhero team. Well, I didn't want to do anything like what they were doing, so I talked to Jack Kirby about it. I said, 'Let's let them not always get along well; let's let them have arguments. Let's make them talk like real people and react like real people. Why should they all get superpowers that make them beautiful? Let's get a guy who becomes very ugly.' That was The Thing. I hate heroes anyway. Just 'cause a guy has superpowers, why couldn't he be a *nebbish,* have sinus trouble and athlete's foot?"

The most successful of the Stan Lee antiheroes was one Spiderman, an immediate hit and still the top of the Marvel line. Spidey, as he is known to his fans, is actually Peter Parker, a teen-ager who has "the proportionate strength of a spider," whatever that means, and yet, in Lee's words, "can still lose a fight, make dumb

mistakes, have acne, have trouble with girls and have not too much money."

In Parker's world, nobody says, "Oh, a creature." In an early story, Spiderman apprehends three criminals robbing a store, and the following dialogue ensues:

Spidey: "If you're thinking of putting up a fight, brother, let me warn you . . ."

Crook: "A fight? The only fight I'll put up is in court. I'm suin' you for assault and battery, and I got witnesses to prove it."

Second crook: "Yeah, that's right."

If it is not already perfectly clear that the last vestiges of the nineteen-forties have fallen away from the world that Spiderman inhabits, it becomes so two panels later when one crook says, right to his face, "Don't you feel like a jerk paradin' around in public in that get-up?"

After overhearing a conversation in another episode between two men who also apparently consider him a kook, Parker goes home and, unlike any superhero before him, does some soul-searching. "Can they be right? Am I really some sort of crackpot wasting my time seeking fame and glory? Why do I do it? Why don't I give the whole thing up?"

The 48-year-old Lee may very well have asked precisely these questions at some point in his career. He's been in the business since 1938 when, as a 16-year-old high school graduate, he held some odd jobs (delivery boy, theater usher, office boy). Then he came to Timely Comics with some scripts and was hired by editors Joe Simon and Jack Kirby.

For the next 20 years, he labored professionally, but without any special devotion, to what he thought of as a temporary job. When Simon and Kirby left, Lee took over as editor as well as writer, and all during the forties and fifties, mass-produced comic books, 40 or 45 different titles a month.

"The top sellers varied from month to month, in cycles. Romance books, mystery books. We followed the trend. When war books were big, we put out war books. Then one day my wife came to me and said, 'You've got to stop kidding yourself. This is your work. You've got to put yourself into it.' So I did. Joanie is the one you really ought to interview. She's beautiful and tal-

ented. And my daughter, Joanie, who's 21, she's also beautiful and talented. I'm a very lucky guy."

His wife, he says, is exactly the dream girl he'd always wanted, and he decided to marry her the first time he saw her. At the time she was married to another man, but that hardly deterred him. For something like 25 years, the Lees lived a quiet domestic life in Hewlett Harbor, L. I., before recently moving back into town. Lee is nothing if not a devoted family man. Among his other self-evident qualities: he enjoys talking about his work. He is in the office Tuesdays and Thursdays, editing, and at home the other five days of the week, writing. "I'm the least temperamental writer you'll ever know," he says. "I write a minimum of four comic books a month. Writing is easy. The thing is characterization. That takes time. The thing I hate most is writing plots. My scripts are full of X-outs [crossed-out words]. I read them out loud while writing, including sound effects. 'Pttuuuu. Take that, you rat!' I get carried away."

The comic industry has treated Lee very well. He is now, he says, in the 50 to 60 per cent income tax bracket, and he has a very high-paying, five-year contract with Cadence Industries, which bought Magazine Management Company from Goodman some 2½ years ago. When the contract expires, he says, he's not sure what he'll do. He has the vague discontent of a man looking for new fields to conquer, or, to use another simile, the look of a superhero adrift in a world that no longer wants him to solve its problems.

Last year he solved a recurring problem for industry workers by helping to form the Academy of Comic Book Artists:

"I felt that the publishers themselves weren't doing anything to improve the image of the comic books, so I thought, why don't *we* do it? Also I wanted to leave it as a legacy to the industry that has supported me over 30 years."

The academy now has as members about 80 writers, artists and letterers. I attended one of their recent meetings, held at the Statler-Hilton Hotel in the Petit Cafe, a barren, pastel-blue and mirrored room with about 200 gray metal folding chairs with glass ashtrays on them, and a gray metal long table with glass ashtrays and a lined yellow pad on it.

Around the room, leaning on gray folding chairs, were "story

boards" from comic books that have been nominated for this year's awards, which are to be called Shazams.

Sketches of the proposed designs for the Shazams were being passed around, most of them serious renderings of the jagged bolt of lightning that accompanied Billy Batson's transformation. One, however, represented a side of comic book artistry that the fans rarely see: A naked young woman, bent forward at the waist, stands upon the pedestal, while the airborne Shazam lightning bolt strikes her in the rear. She has a look of unanticipated delight upon her face.

There were about 30 men present, and one or two young women. Among the artists and writers I spoke to, there was general agreement that working in the comic-book industry was not all magic transformations of unworthy flesh. Problems mentioned as organic included the lack of economic security, the inability of the artists to keep control over their material, insufficient prestige and a catch-all category that is apparently the source of abiding resentment: publishers who do not treat them as serious artists.

As for the censorship of the Comics Code Authority, virtually everybody agreed they wanted more freedom. Younger writers, in fact, are bringing fresh ideas into the field. But, as 33-year-old Archie Goodwin, who writes "Creepy Comics" for Jim Warren Publishers, wryly observes, the real problem is self-censorship: "The truth is, maybe half the people here wouldn't do their work any different if they didn't have censorship."

It did seem to me as I observed the crowd that there was perhaps more than a random sample of serious-purposed people who spoke haltingly, with tendentious meekness. The meeting began with nominations for A. C. B. A. officers for the coming year. I gleefully anticipated some earth-shaking confrontations between good and evil, but none developed. Nobody slipped off to a telephone booth to change. The two nominations for president, Neal Adams and Dick Giordano, by coincidence, jointly draw the Green Lantern-Green Arrow book for National. Lantern and Arrow have been squabbling lately, but Adams and Giordano were not at all disputatious.

In the entire group I was able to uncover only a single secret life.

"This is my secret life," Roy Thomas admitted. "Or rather it was, when I was a teacher at Fox High School in Arnold, Mo." Thomas, a bespectacled 30-year-old who wears his corn-silk hair straight down almost to the shoulders, edits at Marvel. "After school hours, I was publishing a comics fanzine called Alter Ego. I spent all my time at night working on Alter Ego."

"The people in this business," Lee said to me after the meeting, "are sincere, honorable, really decent guys. We're all dedicated, we love comics. The work we do is very important to the readers. I get mail that closes with, 'God bless you.' Most of us, we're like little kids, who, if you pat us on the head, we're happy."

All in all, add a little touch of resentment, discontent and a pinch of paranoia to Lee's description and you have the modern-day comic book superhero. Lee himself has only one frustration in a long, satisfying career:

"For years the big things on campus have been McLuhan and Tolkien, and Stan Lee and Marvel, and everybody knew about McLuhan and Tolkien, but nobody knew about Marvel. Now our competitor is coming out with 'relevant' comics and he has big public relations people, so he's been easing in on our publicity."

Relevance is currently such a lure that even industry classics like Archie are having a stab at it. John Goldwater, president of Archie Comics, says that Archie definitely keeps up with the times, and offers as evidence Xerox copies of a silver print, which is an engraver's photographic proof of an original drawing. It was of a recent six-page Archie story entitled, "Weigh Out Scene."

"This is a civil-rights story," Goldwater said. "It's done subtly. It has to do with a fat boy who comes to town who can't fit into the mainstream with the teen-agers in town. Because of his obesity, he's taunted and humiliated. You know how kids are. Then one night Archie has a dream. And in this dream he is obese and fat and everybody is taunting him and ridiculing him and now he finally realizes what happened to this poor kid. So then there is a complete turnaround. But we don't say, remember, this kid is black. We don't say that. But the subtlety is there."

Goldwater, who is also president of the Comics Code Authority is convinced that "comics don't ruin your mind." He says: "I wouldn't be in this business unless it had some value, some educa-

tional value. If you can get a kid today to read, it's quite some victory—instead of him looking at the boob tube, you know?"

Recently there were some ruffled feelings in the industry when Marvel issued a comic book without the authority seal, which was denied because the subject of drugs was alluded to in one story that showed a stoned black kid tottering on a rooftop. Goldwater felt that hinted a bit of sensationalism, and Infantino believes the subject calls for a more thorough and responsible treatment. Lee scoffs. Black kids getting stoned isn't exactly a biannual occurrence, he suggests. Goodman calls the fuss a tempest in a teapot. Goldwater, at any rate, is not inclined to be harsh:

"Goodman came before the publishers and promised not to do it again. So we're satisfied. Anybody with 15 solid years of high standards of publishing comic books with the seal is entitled to one mistake."

Subsequently the publishers agreed to give themselves permission to deal with the subject. "Narcotics addiction," says the new guideline, "shall not be presented except as a vicious habit."

Goodman is not so sure relevance will continue to sustain sales, but Infantino is elated at National's success with social issues.

National turned toward relevance and social commentary for the same reasons Marvel had a decade earlier. "I'd like to say I had a great dream," says Infantino, "but it didn't happen that way. Green Lantern was dying. The whole superhero line was dying. Everything was sagging, everything. When your sales don't work, they're telling you something. The front office told me, get rid of the book, but I said, let me try something, just for three issues. We started interviewing groups of kids around the country. The one thing they kept repeating: they want to know the truth. Suddenly the light bulb goes on: Wow, we've been missing the boat here!"

In the first of National's relevant books, which came out in the fall of 1970, Green Lantern comes to the aid of a respectable citizen, besieged by a crowd, who turns out to be a slum landlord badly in need of a thrashing. Lantern is confused to discover his pal Green Arrow actually siding with The People. "You mean you're . . . defending . . . these . . . ANARCHISTS?" he says.

Following a tour of the ghetto, Green Lantern is finally brought

face to face with reality by an old black man who says: "I been readin' about you, how you work for the Blue Skins, and how on a planet someplace you helped out the Orange Skins . . . and you done considerable for the Purple Skins. Only there's Skins you never bothered with. The Black Skins. I want to know . . . how come? Answer me that, Mr. Green Lantern."

This story, written by 28-year-old Denny O'Neil, is one of the nominees for the writing Shazam, and the consensus of opinion, even among rival nominees, is that he'll win it. In the following months, O'Neil had the superheroes on the road discovering America and taking up such provocative current issues as the Manson family, the mistreatment of American Indians, the Chicago Seven trial, and, finally, in a forth-coming issue, the style and substance of the President and Vice President.

Mr. Agnew appears as Grandy, a simpering but vicious private-school cook whose ward is a certain ski-nosed child-witch named Sybil. A mere gaze from Sybil can cause great pain; one look from her and even Arrow and Lantern double over in agony. That certainly is making things clear. Grandy is constantly justifying his nastiness: "Old Grandy doesn't kill. I simply do my duty. Punish those who can't respect order. You may die. But that won't be my fault."

"What we're saying here," says Infantino, "is, there can be troubles with your Government unless you have the right leaders. Sure, we expect flak from the Administration, but we feel the kids have a right to know, and they want to know. The kids are more sophisticated than anyone imagines, and we feel the doors are so wide open here that we're going in many directions.

"You wouldn't believe whom I'm talking to. Big-name writers —and they're interested. We have innovations in mind for older audiences, and in graphics we're going to take it such a step forward, it'll blow the mind." He was so excited during our talk that he stood up. "We're akin to a young lady pregnant and having her first baby." He grinned shyly.

The artist who has produced the most innovative work for Infantino is 53-year-old Jack Kirby, about whom Stan Lee says: "He is one of the giants, a real titan. He's had tremendous influence in the field. His art work has great power and drama and

tells a story beautifully. No matter what he draws it looks excit-
ing, and that's the name of the game."

Unlike the "relevant" comic books, Kirby's new line eschews
self-conscious liberal rhetoric about social issues and returns to
the basic function of comic books: to describe in an exciting,
imaginative way how power operates in the world, the struggle
to attain it by those who lack it and the uses to which it is put
by those who have it.

Kirby began to conceive his new comic books when he was still
at Marvel, but felt he might not get enough editorial autonomy.
He left his $35,000-a-year job at Marvel and took his new books
to National. He also moved from New York to Southern Cali-
fornia, where he edits, writes and draws the books.

His new heroes are the Forever People, whom he describes as
"the other side of the gap—the under-30 group. I'm over 50. I've
had no personal experience of the counterculture. It's all from
the imagination."

The Forever People arrive on earth through a "boom tube,"
which is an attempt to offer approximate coordinates for an ex-
periential conjunction of media wash and psychedelic trip. They
are said to be "In Search of a Dream." There are five of them: one
is a relaxed, self-assured, young black man who, probably not by
accident, carries the group's power source, known as the "mother
box"; another is a shaggy-bearded giant who overwhelms his
small-minded taunters with a loving, crushing bear hug; the third,
a beautiful saintly flower child named Serafin is called a "sensi-
tive"; the fourth, a combination rock star-football hero trans-
mogrified into one Mark Moonrider; and the fifth, a girl named
Beautiful Dreamer.

The mother box, which warns them of impending danger, also
transforms them—not into five distinct, ego-involved superheroes
but into a single all-powerful Infinity Man, who comes from a
place where "all of natural law shifts, and bends, and changes.
Where the answer to gravity is antigravity—and simply done."

These new heroes, unlike the characters of the sixties, are brash,
confident youngsters whose superpower lies in their ability to
unify. They are also, says Kirby, "basically nonviolent."

Infantino has been asked up to Yale to talk about Kirby's new

books, and to Brown, for the new course in Comparative Comics. Students in Comp. Com. I will doubtless relish Kirby's toying with words like "gravity" (and other mild Joycean puns sprinkled elsewhere) to suggest elements of his parable of culture vs. counterculture. Suffice it to say here that the Forever People are from New Genesis, where the land is eternally green and children frolic in joy, and their enemy is Darkseid, who serves "holocaust and death."

The story of New Genesis is also told in another new Kirby book called "New Gods." When the old gods died, the story goes, the New Gods rose on New Genesis, where the High-Father, who alone has access to The Source, bows to the young, saying, "They are the carriers of life. They must remain free. Life flowers in freedom."

Opposed to New Genesis is its "dark shadow," Apokolips, the home of evil Darkseid and his rotten minions. Darkseid's planet "is a dismal, unclean place of great ugly houses sheltering uglier machines." Apokolips is an armed camp where those who live with weapons rule the wretches who built them. Life is the evil here. And death the great goal. All that New Genesis stands for is reversed on Apokolips.

Darkseid has not, of course, been content to rule on Apokolips. He wants to duplicate that horror on, of all places, Earth, and he can do this if he manages somehow to acquire the "antilife equation." With it, he will be able to "snuff out all life on Earth—with a word."

Thus is the battle drawn, and the Forever People, notably, are not going to waste their time hassling with raucous hardhats who don't understand the crisis. When a hostile, paranoid, Middle-America type confronts them, they arrange it so that he sees them just about the way he remembers kids to have been in his own childhood: Beautiful Dreamer wearing a sensible frilly dress down to her knees, the cosmic-sensitive Serafin wearing a high-school sweater and beanie, Moonrider with hat and tie and close-cropped hair.

"What's going on here? You kids look so different—and yet so familiar."

"Why sure," says Beautiful Dreamer soothingly. "You used to

know lots of kids like us. Remember? We never passed without saying hello."

In the titanic struggle against Darkseid, the Forever People have lots of help, and they are beginning to populate four different comic books: "Forever People," "New Gods," "Mister Miracle" and "Superman's Pal Jimmy Olsen." Both Superman and Jimmy Olsen are being altered to fit the evolution of Kirby's Faulknerian saga of the difficult days leading to Armageddon. Already identified in the Kirby iconography on the side of the good are the newly revived and updated Newsboy Legion, so popular in the nineteen-forties; various dropout tribes living in "The Wild Area" and "experimenting with life" after harnessing the DNA molecule; and a tribe of technologically sophisticated youths called "Hairies," who live in a mobile "Mountain of Judgment" as protection against those who would destroy them. "You know our story," says one Hairy. "We seek only to be left alone—to use our talents, to develop fully."

On the other side, in support of Darkseid are middle managers and technocrats of the Establishment, like Morgan Edge, a media baron who treats his new employe Clark Kent—now a TV news caster—abominably.

Darkseid's lousy band also includes an assortment of grotesque supervillains. Among them are DeSaad and his terrifying "Fear Machine," and a handsome toothy character named Glorious Godfrey, a revivalist. Godfrey is drawn to look like an actor playing Billy Graham in a Hollywood film biography of Richard Nixon starring George Hamilton.

"I hear you right thinkers," Godfrey says to his grim, eyeless audience of true believers, "You're shouting antilife—the positive belief."

In the background acolytes carry signs: "Life has pitfalls! Antilife is protection!" And, "You can justify anything with antilife!" And, "Life will make you doubt! Antilife will make you right!"

"I have no final answers," Kirby admits. "I have no end in mind. This is like a continuing novel. My feeling about these times is that they're hopeful but full of danger. Any time you have silos buried around the country there's danger. In the forties

when I created Captain America, that was my feeling then, that patriotism. Comics are definitely a native American art. They always have been. And I'm feeling very good about this. My mail has been about 90 per cent positive, and sales are good."

Infantino adds:

"The kids at Yale think Kirby's new books are more tuned in to them than any other media. They're reading transcripts from 'New Gods' over their radio station. The Kirby books are a conscious attempt to show what things look like when you're out where the kids are. The collages, the influence of the drug culture. We're showing them basically what they're seeing. We're turning into what they're experiencing."

If that is true—and I am not so sure it isn't—then perhaps the rest of us had better begin choosing sides. New Genesis anyone?

SCIENCE FICTION

9 FROM *Benjamin DeMott*
Vonnegut's Otherworldly Laughter

Kurt Vonnegut, Jr., represents to many one of the leading voices raised to criticize man's nature and his potential misuse of technological power when he inevitably develops it. Science fiction allows Vonnegut to project himself into the future and there discover a kind of futility and gloom in man's existence.

Bulletin: Kurt Vonnegut, Jr., has broken out of the pack in the Youthcult Hero Stakes, leaving Norman Mailer, Herbert Marcuse, R. D. Laing, A. S. Neill, *et al.* behind at the top of the stretch. Can this upset-in-the-making be explained? Will a Vonnegut victory hurt letters? Hurt the kids? Hurt anybody?

Answers are easier to come by now than they once were, for the earlier novels by the author of *Slaughterhouse-Five,* or *The Children's Crusade, a Duty-Dance with Death* (1969) are back in print, permitting sober inquiry into literary and other lines of development. As it happens, the literary lines are pretty simple. The novelist's first try—*Player Piano* (1952)—is tentatively deferential to conventions of plot, characterization, and social detail. Its

SOURCE. Kurt Vonnegut, Jr., "Vonnegut's Otherwordly Laughter," *Saturday Review*, May 1, 1971, pp. 29–32, p. 38. Copyright © 1971 Saturday Review, Inc.

setting is a factory town resembling Schenectady, where Vonnegut once worked as a PR man for General Electric. Its hero, Paul Proteus, conducts a rebellion against tyrannies of automation and abstraction, and the story is told in orthodox, cause-and-effect narrative rhythms. The tyrannies themselves, moreover—competition, enforced company loyalty, country club parties, ambitious wives, and other matters that were examined in William Whyte's *Organization Man*—are familiar stuff.

Yet, while the surface is in the main traditional, several large cracks do appear in the form of visionary elements. The factory world is, for one thing, futuristic—not today's GE but tomorrow's, fully automated. For another, the portrait of the lives of the townies—people whose test scores exclude them from meaningful work—borrows heavily from Orwell (the proles in *1984*). And the secondary story, detailing a visit to America by a Naïve Stranger, repeatedly touches the fabulous. Symptoms of impatience with "reality" are, in other words, visible from the beginning, hints that for Vonnegut the fabulous could easily become the norm.

And so it does. In the works that follow *Player Piano* fact occasionally asserts itself, usually in historical bits. *Mother Night* (1961) draws on the war-time activities of Lord Haw Haw and Ezra Pound, and on earlier types like Gerald L. K. Smith and Father Coughlin, in telling the tale of an American double agent named Howard W. Campbell hired by Nazis to vilify Jews on the radio. And, as everybody knows, *Slaughterhouse-Five* takes as its crisis the Allied bombing of Dresden and the subsequent firestorm that wiped out hundreds of thousands of lives. But neither book is anything like a chronicle. *Mother Night* is satirical-confessional throughout, and the reportage in *Slaughterhouse-Five* gives way in the end to sci-fi fantasy that flies up from the local disaster to a fanciful, cosmological redefinition of death.

And so it also goes with Vonnegut's major pop hits of the Sixties: *God Bless You, Mr. Rosewater* (1965), *Cat's Cradle* (1963), and *The Sirens of Titan* (1959). Each story floats free of attachment to dailiness. *Rosewater* introduces a rich, bibulous eccentric addicted to kindness (ROSEWATER FOUNDATION/HOW CAN WE HELP YOU?) and determined to outwit the gaggle of sharpies who seek to strip him of his power to do good. *The Sirens of Titan* tells of another quixotic moneybags, Malachi Constant, a man

lured by sirens from another planet into magical space wander-
ings—again few touchdowns on any recognizably human base.
And *Cat's Cradle* is still another imaginary voyage, a "novel"
that begins as a probe of the behavior of the fathers of the atomic
bomb on the day of Hiroshima, but quickly shapes up as a jour-
ney to the end of the world. These three books attempt in their
opening pages to create momentary plausibilities of setting—
Newport, R.I., "Ilium," N.Y., a law office in Washington, D.C.—
and they also venture a word or two of explanation about the
origins of the inheritance or the conscience or the interest in
space exploration that's the initial focus of the narrative. But
the explanations are only teasers: the writer's evident intention
is to slip the nets of ordinary life—to fight off the documentary
sensibility of the age. And, partly because of the increasing fa-
miliarity of the sci-fi mode and partly because of Vonnegut's re-
laxed good humor, the escape from everyday is usually brought
off with grace and ease.

Is this the key to Vonnegut's charm for the young? Certainly
escape is attractive, and so too is the *Yellow-Submarine*, Brechtian
world of mixed tones that his withdrawal enables Vonnegut to
construct. A free-form universe of discourse—fantasy-sermon-sat-
ire—can function as a kind of alternative community, a refuge
from the oppressive rule of things as they are. But that free-form
world, the promise of a truly fresh deal, is obviously only one
element of the success. (A comparable promise is made, after all,
by Terry Southern, Donald Barthelme, and a number of other
writers unconstrained by commonplace social fact; yet none of
them has achieved, or seems likely to achieve, Vonnegut's au-
thority among the young.) The case is that Vonnegut is loved
not alone for his breakout from boring norms of realism, but
for a congeries of opinions, prejudices, and assumptions perfectly
tuned to the mind of the emergent generation. Consider the rec-
ord:

• Youthcult holds that everyone in power is hung up on proce-
dures and forms, blind to the great issues, scared of looking the
facts of the age in the eye. Vonnegut says the same. Nobody "will
talk about the *really* terrific changes going on," says Mr. Rose-
water furiously. Nobody except maybe a sci-fi writer here and

there has "guts enough to *really* care about the future . . . *really* notice what machines do to us, what wars do to us, what cities do to us, what big, simple ideas do to us, what tremendous misunderstandings, mistakes, accidents and catastrophes do to us."

• Youthcult holds that we are living in a world about to be trashed, a hair or two away from cataclysm. Vonnegut says the same.

"Daddy," cries the narrator of *Cat's Cradle* (a person who's written a work called *The Day the World Ended*), "Daddy, why are all the birds dead? Daddy, what makes the sky so sick and wormy? Daddy, what makes the sea so hard and still?"

• Youthcult holds that the work ethos at once begets and is begotten by cruelty and hatred. Vonnegut says the same. "Americans have been taught to hate all people who will not or cannot work, to hate even themselves for that," says Kilgore Trout, the sage of *Rosewater*. "We can thank the vanished frontier for that piece of common-sense cruelty. The time is coming, if it isn't here now, when it will no longer be common sense. It will simply be cruel."

• Youthcult holds that the attempt of the elders to hide the prevalence of brutality from the young (and from themselves) is both criminally evasive and doomed to failure. Vonnegut says the same. At the end of *Mother Night* Howard Campbell, on trial for genocide, receives some junk mail from Creative Playthings pitching for toys that prepare kids for life and help them to "work off aggression." Campbell answers:

"I doubt that any playthings could prepare a child for one millionth of what is going to hit him in the teeth, ready or not. My own feeling is . . . [against] bland, pleasing, smooth, easily manipulated playthings like those in your brochure, friends! Let there be nothing harmonious about our children's playthings, lest they grow up expecting peace and order, and be eaten alive. As for children's working off aggressions, I'm against it. They are going to need all the aggressions they can contain for ultimate release in the adult world Let me tell you that the children in my charge. . . . are spying on real grownups all the time, learning what they fight about, what they're greedy for, how

they satisfy their greed, why and how they lie, what makes them go crazy, the different ways they go crazy and so on"

• Youthcult holds that openness is the highest virtue, and that moral and intellectual rigidity—the belief that absolute right or wrong can be known by men—is the root of our sickness. Vonnegut says the same. In *Slaughterhouse-Five* the writer notes that he "never wrote a story with a villain in it," attributing this to the University of Chicago's Anthropology Department ("they taught . . . that nobody was ridiculous or bad or disgusting"). Howard Campbell preaches solemnly against self-righteousness in *Mother Night:* "There are . . . no good reasons ever to hate without reservation, to imagine that God Almighty Himself hates with you, too. Where's evil? It's that large part of every man that wants to hate without limit, that wants to hate with God on its side." And Vonnegut is forever imagining loony battlefields in the void wherein the collected Mr. Cocksures of the universe can blow themselves to nothingness—"remotes" like the "Chrono-Synclastic Infundibula" described, in children's encyclopedia jargon, in *The Sirens of Titan:*

"Just imagine that your Daddy is the smartest man who ever lived on Earth, and he knows everything there is to find out, and he is exactly right about everything, and he can prove he is right about everything. Now imagine another little child on some nice world a million light years away, and that little child's Daddy is the smartest man who ever lived on that nice world so far away. And he is just as smart and just as right as your Daddy is. Both Daddies are smart, and both Daddies are right. Only if they ever met each other they would get into a terrible argument, because they wouldn't agree on anything. Now, you can say that your Daddy is right and the other little child's Daddy is wrong, but the Universe is an awfully big place. There is room enough for an awful lot of people to be right about things and still not agree. The reason both Daddies can be right and still get into terrible fights is because there are so many different ways of being right. There are places in the Universe, though, where each Daddy could finally catch on to what the other Daddy was talking about We call these places chrono-synclastic infundibula You might think it would be nice to go to a chrono-synclastic in-

fundibula and see all the different ways to be absolutely right, but it is a very dangerous thing to do."

• Youthcult holds that Possibility is all, that men must trip out to the borders of self and experience, penetrate the countries wherein ordinary sequences of time break down and past and future coexist, wherein ego and isolation vanish—wherein, like, thought and feeling, man, like, they just flow. Vonnegut says the same. Time and time over he imagines those countries and populates them with instructive (if not model) creatures—the inhabitants of Mercury, for example, as described in *The Sirens of Titan:*

There is only one sex.
Every creature simply sheds flakes of his own kind, and his own kind is like everybody else's kind.
There is no childhood as such. Flakes begin flaking three Earthling hours after they themselves have been shed. They do not reach maturity, then deteriorate and die. They reach maturity and stay in full bloom, so to speak, for as long as Mercury cares to sing.
There is no way in which one creature can harm another, and no motive for one's harming another.
Hunger, envy, ambition, fear, indignation, religion, and sexual lust are irrelevant and unknown.
The creatures have only one sense, touch.
. . . They have only two possible messages The first is, "Here I am, here I am, here I am." The second is, "So glad you are, so glad you are, so glad you are." . . .
Because of their love for music and their willingness to deploy themselves in the service of beauty, the creatures are given a lovely name by Earthlings. They are called *harmoniums.*

As should be said at once, the dogmas just summarized aren't highly supportive to careerists, lads on the way up, pushers, drivers, scrappers. Instead of toughening wills, they foster softness, acquiescence, an indisposition to stamp your mark on life. And the general thrust, furthermore, like that of hundreds of writers from Blake to Hesse, is "anti-intellectual": don't burn the books, but don't crack them, either. "You can safely ignore the arts and sciences," says Eliot Rosewater. "They never helped anybody."

See my Pop, the Nobel Laureate physicist, father of the atom bomb, says Newton Hoenikker in *Cat's Cradle*. The morning Dr. Hoenikker left for Sweden "Mother cooked a big breakfast. And then, when she cleared off the table, she found a quarter and a dime and three pennies by Father's coffee cup. He'd tipped her." Where would true brilliance wind up, asks Vonnegut, if it ever materialized in our midst? Not at the top, is his answer, but in some Green Stamp redemption center, clerking—witness the case of Kilgore Trout.

It also needs to be said that Vonnegut's best literary self is neither dogmatic nor sermonical, nor as simplistic as most of the foregoing themes. It seldom appears, this best self, in comic-strip send-ups of greed like *God Bless You, Mr. Rosewater*. Neither do you meet it in the sci-fi, futuristic, or cataclysmic corridors of *Slaughterhouse-Five* or *The Sirens of Titan* or *Cat's Cradle*. The strongest writing in this *oeuvre* is found in the least fanciful, most tightly made tales—*Player Piano* and *Mother Night*. And again and again in both books the comedy cuts cleanest when the subject in view is that of classical satire—namely, self-delusion. *Player Piano* is a rich survey of ways in which inflexibility and self-simplification exact respect as "integrity," and a mocking indictment of the conception of civilization "as a vast and faulty dike, with thousands of men . . . in a rank stretching to the horizon, each man grimly [and self-congratulatingly] stopping a leak with his finger." The memorable set piece, a brilliantly worked conceit, matches a machine-mesmerized manager against Checker Charley, a sick computer, and dramatizes swiftly, precisely, fiercely a dozen brands of contemporary superstition. The computer plays poorly, is obviously shot—yet the human opponent can't believe in his own success:

"To Paul's surprise, he took one of [Charley's] pieces without, as far as he could see, laying himself open to any sort of disaster. And then he took another piece, and another. He shook his head in puzzlement and respect. The machine apparently took a long-range view of the game with a grand strategy not yet evident. Checker Charley, as though confirming his thoughts, made an ominous hissing noise, which grew in volume as the game progressed."

And when the explosion comes, human hearts—self-conned into

faith that men are machines and vice versa—are torn and "good men" weep:

"Fire!" . . .

A waiter came running with a fire extinguisher and sent a jet of fluid into Checker Charley's entrails. Steam billowed up as the jet fizzed and sputtered on the glowing parts. The lights on Charley's steel bosom were skittering about the board wildly now, playing a demoniacal and swift game according to rules only the machine could understand. All the lights went on at once, a hum swelled louder and louder, until it sounded like a thunderous organ note, and suddenly died. One by one, the little lamps winked out, like a village going to sleep.

"Oh my, my, oh my"

The engineers crowded around Checker Charley, and those in the front rank probed through the ashes, melted tubes, and blackened wires. Tragedy was in every face. Something beautiful had died.

(The feigned grief, raspingly tender, of the sleeping-village metaphor is vintage Vonnegut.)

And in *Mother Night* a precisely analogous kind of comedy is achieved in a dramatization of the mind of a Jew-baiter that simultaneously illuminates the capacity of the meanest of men to see himself as virtuous, and the incapacity of the best men to name their virtues in terms that don't trivialize them. (Fascists engaged in organizing a bully-boy, storm-trooping Iron Guard describe themselves—earnestly—as "working with youngsters . . . just ordinary kids from all walks of life . . . kids who would ordinarily be at loose ends and getting into trouble. . . .") At his best, powered by the pressure of his own astonishment at the spectacle of the moral gymnastics of contemporary compartmentalized man, the creature who invariably "serves evil too openly and good too secretly," Vonnegut is a potent satirist, with a fine eye for the self-deceit built into mod vocabularies of altruism.

But at certain moments in the history of letters the nature of a writer's best or worst self in literary terms matters less than the function the man performs for his primary audience. The present is one of those times—and the function performed by Vonnegut isn't negligible. It is, as indicated, that of articulating

the blackest suspicions of a skeptical, cynical generation without running on into orgies of hate or ironical partisanship of evil. Vonnegut's fictional world is often formally incoherent, a mix of jokebook turns, fantasies, cartoon and sermonical bits, Luddite posturings, outcries against cruelty and greed. Lax, rambling, muzzy, sad-eyed, Beatle-toned, sticky at intervals, the writer can be damned as soft at his center, self-advertising in his proclaimed vulnerability to pain and suffering, deeply *un*fascinated by anything difficult.

But viciousness has no dominion over him, and this makes the considerable difference. The author of *Mother Night* may dream of black comedy, but kindness keeps breaking in—there and everywhere else. The man of despair hums on about the profound wretchedness of men and things, but always he's challenged by the inventor inside him, a fabulist in love with images of goodness, generosity, hope, and forever on the verge of declaiming, flat out, with no embarrassment whatever, that, dammit, men and things ought to be—*could be*—infinitely better than they are. The results, viewed "esthetically," aren't uniformly exhilarating: both art and intellect vanish periodically; bullsession simplisms often mound up and drift.

But, to repeat, the work as a whole does serve a function. Its unbrutal laughter is a surcease from high-fashion meanness and knowingness, a patch of dry land on which, by pumping a little more breath into "silly," "innocent" faith in love, moral aspiration can avoid killing itself off prematurely. Say it out straight: on balance, the kids' lighting on Kurt Vonnegut is an undeservedly good break for the age.

FICTION

10 FROM *John G. Cawelti*

The Concept of Formula in the Study of Popular Literature

That intelligent people take seriously the study of Popular Culture, though not new, is one of the promising developments of present day academic and critical awareness. This interest demonstrates that Popular Culture is by no means as simplistic as used to be thought and that the study of it is indispensable.

The growing interest among humanistic scholars and teachers in popular culture is one of the more exciting academic trends of the present day. This field of study represents a great expansion in the range of human expression and activity subjected to the scrutiny of historians and scholars of the arts. Consequently one of the central problems in giving some shape to our inquiries into popular culture has been the need for analytical concepts which might enable us to find our way through the huge amount of material which is the potential subject-matter of studies in popular culture. Moreover, we badly need some way

SOURCE. John G. Cawelti, "The Concept of Formula in the Study of Popular Literature," pp. 381–390. Reprinted with the permission of the *Journal of Popular Culture* from the *Journal of Popular Culture*, Volume III:3, Winter 1969. Copyright © 1969 by Ray B. Browne.

of relating the various perspectives, historical, psychological, sociological and aesthetic, which are being used in the investigation of such phenomena as the Western, the spy story, pop music, the comic strip, film and TV.

To some extent, students of popular culture have simply applied to a wider range of materials the historical and critical methods of traditional humanistic scholarship. This practice has led to more complex analyses of such popular forms as the detective story and richer, more carefully researched accounts of the development of various popular traditions. Approaching the materials of popular culture with the traditional arsenal of humanistic disciplines is certainly a necessary first step. Nonetheless, the analysis of popular culture is somewhat different from that of the fine arts. When we are studying the fine arts, we are essentially interested in the unique achievement of the individual artist, while in the case of popular culture, we are dealing with a product that is in some sense collective. Of course it is possible to study the fine arts as collective products just as it is possible to examine individual works of popular culture as unique artistic creations. In the former case, the present discussion should apply with some qualifications to the fine arts, while in the latter, the traditional methods of humanistic scholarship are obviously the most appropriate, with some allowance for the special aesthetic problems of the popular arts.

Students of popular culture have defined the field in terms of several different concepts. When scholars were first interesting themselves in dime novels, detective stories, etc., they thought of them as subliterature. This concept reflected the traditional qualitative distinction between high culture and mass culture. Unfortunately it was really too vague to be of much analytical use. Even if one could determine where literature left off and subliterature began, a distinction that usually depended on the individual tastes of the inquirer, the term suggested only that the object of study was a debased form of something better. Like many concepts that have been applied to the study of popular culture, the idea of subliterature inextricably confused normative and descriptive problems.

Four additional concepts have come into fairly wide use in recent work: a) the analysis of cultural themes; b) the concept

of medium; c) the idea of myth and d) the concept of formula. I would like to deal briefly with the first three, mainly by way of getting to a fuller discussion of what I consider the most promising concept of all.

The analysis of cultural, social, or psychological themes is certainly a tried and true method of dealing with popular culture. In essence, what the analyst does is to determine what themes appear most often or most prominently in the works under analysis and to group different works according to the presence or absence of the themes he is interested in. Unfortunately, there is a certain vagueness about the concept of theme. Such various things as the ideal of progress, the oedipal conflict, racism, and innocence have all been treated as themes. In effect, a theme turns out to be any prominent element or characteristic of a group of works which seems to have some relevance to a social or cultural problem. Though the vagueness of the concept can be cleared up when the investigator defines the particular theme or set of themes he is interested in, the concept of theme still seems inadequate because it depends on the isolation of particular elements from a total structure. This not only tends to over simplify the works under investigation, but to lead to the kind of falsifying reduction that translates one kind of experience into another. Thus, a story of a certain kind becomes a piece of social rhetoric or the revelation of an unconscious urge. No doubt a story is or can be these things and many others, but to treat it as if it were only one or another social or psychological function is too great a reduction. What we need is a concept that will enable us to deal with the total structure of themes and its relationship to the story elements in the complete work.

The concept of medium has become notorious through the fascinating theories of Marshall McLuhan, Walter Ong and others who insist that medium rather than content or form as we have traditionally understood them ought to be the focus of our cultural analyses. This concept seems to have a particular application to studies in popular culture because many of the works we are concerned with are transmitted through the new electric media which McLuhan sees as so different from the Gutenberg galaxy, the media associated with print. The concept of medium is an important one and McLuhan is doubtless correct

that it has been insufficiently explored in the past, but I am not persuaded that more sophisticated studies of the nature of media will do away with the need for generalizations about content. I am sure that we will need to revise many of our notions about where medium leaves off and content begins as the new studies in media progress, but for the present, I would like to forget about the idea of medium altogether with the explanation that I'm concerned with a different kind of problem, the exploration of the content of the popular media.

One more distinction along these lines is necessary. In this paper I will be concerned primarily with stories and with understanding the various cultural significances of these stories. While a large proportion of popular culture can be defined as stories of different kinds, this is certainly not an exhaustive way of defining popular culture. Just as there are other arts than fiction, so there are works of popular culture which do not tell stories. With additional qualifications the concepts I am seeking to define are applicable to the analysis of other expressions of popular culture than those embodied in stories, but to keep my task as simple as possible, I have chosen to limit myself to the discussion of stories.

The most important generalizing concept which has been applied to cultural studies in recent years is that of myth. Indeed, it could be argued that the concept of formula which I will develop in the course of this paper is simply another variation on the idea of myth. But if this is the case, I would argue that distinctions between meanings of the concept of myth are worth making and naming, for many different meanings can be ascribed to the term. In fact, the way in which some people use the term myth hardly separates it from the concept of theme, as when we talk about the myth of progress or the myth of success. There is also another common meaning of the term which further obfuscates its use, namely myth as a common belief which is demonstrably false as in the common opposition between myth and reality. Thus, when a critic uses the term myth one must first get clear whether he means to say that the object he is describing is a false belief, or simply a belief, or something still more complicated like an archetypal pattern. Moreover, because of the special connection of the term myth with a group of stories

which have survived from ancient cultures, particularly the Greco-Roman, the scholar who uses the concept in the analysis of contemporary popular culture sometimes finds himself drawn into another kind of reductionism which takes the form of statements like the following: "the solution of the paradox of James Bond's popularity may be, not in considering the novels as thrillers, but as something very different, as historic epic and romance, based on the stuff of myth and legend." But if the retelling of myth is what makes something popular why on earth didn't Mr. Fleming simply retell the ancient myths.

Because of this great confusion about the term myth, I propose to develop another concept which I think I can define more clearly and then to differentiate this concept from that of myth, thereby giving us two more clearly defined generalizing concepts to work with. Let me begin with a kind of axiom or assumption which I hope I can persuade you to accept without elaborate argumentation: all cultural products contain a mixture of two kinds of elements: conventions and inventions. Conventions are elements which are known to both the creator and his audience beforehand—they consist of things like favorite plots, stereotyped characters, accepted ideas, commonly known metaphors and other linguistic devices, etc. Inventions, on the other hand, are elements which are uniquely imagined by the creator such as new kinds of characters, ideas, or linguistic forms. Of course it is difficult to distinguish in every case between conventions and inventions because many elements lie somewhere along a continuum between the two poles. Nonetheless, familiarity with a group of literary works will usually soon reveal what the major conventions are and therefore, what in the case of an individual work is unique to that creator.

Convention and invention have quite different cultural functions. Conventions represent familiar shared images and meanings and they assert an ongoing continuity of values; inventions confront us with a new perception or meaning which we have not realized before. Both these functions are important to culture. Conventions help maintain a culture's stability while inventions help it respond to changing circumstances and provide new information about the world. The same thing is true on the individual level. If the individual does not encounter a large

number of conventionalized experiences and situations, the strain on his sense of continuity and identity will lead to great tensions and even to neurotic breakdowns. On the other hand, without new information about his world, the individual will be increasingly unable to cope with it and will withdraw behind a barrier of conventions as some people withdraw from life into compulsive reading of detective stories.

Most works of art contain a mixture of convention and invention. Both Homer and Shakespeare show a large proportion of conventional elements mixed with inventions of great genius. Hamlet, for example, depends on a long tradition of stories of revenge, but only Shakespeare could have invented a character who embodies so many complex perceptions of life that every generation is able to find new ways of viewing him. So long as cultures were relatively stable over long periods of time and homogeneous in their structure, the relation between convention and invention in works of literature posed relatively few problems. Since the Renaissance, however, modern cultures have become increasingly heterogeneous and plusalistic in their structure and discontinuous in time. In consequence, while public communications have become increasingly conventional in order to be understood by an extremely broad and diverse audience, the intellectual elites have placed ever higher valuation on invention out of a sense that rapid cultural changes require continually new perceptions of the world. Thus we have arrived at a situation in which the model great work of literature is Joyce's *Finnegan's Wake,* a creation which is almost as far as possible along the continuum toward total invention as it is possible to go without leaving the possibility of shared meanings behind. At the same time, there has developed a vast amount of literature characterized by the highest degree of conventionalization.

This brings us to an initial definition of formula. A formula is a conventional system for structuring cultural products. It can be distinguished from form which is an invented system of organization. Like the distinction between convention and invention, the distinction between formula and form can be best envisaged as a continuum between two poles; one pole is that of a completely conventional structure of conventions—an episode of the Lone Ranger or one of the Tarzan books comes close

to this pole; the other end of the continuum is a completely original structure which orders inventions—*Finnegan's Wake* is perhaps the best example of this, though one might also cite such examples as Resnais' film "Last Year at Marienbad," T. S. Eliot's poem "The Waste Land," or Becket's play "Waiting for Godot." All of these works not only manifest a high degree of invention in their elements but unique organizing principles. "The Waste Land" makes the distinction even sharper for that poem contains a substantial number of conventional elements—even to the point of using quotations from past literary works—but these elements are structured in such a fashion that a new perception of familiar elements is forced upon the reader.

I would like to emphasize that the distinction between form and formula as I am using it here is a descriptive rather than a qualitative one. Though it is likely for a number of reasons that a work possessing more form than formula will be a greater work, we should avoid this easy judgment in our study of popular culture. In distinguishing form from formula we are trying to deal with the relationship between the work and its culture, and not with its artistic quality. Whether or not a different set of aesthetic criteria are necessary in the judgment of formal as opposed to formulaic works is an important and interesting question, but necessarily the subject of another series of reflections.

We can further differentiate the conception of formula by comparing it to genre and myth. Genre, in the sense of tragedy, comedy, romance, etc., seems to be based on a difference between basic attitudes or feelings about life. I find Northrop Frye's suggestion that the genres embody fundamental archetypal patterns reflecting stages of the human life cycle, a very fruitful idea here. In Frye's sense of the term genre and myth are universal patterns of action which manifest themselves in all human cultures. Following Frye, let me briefly suggest a formulation of this kind—genre can be defined as a structural pattern which embodies a universal life pattern or myth in the materials of language; formula, on the other hand is cultural; it represents the way in which a culture has embodied both mythical archetypes and its own preoccupations in narrative form.

An example will help clarify this distinction. The western and the spy story can both be seen as embodiments of the archetypal

pattern of the hero's quest which Frye discusses under the general heading of the mythos of romance. Or if we prefer psychoanalytic archetypes these formulas embody the oedipal myth in fairly explicit fashion, since they deal with the hero's conquest of a dangerous and powerful figure. However, though we can doubtless characterize both western and spy stories in terms of these universal archetypes, they do not account for the basic and important differences in setting, characters, and action between the western and the spy story. These differences are clearly cultural and they reflect the particular preoccupations and needs of the time in which they were created and the group which created them: the western shows its nineteenth century American origin while the spy story reflects the fact that it is largely a twentieth century British creation. Of course, a formula articulated by one culture can be taken over by another. However, we will often find important differences in the formula as it moves from one culture or from one period to another. For example, the gunfighter Western of the 1950's is importantly different from the cowboy romances of Owen Wister and Zane Grey, just as the American spy stories of Donald Hamilton differ from the British secret agent adventures of Eric Ambler and Graham Greene.

The cultural nature of formulas suggests two further points about them. First, while myths, because of their basic and universal nature turn up in many different manifestations, formulas, because of their close connection to a particular culture and period of time, tend to have a much more limited repertory of plots, characters, and settings. For example, the pattern of action known generally as the Oedipus myth can be discerned in an enormous range of stories from *Oedipus Rex* to the latest Western. Indeed, the very difficulty with this myth as an analytical tool is that it is so universal that it hardly serves to differentiate one story from another. Formulas, however, are much more specific: Westerns must have a certain kind of setting, a particular cast of characters, and follow a limited number of lines of action. A Western that does not take place in the West, near the frontiers, at a point in history when social order and anarchy are in tension, and that does not involve some form of pursuit, is simply not a Western. A detective story that does not involve the solution of a mysterious crime is not a detective story. This

greater specificity of plot, character, and setting reflects a more limited framework of interest, values, and tensions that relate to culture rather than to the generic nature of man.

The second point is a hypothesis about why formulas come into existence and enjoy such wide popular sue. Why of all the infinite possible subjects for fictions do a few like the adventures of the detective, the secret agent, and the cowboy so dominate the field.

I suggest that formulas are important because they represent syntheses of several important cultural functions which, in modern cultures have been taken over by the popular arts. Let me suggest just one or two examples of what I mean. In earlier more homogeneous cultures religious ritual performed the important function of articulating and reaffirming the primary cultural values. Today, with cultures composed of a multiplicity of differing religious groups, the synthesis of values and their reaffirmation has become an increasingly important function of the mass media and the popular arts. Thus, one important dimension of formula is social or cultural ritual. Homogeneous cultures also possessed a large repertory of games and songs which all members of the culture understood and could participate in both for a sense of group solidarity and for personal enjoyment and recreation. Today, the great spectator sports provide one way in which a mass audience can participate in games together. Artistic formulas also fulfill this function in that they constitute entertainments with rules known to everyone. Thus, a very wide audience can follow a Western, appreciate its fine points and vicariously participate in its pattern of suspense and resolution. Indeed one of the more interesting ways of defining a western is as a game: a western is a three-sided game played on a field where the middle line is the frontier and the two main areas of play are the settled town and the savage wilderness. The three sides are the good group of townspeople who stand for law and order, but are handicapped by lack of force; the villains who reject law and order and have force; and the hero who has ties with both sides. The object of the game is to get the hero to lend his force to the good group and to destroy the villain. Various rules determine how this can be done; for example, the hero cannot use force against the villain unless strongly provoked.

Also like games, the formula always gets to its goal. Someone must win, and the story must be resolved.

This game dimension of formulas has two aspects. First, there is the patterned experience of excitement, suspense, and release which we associate with the functions of entertainment and recreation. Second, there is the aspect of play as ego-enhancement through the temporary resolution of inescapable frustrations and tensions through fantasy. As Piaget sums up this aspect of play:

"Conflicts are foreign to play, or, if they do occur, it is so that the ego may be freed from them by compensation or liquidation, whereas serious activity has to grapple with conflicts which are inescapable. The conflict between obedience and individual liberty is, for example, the affliction of childhood [and we might note a key theme of the Western] and in real life the only solutions to this conflict are submission, revolt, or cooperation which involves some measure of compromise. In play, however, the conflicts are transposed in such a way that the ego is revenged, either by suppression of the problem or by giving it an acceptable solution . . . it is because the ego dominates the whole universe in play that it is freed from conflict."

Thus, the game dimension of formula is a culture's way of simultaneously entertaining itself and of creating an acceptable pattern of temporary escape from the serious restrictions and limitations of human life. In formula stories, the detective always solves the crime, the hero always determines and carries out true justice, and the agent accomplishes his mission or at least preserves himself from the omnipresent threats of the enemy.

Finally, formula stories seem to be one way in which the individuals in a culture act out certain unconscious or repressed needs, or express in an overt and symbolic fashion certain latent motives which they must give expression to, but cannot face openly. This is the most difficult aspect of formula to pin down. Many would argue that one cannot meaningfully discuss latent contents or unconscious motives beyond the individual level or outside of the clinical context. Certainly it is easy to generate a great deal of pseudo-psychoanalytic theories about literary formulas and to make deep symbolic interpretations which it is

clearly impossible to substantiate convincingly. However, though it may be difficult to develop a reliable method of analysis of this aspect of formulas, I am convinced that the Freudian insight that recurrent myths and stories embody a kind of collective dreaming process is essentially correct and has an important application on the cultural as well as the universal level, that is, that the idea of a collective dream applies to formula as well as to myth. But there is no doubt that we need to put much more thought into our approach to these additional dimensions of formula and about their relation to the basic dimension of a narrative construction.

My argument, then, is that formula stories like the detective story, the Western, the seduction novel, the biblical epic, and many others are structures of narrative conventions which carry out a variety of cultural functions in a unified way. We can best define these formulas as principles for the selection of certain plots, characters, and settings, which possess in addition to their basic narrative structure the dimensions of collective ritual, game and dream. To analyze these formulas we must first define them as narrative structures of a certain kind and then investigate how the additional dimensions of ritual, game and dream have been synthesized into the particular patterns of plot, character and setting which have become associated with the formula. Once we have understood the way in which particular formulas are structured, we will be able to compare them, and also to relate them to the cultures which use them. By these methods I feel that we will arrive at a new understanding of the phenomena of popular literature and new insights into the patterns of culture.

11 FROM *Mark Spilka*
Erich Segal as Little Nell: Or the Real Meaning of Love Story

The remarkable success of the novel and movie Love Story *has both delighted and infuriated "serious" critics and has raised many questions about the nature of a society and the works of art they appreciate. Many academics—and other "sophisticates" —have been scathing in their attacks and have found reasons to condemn the work. But their paying serious attention to the work, though to condemn, indicates the dimensions of their new awareness of the importance of such works.*

What can you say about a young author who identifies with his dying heroine and her hockey jock so as to wind up crying in paternal arms? That he gets to indulge his feminine impulses, and then be forgiven for them, in one of the most profitable and widely-shared acts of public wish-fulfillment in recent entertainment history? Or more fairly, that he gets to play the tender person he surely is against the tough one he would like to be, until the latter has been tenderized by love and grief? Either way the

SOURCE. Mark Spilka, "Erich Segal as Little Nell: Or the Real Meaning of Love Story." Reprinted with the permission of the *Journal of Popular Culture* from the *Journal of Popular Culture*, Volume V:4. Copyright © 1972.

story reads more interestingly, and makes more sense, as the author's fantasy than as his sentimental art.

It makes more sense because the answer to the narrator's opening question, "What can you say about a twenty-five-year-old girl who died?" is not the one which the book's title and much of its plot proposes: *That she taught her Harvard athlete how to love;* but rather *That she taught him how to love his father.* And it reads more interestingly because the homoerotic threat to that love, which the author's sentimental art disguises, is now exposed as the prominent clue to the story's resolution it really is. *Love Story* is the working out, through fantasy, of one man's role-confusions which, through sentimental art, has released the generation-bridging tears of modern millions. It is *The Old Curiosity Shop* of our time and Erich Segal is its Little Nell.

Consider how resonant words and acts become once the heroine is seen as Erich Segal in drag and the hero as his would-be out. There is the opening description of her as "a bespectacled mouse type" which is later echoed when the hero's father says: "Stay here and talk like a man," and the hero thinks: "As opposed to what? A boy? A girl? A mouse? Anyway I stayed." There is the opening connection of the hero's name, Oliver Barrett, with the poet Elizabeth Barrett who had such troubles with her father on Wimpole Street; and there is the accompanying connection of the heroine's uncaptitalized handwriting with a fellow poet's: "who did she think she was, e.e. cummings?"; and the later confusion of her name, Cavilleri, with *Cavalleria Rusticana* by Barrett's mother. A chivalric city mouse himself (see his cover photo), Segal may or may not wear spectacles, have brown eyes or A minus legs like his heroine, but this is literally all the description he ever gives us—via narrator Barrett—of Jennifer in the flesh. She is not physically imagined, though she herself frankly imagines the narrator physically, as when she responds to his opening question, "Why did you bulldoze me into buying you coffee?" with "I like your body"; or when she responds to his vengeful promise from the penalty box, "Oh how I'm gonna total that bastard Al Redding," with "Are you a dirty player? . . . Would you ever 'total' me?" Her healthy delight in hockey-rink violence may be common among Radcliffe intellectuals, and not a sign of the author's sporting predilections as an ex-Harvard

runner; but compare the narrator's descriptions of athletic life
with his blankness on her physical existence. Here is his locker-
room rhapsody after the first hockey game:

Every afternoon of my college life I walked into that place,
greeted my buddies with friendly obscenities, shed the trappings
of civilization and turned into a jock. How great to put on the
pads and . . . take the skates and walk out toward the Watson
Rink.

The return to Dillon would be even better. Peeling off the
sweaty gear, strutting naked to the supply desk to get a towel.

"How'd it go today, Ollie?

"Good, Richie. Good, Jimmy."

Then into the showers to listen to who did what to whom how
many times last Saturday night. *"We got these pigs from Mount
Ida, see . . . ?"* . . . Being blessed with a bad knee . . . , I had to
give it some whirlpool after playing. . . . I let my whole pleasantly
aching body slide into the whirlpool, closed my eyes and just sat
there, up to my neck in warmth. Ahhhhhhh.

Jesus! Jenny would be waiting outside How long had I
lingered in that comfort while she was out there in the Cam-
bridge cold?

This loving evocation of the whole experience of turning into
a jock, of male nudeness, vicarious virility, and narcissistic self-
absorption tells us where the author lives; he is by contrast
scarcely alive in the love scene which follows, in which Oliver
rushes out into the cold, kisses Jennifer lightly on the forehead,
then kisses her "not on the forehead, and not lightly." "It lasted
a long nice time," is his only reaction to the experience, while
she merely doesn't like the fact that she likes it.

The narrator's reticence about sex is of course thematic. When
his roommate asks for details of his love-life with Jenny, he re-
fuses to give them. Like Salinger (without whose diction he
virtually could not speak), he doesn't want to discuss sex when
love is his real concern. Jenny has been schooling him in that
subject, and in the fifth chapter he gets his crucial lesson. "I
would like to say a word about our physical relationship," he
begins in his best Salinger manner; then he speaks of their only
contact, "those kisses already mentioned (all of which I still re-

member in greatest detail)"—though in fact he remembers only a few details. Next he cites his standard of fast action, and how a dozen girls at a Wellesley dorm would "have laughed and severely questioned the femininity of the girl involved," if told "that Oliver Barrett IV had been dating a young lady *daily* for three weeks and had not slept with her." Well, yes, femininity *is* in question, and masculinity too, but not for the points we are being hit with, that they are not defined by availability or conquest. We see how they are defined when Oliver finally admits he is dying to make love to Jenny and "It all happened at once":

"Our first physical encounter was the polar opposite of our first verbal one. It was all so unhurried, so soft, so gentle. I had never realized that this was the real Jenny—the soft one, whose touch was so light and loving. And yet what truly shocked me was my own response. *I* was gentle. *I* was tender. Was this the real Oliver Barrett IV?"

Well he might ask in a scene where there are no bodies to "encounter," only affects. But there is one object Oliver can grasp: the golden cross which "had been her mother's" which Jenny wears "for sentimental reasons" on an unlockable chain around her neck—"Meaning that when we made love, she still wore the cross"—meaning that sex has been sanctioned, possibly purified, certainly spiritualized, through sentiment. And of course he can also grasp those obvious spiritual lessons: that a really feminine woman wants gentle sex, that a really masculine man may give it without losing virility, and finally, that affection can move gently, unhurriedly into sex, and perhaps right through it, without ever changing into passion.

This passionless sex seems to move a step beyond the sexless loves of J. D. Salinger; it is not where contemporary youth are at, but it leans in that direction by stressing the affections and by dissolving the urgencies of sex and self which characterize much romantic love. Thus Oliver explains that he was afraid to rush Jenny into bed because "she might laugh at what I had traditionally considered the suave romantic (and unstoppable) style of Oliver Barrett IV." We never see that style in the story, no more than we "see" what happens here. But we are *told* what happens, in the same way that the book's title tells us—or a

Beatles' song tells us—that affection, fondness, relaxed play, have replaced the intensities and passions we generally associate with romantic songs and tales. New attitudes have been announced— new clichés really—which contemporary readers plainly recognize. Segal, who helped to write the script for the Beatles' cartoon movie, *Yellow Submarine,* knows that "love" means something other than "romance" in songs like "All You Need Is Love"— means indiscriminate affection, really, as stylized and hence qualified by insouciance, spoofing, spontaneity, in the best Beatles' manner. To his credit Segal tries to build such attitudes into his own literary manner and to some extent succeeds. My reservation here is that he also builds into his work his sexual fears, and that his reticence hides the sources of those fears, though they keep coming back like a song.

Or fail to come back at all. Mothers, for instance, are so strangely absent from this tale as to seem unthinkable. Jenny's mother is dead and is directly mentioned only twice; Oliver's appears *only* in chapter 7 where she functions as a half-educated adjunct to his father when he brings Jenny to meet his parents. He literally never thinks of her before this occasion, and only twice after, when he notes her handwriting on an envelope and when he sees her picture on his father's desk. Such unthinkability is, to say the least, peculiar for a narrator who hates his father and who either cannot or will not imagine women physically or describe sexual love. Happily it enhances the thinkability of fathers and so clears the ground for a rich return of repressed material.

Sometimes the repressed returns in the form of double-takes which allow both author and reader to experience slight neurotic alarms without looking too closely into them. Two such moments occur in the fourth chapter when Oliver learns that Jenny is making a phone call in her dormitory lounge. Approaching the phone booth, he hears her tell a man named Phil that she loves him and sees her blow kisses into the phone. He has been thinking about his apparent rival, a music student named Martin Davidson, and now he hastily concludes that "some bastard named Phil" has beaten out both suitors, has crawled into bed with Jenny while he was off playing hockey at Cornell. The man turns out to be her father, and the type of love, affection; but

Oliver's mistake allows us to think for a moment of Jenny in bed with her father, and he will himself speak of incest as Jenny's family problem as the same dialogue continues. Meanwhile we learn that Jenny has been raised by her father, a Cranston, R.I., baker; that he refuses to let her drive because of her mother's death in a car crash; and that this was "a real drag" when Jenny took piano lessons in Providence in her high school days, though "she got to read all of Proust on those long bus rides." Such resonant compensations remind us that our well-read author originally conceived his Italian girl from Cranston as a Jewish girl from New York—that is to say, as someone like himself—until Hollywood made him change her background and her buses.

Whether Jewish or Italian, Jenny's first-name basis with her father indicates that she comes from one of those warm "foreign" families we have all met in Steinbeck and Saroyan. Oliver comes from one of those cold New England families in Marquand where the fathers always forbid their sons to marry common girls. When Jenny asks him what he calls his father, Oliver's reply is "Sonovabitch," and he goes on to mention his intimidating attributes—his stony face, the "gray stone edifice in Harvard Yard" named Barrett Hall which it recalls, and the "muscular intimidation" of his athletic status as an Olympic sculler. When Jenny remains skeptical we get our second double-take:

"But what does he do to qualify as a sonovabitch?" Jenny asked.

"Make me," I replied.

"Beg pardon?"

"*Make* me," I repeated.

Her eyes widened like saucers. "You mean like incest?" Jenny asked.

"Don't give me your family problems, Jen. I've got enough of my own."

"Like what, Oliver?" she asked, "like just what is it he makes you do?"

"The 'right things,' " I said.

By the "right things" Oliver means being "programmed for the Barrett Tradition" and "having to deliver *x* amount of

achievement every single term" which is then taken for granted. Jenny continues to find such explanations unconvincing and exclaims "Thank God you're hung up about your father" as the chapter ends. For a moment she has defined that hangup for us as incest, or fear of homoerotic love with his father, which does seem like a better explanation for hostility than those he cites; but when he jokingly passes the problem off as Jenny's the explanation is abruptly dropped. Still, if Jenny chiefly represents a feminine attachment to fathers which is both tender *and* erotic, then she is herself what Oliver fears in his own suppressed attachment: which is why he has to leave his father to marry her and be widowed to return.

Oliver's marriage to Jenny is in fact briefly viewed as psychological rebellion. "You bug him and bug him and bug him," says Jenny in her resonant way. "I don't think you'd stop at anything, just to get to your old man." He might even marry her for this reason, since "in a crazy way" he loves her "negative social status" just as she loves his name and numeral as parts of himself. Oliver feels humbled by her perception and her courage in facing up to dubious motives. But when his father shows the same perception about his motives and calls for the same courage from him, then asks him to finish law school before marrying, Oliver gets angry. He sees his father's time-test as arbitrary, sees himself as "standing up to" his "arbitrariness," his "compulsion to dominate and control my life"; and when his father apparently yields to that compulsion and says "Marry her now, and I will not give you the time of day," Oliver rebels. "Father, you don't *know* the time of day," he declares and walks "out of his life" to begin his own.

Yet Oliver III does know the time of day. As a former member of the Roosevelt administration and as present head of the Peace Corps, he must at least be credited with more social awareness than his son ever shows; and as a concerned father he must at least be judged as more sensitive and perceptive than his son at these early interviews. Segal has worked hard thus far to telegraph these points (who could miss them?) through Oliver's misjudging eyes. Yet now he would have us believe that Oliver III reverts to stereotype, becomes Old Stonyface, and gives his son an ultimatum straight from Wimpole Street. All signals are reversed,

Oliver is right about his father's villainy, and we have an act of social rebellion which must comfort modern millions by its reassuring familiarity, but which otherwise makes little sense. Whether the father's action is "impulsive" as "you bug him" implies, or "compulsive" as Oliver asserts, we have not been given sufficient evidence to judge its credibility. All we have seen so far is the perceptive loving man Segal telegraphs and the villain Oliver creates to protect himself from engulfment and from his own tender feelings. Missing from this picture is the overwhelming conviction of the father's power which would drive those tender feelings into hiding and turn Oliver into an unfeeling rival. As Jenny confirms, Oliver himself presents that power as an unconvincing set of intimidations, social, athletic and paternal. We never see it as an aspect of character strong enough to create this kind of cold hostility and suppressed affection. What we do see is a melodramatic action which chiefly serves to unite a divided personality in unholy matrimony.

Unholy because these two young atheists perform their own ceremony and again betray themselves through poetry. Jennifer reads a sonnet by (who else?) Elizabeth Barrett which begins with the marvellously phallic lines, "When our two souls stand up erect and strong, / Face to face, silent, drawing nigh and nigher, / Until the lengthening wings break into fire . . ." and which ends by predicting (what else?) early death. Oliver chooses lines from Walt Whitman, that indiscriminate lover, inviting some camerado to take his hand and travel with him on the open road for life. So blessed by nineteenth-century poets, our young moderns of the '60s begin the life of an establishment couple of the '50s. Jennifer works to put Oliver through law school; both work in the summer; they scrounge for money but not for love; he "achieves" honors and gets the highest bid from the best law firm in New York; and they continue to use profanity as Salinger used it in the '50s, to guarantee their own authenticity and lack of phoniness and to control their own excessive sentiment.

Meanwhile there is another phone scene, probably the most vital scene in the book since it sets the novel's theme, provides its punch line, and exposes its suppressed assumptions. An invitation arrives from Mr. and Mrs. Oliver Barrett III requesting our young marrieds to attend a dinner celebrating Mr. Barrett's

sixtieth birthday. Jennifer says "Ollie—he's reaching out to you,"
cites his advanced age as a basis for reconciliation, invokes the
future resentment of their son (nicknamed Bozo) at his own
intimidating ways. When Oliver resists each argument she sets the
book's theme with what he calls "an absolute non sequitur":

"Your father loves you too, Oliver. He loves you just the way
you'll love Bozo. But you Barretts are so damn proud and com-
petitive, you'll go through life thinking you hate each other."
 "If it weren't for you," I said facetiously.
 "Yes," she said.

Here is the real "love story." Jenny's role is to bring the Bar-
retts together, to make them realize their true affection. All her
schooling of Oliver—her systematic deflation of his self-impor-
tance, her correction of his views on sexual love—is designed to
make him less adamant in his pride, less resentful in his rivalry,
and less afraid of his own tender feelings. If he has "grown up
with the notion that [he] always had to be number one," as he
tells us in the novel's second paragraph, Jenny has placed him
more equably among the things she loves—Bach, Barrett, the
Beatles, Mozart—in merely alphabetical order. In this chapter she
speaks virtually as that part of himself he has suppressed.
 Deciding to call the older Barretts instead of sending a negative
RSVP, she gets Oliver's father on the phone. As the conversation
proceeds she keeps putting her hand over the mouthpiece to plead
with Oliver not to say no, not to let his wounded father bleed, just
to say hello, if only for her sake; all of which Oliver rejects yet at
the same time visualizes as a psychic parable with the three of
them "just standing (I somehow imagined my father being there
as well)" waiting for him to act. When he does nothing Jenny
calls him a heartless bastard in "whispered fury," proceeds to
speak to his father for him, and provokes an "insane" reaction
from him which reveals the book's suppressed assumptions:

"Mr. Barrett, Oliver does want you to know that in his own
special way . . ." She paused for breath. She had been sobbing, so
it wasn't easy. I was much too astonished to do anything but await
the end of my alleged "message."

"Oliver loves you very much," she said, and hung up very quickly.

There is no rational explanation for my actions in the next split second. I plead temporary insanity. Correction: I plead nothing. I must never be forgiven for what I did.

I ripped the phone from her hand, then from the socket—and hurled it across the room.

"God damn you, Jenny! Why don't you get the hell out of my life!"

I stood still, panting like the animal I had suddenly become. Jesus Christ! What the hell had happened to me? I turned to look at Jen.

But she was gone.

Lacking, as Oliver says, a "rational explanation" for his actions, let us try an irrational one. To tell your father you love him "very much" is to become a sobbing woman. Having brought into the open what Oliver fears about himself, having the means of conveying that feared love ripped out of her hand, "then from the socket," Jenny of course disappears. Oliver has told her to get out of his life and she does, and not merely for the evening, but from this point onward as the living agent of his homoerotic fears and revulsions. There is something more than a touch of comedy when Oliver, searching for the woman he has "scared to death," opens the door of one of the piano practice rooms at Radcliffe and sees at the piano not Jenny but "An ugly, big-shouldered hippie Radcliffe girl" annoyed at his invasion. Repellent femininity lives, whereas from now on—the chapter is 13—the "real Jenny," the "soft one," will be dying. Yet she is there on the steps when he returns home late that night, and though vengefully deprived of love's vocal instrument, she is still good for a dying aphorism. And so, when Oliver tries to tell her he is sorry, she stops him with the quiet but now famous line, "Love means not ever having to say you're sorry."

Let us be generous and put this a cut above the "Love is a warm blanket" series from which it derives its currency for modern millions. Segal means to convey a guilt-free relation which, if it is good, contains angry outbursts without any need for fixing blame. But this kind of homely psychology for young mar-

rieds doesn't begin to contain the meaning of Oliver's violence, which reaches back to his "animalistic" hockey fights whenever his father watches him and forward to Jenny's death, and for which he cannot even forgive himself. It is about as wise as saying "never go to sleep on a quarrel" as these lovers proceed to do; and perhaps less wise than another implicit counter-aphorism from Lawrence's *Sons and Lovers,* that love means being responsible enough to say you're sorry when you've mucked things up this badly, as Walter Morel cannot do. Apologies can be abject or courageous, depending on circumstances, and it is the measure of this tale's essential shallowness that it sets up this aphorism as its pathetic trigger for the closing scene without looking closely at these or any other circumstances. Its method is the snapshot sequence, as in its own film trailer or in Oliver's locker-room album, and for this new kind of slick sentimentality snappy sayings are just right.

Fortunately there is much to learn from sentimental art even when, or especially when, it runs to shallowness. We still ponder the thumping morbidities of Edgar Allen Poe, who believed that the death of a beautiful young girl like Annabel Lee was the only theme for poetry; and we cope willingly enough with Dickens, who moved an international audience to tears with the death of Little Nell. We may want to give Segal at least passing consideration for choosing his theme with Poe's deliberation and pursuing it with Dickens' zeal for popular success. He has done his predecessors one better, moreover, by making his young girl's death the occasion for reuniting a prejudiced father and his prideful son. This new twist could be important if it means that modern readers are responding sentimentally to a new kind of family romance, one in which the role confusions of childhood may be "resolved" by a young girl's gallant sacrifice to the cause of male identity. So on to that gallant sacrifice.

Jenny's blood disorder is not apparent until Oliver graduates from law school, gets his first job, and the young marrieds try unsuccessfully to have a baby. When they go to a doctor to discover where the "insufficiency" lies, Oliver is told that it lies with Jenny. She is unable to have a baby because she is dying of a rare form of leukemia. Or perhaps she is dying because she can't have a baby. The causal sequence is blurred by questions of sterility vs.

virility, of insufficiency vs. fertility, of programmed vs. spontane-
ous sex, and of the conception of a superjock named Bozo, an
incredible 240 pound diapered infant who will chase Oliver
through Central Park shouting "You be nicer to my mother,
Preppie." Oliver hopes Jenny will keep Bozo from destroying him
for mistreating her; but as we have seen he has already destroyed
her by tearing out her telephone. Perhaps she is dying from that
curious "insufficiency."

Let me speak more plainly about the sex-myths working
through this incident. Women bleed every month, as if periodi-
cally wounded, presumably by the brutes who sleep with them;
and so, to the unconscious minds of men afraid of hurting women,
sex may seem like the cause of blood disorders. As may pregnancy,
the inflation of wombs to the point where deflation or birth must
seem like the bloody and deathly ordeal it sometimes is. Yet
pregnancy may also seem enviable to men whose love for each
other is limited by lack of issue; and the realization that they
cannot have children, or be complete women, may have some
bearing on decisions to give up one sexual role and try another.
In *Sexual Politics* Kate Millett talks about "womb envy" in
Lawrence but seems disappointed that he gave it up for penis-
worship; presumably she would approve of trading it in for some
form of penis-retaining tenderness, which seems to me what Segal
has done in killing Jenny off (Kate wouldn't like that) so that
Oliver may embrace his father and still be manly. When we ask
such questions as, "Who else can't have a baby?" and "Who else
might like to be a superjock?" among collegians of "foreign"
extraction connected with this novel, we see how this equation
after all makes a hell of a lot more sense than the apparent story.
The union of father and son is not an incidental consequence of
this remarkable young lady's life and death: it is the whole point
of the novel, a deliberate and significant revision—as we shall see
later on—of the filmscript on which it is based. But back to the
long death.

Even after its discovery Jenny's dying continues to be couched
in sexual terms. When she goes to the hospital the cab-driver
mistakes the trip for an approaching birth and the young mar-
rieds play out the illusion with him. When Oliver speeds to
Boston to ask his father for $5000 for an unexplained purpose,

his father asks if he has "gotten some girl in trouble" and Oliver says "yes." When Jenny's father arrives to live with Oliver while Jenny is dying, he copes with grief by cleaning their apartment, washing, polishing, scrubbing—activities which she describes as "not being man's work" when Oliver tries them. In her last moments she kicks Oliver out of the room so she can speak to her father "man to man"; then she calls Oliver back and asks him to climb into bed with her and hold her and dies when he does. Segal means this to be a supremely tender moment, the epitome of pure creaturely love; but it is not unlike the similarly asexual embrace in death of the drowning brother and sister in George Eliot's *The Mill on the Floss,* or the burial of Grandfather Trent in the same grave with Little Nell, or Dickens' dream of being buried in the same grave with the prototype of Nell, his wife's sister, Mary Hogarth. The embrace in death which allows forbidden love to happen while at the same time expunging and denying its occurrence is a familiar sex-myth, one which helps to explain why we never "see" these lovers go to bed together in this novel except at this point. This is the impossible homoerotic embrace, the laying of his own feminine ghost, which Oliver must undergo if he is to embrace his father without fear. If there is a birth in question in this death, it is surely his birth as a man capable of tenderness without loss of manliness.

This is of course what Segal means us to feel without looking closely at the forbidden aspects of the experience. He shows Oliver fighting his need to cry in these last moments, calling himself a "tough bastard" who never weeps. He even has Jenny tell him "to stop being sick," to stop blaming himself for her death and feeling guilty about it; but this is only more homely psychology from the wise young lady who knows that Oliver blames himself for depriving her of a musical career in Paris, and the point of this guilt is surely that Oliver wants her to die, to get out of his life as the agent of homoerotic fears he is now expunging, and that Segal too wants her to die. "In death they were not divided," says George Eliot of her loving pair; but the nice thing about this death is that they *are* divided.

The chapter which follows is not anti-climactic, then; it is the real revised, restored, redemptive climax. Inexplicably Oliver's father arrives at the hospital for the necessary confrontation.

When Oliver pushes past him into the open air outside the hospital, he follows and says "I'm sorry" at the news of Jenny's death, meaning that he regrets it and wants to offer sympathy. But Oliver brushes past that meaning to his own need for forgiveness for hating the man who made him fear the erotic impulses behind affection. "Love means not ever having to say you're sorry," he says, "Not knowing why" he says it. Then he does "what I had never done in his presence, much less in his arms. I cried." Which seems to me a happy enough ending, if a slightly dishonest one, since it covers up the frightening but very human sources of his need for forgiveness along with the very great difficulties of asking for it in this way, of reaching this point of emotional development, most of which Segal passes off as the sensitizing effect of prolonged and bravely shouldered grief. The terrible cost of role confusion in modern culture is being expressed here without really being paid. The resolution is too easy, which may be one reason why it appeals to so many people. But then not everyone has a dying girl handy for the payoff.

Leslie Fiedler tells us that an Age of Sentimentality is at hand. The popular success of *Love Story* seems to support him, though there is some question as to whether he would return the compliment. *Love Story* is too safe, too conventional in its expert blend of old and new clichés to suit Fiedler's taste for wild, marvellous and grotesque as well as sentimental effects. To meet his exuberant demands the tale would have to show Oliver growing shoulder-length hair and keeping house for Jenny's father after Jenny dies in his own father's arms; or the director of the inevitable Broadway musical would have to cast a transvestite in the role of Jenny, to give further piquancy and point to the father's objections to his son's marriage. But then I have already shown that such extravagant devices are in fact appropriate to the whole psychodrama as it stands and may even explain the novel's unforeseen success. If the author's fantasies are somehow shared by his readers, if there is something in their own experience to which these fantasies appeal, then we may be present at the birth of a sentimental sex-myth as potent for this century as the Nell-myth was for the last.

The myth is that our children know what love means, and that they will use this knowledge to embrace and save us all. Genera-

tions will be joined, role confusions will be resolved, starved affections will at last be fed. It is of course a family myth, one which derives its potency from the fact that modern millions are indeed starved for affection, confused about sexual roles, and frightened by new parent-child polarities. *Love Story* eases all these conditions with its facile wisdom and its sacrificial sop—the death of Jenny—to the real difficulties of family relations. It builds toward and delivers its one-two punch of pathetic effects with admirable tact and economy.

Back in the 1920s I. A. Richards defined a sentimental response as one which was in excess of what a given situation warranted or inappropriate to it. The response was crude rather than discriminating, and it generally disguised an inhibition of unsafe feelings through an effusion of safe ones. It seems only fair to say at this point that the affections have been as repressed and inhibited in modern times as sex was in Victorian times. In its attempt to release the affections *Love Story* is as modern as Salinger, the Beatles, and *The Strawberry Statement* can possibly make it. The new easygoing love, the diction and profanity which protect it, the converted athlete who learns what it means—such borrowings account for whatever liberation the tale affords. And yet it applies these borrowings in such narrow, poorly defined, safely old-fashioned contexts as to nullify their freshness. The rebelling athlete in *Strawberry* responds to contemporary political forces which disrupt a campus and threaten his militant beloved; the rebelling athlete in *Love Story* responds to a situation from *The Late George Apley* and *The Barretts of Wimpole Street* which affects a music student. The Beatles respond sympathetically to urban loneliness, the drug experience, and the new sexual freedom as well as the new affection; Segal responds to hockey, music, and filial piety. Salinger deals directly with sexual squalor and depicts contemporary middle class mores with satiric sharpness; Segal fakes sexuality and handles race, class, and religion as so many props and slogans. Within such vacuous and innocuous contexts the new affection threatens to become as safe and stale as its surroundings; working chiefly as a set of new clichés, it tends to trigger rather than convey the "feel" of new relations; and finally, like old-fashioned sentimentality, it invites effusions which seem far in excess of what this modest story warrants.

What seems particularly old-fashioned about *Love Story* is the idealization of its heroine. A wonder-girl like Little Nell, she is always right, always penetratingly wise, always courageous in the face of adversity, always loving and self-sacrificing. These ideal qualities are tempered by her systematic profanity by which we know she is authentic, and by her smartass putdowns of the hero by which we know she loves him. But otherwise she is the most nobly perfect young lady in popular fiction since Nell. We have only to remember that domestic saint writ small, that intrepid heroine who led Grandfather Trent across industrial England, saving him from wicked pursuers and bad habits, seeking refuge finally in a ruined Gothic Church in the country, then dying from the strain of self-sacrifice—to see that Jenny also lives and dies in accord with nineteenth-century myths of women as moral and spiritual guides for unworthy men and of young girls as the best and purest of those guides. As bumbling Oliver acknowledges: "What I had loved so much about Jenny was her ability to see inside me, to understand things I never needed to carve out in words. . . . Christ, how unworthy I felt!"

Unworthy Oliver continues nonetheless to tell us "nothing but good" about Jenny, after the old Roman maxim for the dead. Seen always from his admiring point of view, she even looks good while dominating his life exactly as his father was supposed not to do. Probably her dominance insures her appeal for many women and for men who identify with strong women and perhaps even for bumbling men; but it scarcely furthers selfless, guiltless love. Jennifer's last name, Cavilleri, was shaped by Segal from the Latin verb, *cavillor*, meaning to scoff, to jeer, to satirize. This is how Jenny treats Oliver from her opening jeer ("I'm not talking legality, Preppie, I'm talking ethics") to her final instructions on how he must behave during and after her death. By this time even Oliver may feel that the net effect of her method is to emphasize her own importance by diminishing his. This is of course the flaw in the book's attack on self-importance in men or women. Together with the flaw in its recurring attack on sexuality, a Baker, it indicates the serious limits of the new knowledge about love. However liberating and refreshing the new affection may be, it doesn't begin to meet human needs in any full or complex way.

The secret of its popular reception may be found in the spare-

ness of Segal's style. Following McLuhan's advice, he has left interstices in text and film for his audience to fill, asking them in effect to supply what they already know, to leave out what they fear, and to enjoy what they have always wanted. His reviewers have proven more than ready to comply. Though the tale is old-fashioned they have praised its contemporaneity; though the characters are mere sketches they have found them "memorable" and haunting; though neurotic sexuality is rampant they have cheered its healthy absence; and they have taken the book's pathos at face value. They have also called for vicarious involvement of the crudest kind. Thus, for one reviewer who feels "less like a reader than an unwritten Segal character, living it all out from the inside," it is not so much what Segal says "as what he leaves to the reader to grasp—between the words. In this 'Love Story' you are not just an observer." As indeed you are not, if to become an unwritten Segal character is to live out your fantasies inside the book as its signal system allows.

That a sophisticated classics professor can create an audience of such unwritten characters is interesting; but more interesting still is the fact that so many people are so willing to return with him to that stage in youthful development when they first needed a father's love and either failed to get it like Oliver, or like Jenny got more than they could handle. If this is the common denominator for the tale's appeal, then its bourgeois audience merely seeks release from fantasies indulged more directly by our far-out unisex cults, and role confusion is more widespread among us than even these blenders have imagined.

The film version of the tale argues against this interpretation. It works in several ways to shape Oliver in a more confidently masculine mold. First, it scraps the explicit theme of gentleness and shows him pushing for sexual love with Jenny against *her* fears, not his own; and simply by making Jenny visible and showing the lovers nude in bed it avoids his visual lapses in the novel. Second, it scraps the final embrace with his father and the whole issue of masculine tears; he simply delivers the punchline about love and walks on past his father to a rink where Jenny had last watched him skate and where the film had retrospectively begun. Though there is a hint of reconciliation, the chief effect is of a sad but firm putdown of the father (cast grossly as a heavy and

denied even his Peace Corps post!); *he* is the "sorry" or guilty person here and is surpassed now by his son in stoic wisdom and restraint. What we get, then, is the story of Oliver moving from strength to strength with a few timely assists from Jenny. Her death leaves him alone but intact, and its sentimental appeal rests entirely with her nobilities as his girl guide during their shortlived bliss.

This ending is at least more consistent with the title theme; it also seems less sentimental than the book's conclusion since it punishes one father—his—for not knowing what love means, after first rewarding the other—hers—with a final tearless squeeze. The theme of parental reconciliation is thus muted and the homoerotic threat which runs through the novel is largely subdued. But the novel's one-two punch is also lost along with most of its case for filial piety and the viability of tears. Segal seems to have got his own back by writing the book: he presents Oliver as a tough inflated bumbler who needs softening and deflation, casts Jenny as his all-wise sacrificial softener and deflater, gives the father finer qualities, and restores or reshapes the mutually redeeming climax which these changes invite. These restorations get him into trouble, as we have seen, but they also make the book more interesting than the film. At least it attempts a larger dream of reconciliation and a gentler form of manhood at the risk of fantasies which, for all their extravagance, bring us closer to our hidden selves.

MUSIC

12 FROM *Bruce Lohof*
The Bacharach Phenomenon: A Study in Popular Heroism

In the world of popular music, where, according to many observers, there is a great number of songs without any esthetic or social pretensions of value, the American public appreciates the truly "great" works: clever, esthetically satisfying lyrics sung to witty music. Burt Bacharach's songs satisfy all the requirements. Little wonder that he is so widely and deeply appreciated.

The story is told that in 1943, Burt Bacharach, then a lad of fifteen years, was whistling a tune while a Manhattan bus carried him to his piano lesson.

"Is that 'The Two O'Clock Jump'?" asked a young man seated next to him. He was, it turned out, Leonard Bernstein, assistant conductor of the New York Philharmonic Orchestra.

"I've never heard of you," said the callow Bacharach. But the two young musicians chatted for a while, and when the bus rolled up to Burt's stop, he got off, saying: "So long, Lenny, see you at the top."

SOURCE. Bruce A. Lohof, "The Bacharach Phenomenon: A Study in Popular Heroism," reprinted with the permission of *Popular Music and Society* from the journal *Popular Music and Society*, Volume I:1, Fall 1971. Copyright © 1971 by R. Serge Denisoff.

This pretentious augury of youth in time became prophecy fulfilled. Leonard Bernstein disembarked from that bus to become conductor of the New York City Symphony and, later, musical director of the New York Philharmonic. He has watched the ballerinas twirl to his *Fancy Free;* he has listened with millions to the music of his Broadway-come-Hollywood hit *West Side Story;* he has seen Marlon Brando mumble and stumble to the accompaniment of his score for *On the Waterfront.* He has become a widely televised lecturer-conductor, an ambassador of classical music to the court of little children, and a tousle-headed symbol of a culture that is not only *haute* but good fun as well. And what of Bacharach? For his part he has become a famous composer of popular music. More, he has become a national idol. He is for his time what Stephen Foster, Irving Berlin, George Gershwin, and Cole Porter were for theirs. He is, as one news magazine put it in its cover story of him: "The Music Man 1970."[1]

How does a callow lad grow into a Music Man? Composers these days must sing their own praises if they would be famous. Moreover, they must sing them drenched in the day-glo of strobe lights and psychedelia (e.g., the Beatles and Bob Dylan). The others—Sammy Cahn, Henry Mancini, *et al*—continue to receive about as much public acclaim as a group of certified public accountants. How is it, then, that in this setting Burt Bacharach, tunesmith, would become a national idol? What are the contours of the Bacharach phenomenon? And what do they tell us about the stuff of which popular heroes are made?

That Bacharach is a popular hero is no longer open to question. Students of hero-worship have long since charted the genetic process by which heroes are born, and Bacharach has definitely entered the sequence. Two decades ago Orrin Klapp designated "the main phases of this process . . . as follows: (1) spontaneous or unorganized popular homage, (2) formal recognition and honor, (3) the building up of an idealized image or legend of the hero, (4) commemoration of the hero, and (5) established cult." Klapp hastened to remind his readers that all heroes need not pass through the entire sequence.[2] But Bacharach is already on his way.

Popular homage takes a variety of forms. Charles Lindbergh's

heroism began at Orly Field when thousands of Frenchmen dragged him bodily from "The Spirit of St. Louis" and carried him upon their shoulders for nearly a half hour. The heroism of the brothers Kennedy was born in the frenzied mobs that thronged to touch and see them. The homage paid to athletes and actors is measured at the box office. So too, in a manner of speaking, is that paid to Burt Bacharach. At age forty-two he is, by pecuniary standards, the beneficiary of popular homage. The people have deigned to turn more than two dozen of his songs into hits.[3] A single artist, Dionne Warwick, has sold more than twelve million copies of Bacharach tunes. One of his songs, "Raindrops Keep Fallin' On My Head," has sold three million recordings and nearly a million copies of sheet music. Bacharach commands $35,000 per week for concerts. He owns a lucrative share of the company which produces his recordings and all of the publishing house that sells his music. In a land and business where popular homage is gauged in dollars, Bacharach is a wealthy man.[4]

Formal recognition and honor began in 1970. In March, Bacharach received two "Oscars" from the American Academy of Motion Picture Arts and Sciences, one for the musical score of *Butch Cassidy and the Sundance Kid*, the other for a song from that score, "Raindrops Keep Fallin' On My Head." A month later the National Academy of Recording Arts and Sciences awarded him two "Grammies," one for the score of *Butch Cassidy and the Sundance Kid*, the other for the recorded soundtrack of his Broadway hit, *Promises, Promises*. Continued formal recognition of Bacharach can be confidently predicted.

Following in the train of spontaneous homage and formal recognition—and in keeping with Klapp's sequence of hero-development—is the evolution of a Bacharach *image and legend*. The Bacharach of the flesh is, of course, an unknown quantity. This is true, certainly, of all public figures. But it is doubly true of Bacharach, for his is an occupation that usually dictates obscurity, leaving the limelight to those who perform the music. (It is interesting to note, for example, that Bacharach's lyricist partner Hal David remains a completely obscure figure.) The public's ignorance of the real Bacharach makes the evolution of a consumable Bacharach necessary, for heroes can be mysterious

or enigmatic, but never intangible. It also makes such an evolution easy, for little of the real Bacharach exists to erase or contradict.

The consumable Bacharach is partially an image. We know, for instance, that he is erotically handsome. "Burt has turned out to be a sex symbol," producer David Merrick has been quoted as saying.[5] We know also that in matters both tonsorial and sartorial he is impeccably disheveled, studiously unkempt, casually "in." Still another part of the image looms large in his concerts, live or televised: the calisthenic nature of his musical conducting style, complete with karate chops to the percussion section, blurring fingers in the direction of the woodwinds, lightning body swivels from one piano to another. Each of these pieces of the Bacharach image is, moreover, caught in the stop-action portrait that image makers have used as a signature for his televised concerts.[6] The erotic good looks, the tousled hair and casual clothing, the calisthenics—all of it is there, captured forever like the maiden running across Keat's Grecian urn.

But the consumable Bacharach is also partially legend. And the Bacharach legend, like all heroic epics, takes a familiar form. We nod in recollection at the Alger-come-vaudeville flavor of Bacharach's odyssey in the borscht circuit. Working in a Catskills hotel with a quintet for forty dollars a week (for the quintet, that is), sleeping bunkhouse-style in a chicken shack across the road from the hotel. "We couldn't go home," the legendary Bacharach remembers. "The city meant polio in those days. We were like prisoners. One morning we woke up to fire engines. The hotel had burned down. We cheered."[7] Surprise and then reassurance rolls over us as we discover that Bacharach's Penelope is Angie Dickinson the actress. We knew and loved her when he was Mr. Angie Dickinson, "Magic Moments" was a Perry Como song, and Gene Pitney was singing "The Man Who Shot Liberty Valance." Finally, we thrill to the revelation that Bacharach has been an arranger and accompanist for Vic Damone, the Ames Brothers, Steve Lawrence, and most important, Marlene Dietrich. Dietrich, of course, is more than a hero; she is a goddess. And Bacharach's intimacies with her constitute an important part of the Bacharach legend. Like Odysseus before him, whose mythic sponsor was Athene, Bacharach has been touched by the Olympians. "She's

the most generous and giving woman I know," he has said of Dietrich. "If I had a cold she'd swamp me with vitamin C. She once pulverized six steaks for their juice to give me energy. She used to wash my shirts."[8] Could Odysseus have said as much? Bacharach still wears a talisman around his neck as a sign of his Olympian connections: a Dior plaid mohair scarf some twelve feet long. The scarf was given to him by Dietrich while he accompanied her on the international concert stage. "When I arrived in Poland to meet Marlene, she was waiting for me, in a snowstorm, at the airport with this scarf, so I'd be warm." Attesting to the acceptance of the talisman, Bacharach has said: "I can't wear bizarre clothes . . . but anything Marlene gave me always felt sensible and right."[9]

The consumable Bacharach, then, exists. Partly image and partly legend, it qualifies as fulfillment of Klapp's third criterion of American heroes. What of the final criterion, commemoration and cult establishment? Already Bacharach fan clubs have begun. But history, the fans, and Bacharach will have to wait. Total heroism, one suspects, will come only after a fiery death by automobile (a la James Dean) or airplane (a la Will Rogers), followed—after a respectable period of mourning—by the issuance of a commemorative stamp. Bacharach is doubtless reluctant to follow through. In any case, Klapp insists that it is not mandatory. Bacharach is already a heroic figure, born of genetic processes with which hero-watchers are familiar.

If the Bacharach phenomenon mirrors a generic form of hero-making, it also mirrors a generic form of hero-being, for the constituent parts of Bacharach's hero status are typical of heroism generally. For instance:

Hero-making situations.[10] Heroes, like bacteria, live best in congenial environments. The hero's Petri dish may be a grand political or military crisis, some stupendous scientific achievement, a mere theatrical or sporting event. Indeed, any situation is hero-making if it focuses public attention upon some unmet need. Burt Bacharach lives in such an environment. The world of popular music receives a constant glare from the public eye. Americans spend more than a billion dollars annually on recorded popular music. The demand for popular tunes is insatiable, the locale ubiquitous. Moreover, Americans have what Daniel Boor-

stin calls "extravagant expectations" with respect to music (and everything else). The music must not only keep coming, it must be original and stimulating. The latest tune must also be the greatest tune.[11] The composer becomes Sisyphus in a spotlight, forever rolling his rock through the glare of public attention toward an unmet need. His situation is truly heroic.

Heroic role. But situation does not a hero make. He must rise to the occasion by fulfilling one of many heroic roles. He must become a conquering hero (Beowulf or Babe Ruth) or a Cinderella (David [of David-and-Goliath] or Charles Lindbergh), a clever hero whose brains triumph over brawn (Br'er Rabbit), an avenging hero (James Bond), a benefactor (Robin Hood), or a martyr (Joan of Arc).[12] Bacharach's manner is too soft for him to play the conqueror, too shy to play the avenger. Nor is he a man given to beneficence or martyrdom. Like many American heroes—molded as they are in the Algeresque tradition—Bacharach is a Cinderella, a "dark horse" who has made good. His legend fits the typical pattern: obscure origins, "instant" success in his late thirties after decades of hard work and meager rewards.[13] Even in success he is the Cinderella man surmounting adversity. Legend has it that when *Promises, Promises* was in Boston preparing for Broadway it was decided that another song would be needed. Bacharach—haggard from a bout with pneumonia that had put him into the hospital—and David wrote the song in a single day. It entered the show immediately. Sick men do not write good songs in a single day. But heroes do. The tune —"I'll Never Fall in Love Again"—was later recorded by Dionne Warwick and spent eleven weeks on the hit record charts.[14]

"Color." "The quality of 'color,' " says Klapp, "seems to be in actions or traits which excite popular interest and imagination."[15] "Color" is a paler shade of charisma, and heroes—Bacharach included—have it. "Color" is Muhammad Ali's circling style of pugilism and his doggerel style of poetry. "Color" is the way John Kennedy said "viga'," the way Bobby nervously fought his tousled locks, and the way every Kennedy played touch football. "Color" exudes also from the properties of heroes: Roosevelt's cigaret holder and Churchill's cigar, King Arthur's Excalibur and Patton's pearl-handled pistols, Christ's seamless robe and Linus's filthy blanket. Bacharach's "color" is, of course, found in

his image and legend. His handsome features, his clothing, his style of musical conducting, the stories which surround him—all lend that necessary ingredient to the heroism of Burt Bacharach.

But Bacharach's most precious and "colorful" possession is his music. "There are times," an official Bacharach biography says, "when a valuable suggestion is dropped into the mind of a budding composer that remains with him. . . . Burt Bacharach . . . has never forgotten the advice of one of his music tutors, 'Don't be afraid of writing something people can remember and whistle.' "[16] This is a curious anecdote to find in a Bacharach publicity packet, for Bacharach songs cannot be whistled by the man in the street. Indeed, many professional performers sing his music only with great difficulty.[17] His songs are complex and sophisticated. Most popular music is written to formula—3/4 or 4/4 time, 8-bar phrases and a 32-bar song. This fact explains the popular composer's ability to meet the outrageous demands of an insatiable listening public.

But Bacharach rejects such formulae. Regular rhythms seem to bore him. In one passage of "Promises, Promises," for instance, he moves from 3/4 time to 4/4, 3/4, 5/4, 3/4, 4/4, 6/4, 3/4, 4/4, 6/4, 3/4, 3/8, 4/8, 4/4, 5/4, and back to 3/4. For toe-tappers the results are discouraging; they are also exciting and unpredictable. Nor does Bacharach suffer from the 8-to-the-bar syndrome. Some of his music—e.g., "Are You There (With Another Girl)," written in 6-bar phrases—is orthodox but unconventional. Other songs, such as "The Look of Love" and "I Say a Little Prayer," pretend orthodoxy, but a rambunctious urgency punctuates them with an occasional measure of 2/4 time. Still other pieces are written with formal rhythms, but only, it would seem, to keep the band together. The phrases, musical and lyric, have patterns and pulses of their own. Listen, for example, to "A House Is Not a Home," "The Windows of the World," or "Make It Easy on Yourself." Phrasing dictates rhythm, not vice versa, as is the case in formulaic tunes.[18] And there are other idiosyncrasies. Music critic Charles Champlin has said it well: "He has a way of doing unconventional things with time, with the length of a phrase, with chord patterns and the logic by which one note follows another."[19] There is, in short, a Bacharachian flavor to his

music, a distinctive spirit which, without making them all sound
alike, stamps each of his songs with the Bacharach mark. And
the musical mark is, of course, part of the Bacharach "color."
To think of him without his music is to see him in two dimen-
sions, without his graying temples, his soft voice, his Dietrich
scarf. To watch and hear Bacharach performing his music is to
see him literally in living "color."

Personal traits. Klapp has written that the personal habits and
characteristics of heroes are relatively unimportant to their hero-
ism. "Distance," he says, "builds the 'great man,' " and distance
stands as a buffer between the intimacies of the hero from the
curiosities of his worshipful millions.[20] Still, any personal traits
which an attentive public is able to perceive may abet the hero's
greatness, especially when they are consistent with the heroic role
he has taken and the "color" which cloaks him. Babe Ruth,
whose heroism grew from his baseball bat, was the more awesome
a figure after scientists proved his eye-hand coordination to be
superior to that of most humans. Such is also the case with Bach-
arach. To the extent that we know the Bacharach of the flesh,
we find him consistent with the consumable Bacharach.

We know, for instance, that he is a tireless musician consumed
by his work. Each of his television programs gives us a glimpse
of his working day—the creation, movieola at his side, of a mo-
tion picture score; the production, Dionne Warwick at his side,
of another hit record. We know him to be a perfectionist who
drives his musicians like a plantation overseer drives his slaves;
and we know (or at least we've been told) that they dote upon
him in spite of it. It is important that heroes be dedicated to
the root base of their fame, and Bacharach is dedicated to his
music.

But we know also something of his private life. His marriage
to Angie Dickinson, and their daughter, Lea Nikki, born in 1967,
contribute substantially to his heroism. Bacharach is everyman,
writ large. Like us, he has a family, but it is a hero's family, made
of finer stuff. We know also that the Bacharachs live in a luxuri-
ous but rented home in Beverly Hills. Nothing could be more
proper. It may be well for ancient heroes to reside in temples of
stone. Their world is static. But the world of popular music is a
popping, whirling scene. Action is its essence. Thus the sumptu-

ous but rented temple is appropriate to its great man. "I'm an impatient man," says Bacharach. "I go one month at a time. That's why Angie and I rent the house. I couldn't wait for one to get built."[21]

So it is that a tunesmith becomes a popular hero. Popular homage turns into formal recognition. Image and legend is constructed, commemorated, and cultified. So it is that a tunesmith stays a hero. A hero-making situation, a heroic role, "color," and compatible personal traits—this is hero stuff. Moreover, this is hero stuff for great men both popular and classical, for Beowulf and Mickey Mouse, Christ and Kennedy.

Still, there is a crucial distinction. Popular heroes are not classical heroes. Peanuts is not Achilles. Greta Garbo was an awesome hero, but no more. Her heroism, like the heroism of all popular idols, was but an eyeblink as compared to the history of the Odysseus cult. Popular heroes are different from classical heroes, and the distinction is symbolized by Bacharach's rented mansion in Beverly Hills. Bacharach is a rented hero. Like Bacharach, the millions who heroize him are impatient men who "go one month at a time." They, too, live in a popping, whirling scene. The man who would be smitten by their worship must be a moving target.

Until yesterday humankind lived in an arrested, static world. To be heroic in the eyes of the ancients was to personify the values of an arrested culture. But the pace of change has accelerated. To an ancient hero, to *stand* for something, is, in our electronic universe, to be obsolete. To be a man for all seasons is to be old-style. Modern heroes last one season at most. To be a newstyle hero is not to *stand* for something, but to *move* for something. Bacharach is a newstyle hero in a newstyle world. The Bacharach phenomenon is a study in motion, a reflection of the frenetic nature of time since yesterday. Bacharach is a popular hero, finally, because he is a moving hero.

NOTES

1. Hubert Saal, "Burt Bacharach, The Music Man 1970," *Newsweek*, June 22, 1970, pp. 50–54.

2. Orrin E. Klapp, "Hero Worship in America," *American Sociological Review*, XIV (February, 1949), p. 54. See also Klapp, *Heroes, Villains, and Fools* (Englewood Cliffs, 1962).

3. Among Bacharach's hit songs are: "Any Day Now," "Tower of Strength," "You're Following Me," "The Man Who Shot Liberty Valance," "Magic Moments," "Don't Make Me Over," "Make It Easy on Yourself," "Only Love Can Break a Heart," "Blue on Blue," "True Love Never Runs Smooth," "24 Hours from Tulsa," "Anyone Who Had a Heart," "Wishin' and Hopin'," "Walk on By," "Reach Out for Me," "I Wake up Cryin'," "Don't Envy Me," "(There's) Always Something There to Remind Me," "Trains and Boats and Planes," "What the World Needs Now Is Love," "The Windows of the World," "I Say a Little Prayer," "Raindrops Keep Fallin' on My Head," "I'll Never Fall in Love Again," "Wives and Lovers," "A House Is Not a Home," "Send Me No Flowers," "What's New, Pussycat," and "Alfie." See American Society of Composers, Authors and Publishers, *The ASCAP Biographical Dictionary of Composers, Authors, and Publishers*, 3rd ed. (New York, 1966), pp. 26–27.

4. Data are from Saal, pp. 50, 53.

5. Quoted in *ibid.*, p. 50.

6. The stop-action image first appeared in "An Evening with Burt Bacharach," *Kraft Music Hall*, N.B.C. Television, 1970, and reappeared in "Another Evening with Burt Bacharach," *Kraft Music Hall*, N.B.C. Television, 1970.

7. Quoted in Saal, p. 52.

8. Quoted in *ibid.*, p. 53.

9. Quoted in "Composer in Tartan Cap," *The New Yorker*, 44 (December 21, 1968), p. 27.

10. This and other characteristics of heroes mentioned below are discussed in Orrin E. Klapp, "The Creation of Popular Heroes," *American Journal of Sociology*, LIV (September, 1948), pp. 135–41.

11. See Daniel J. Boorstin, *The Image: A Guide to Pseudo-Events in America* (New York, 1961), pp. 3–6, 171–78.

12. See Klapp, "Creation of Popular Heroes," pp. 136–37.

13. Leo Lowenthal's content analysis of 168 popular biographies found "hardship" antedating success in so many careers that the "troubles and difficulties with which the road to success is paved are discussed in the form of stereotypes. Over and over again we hear that the going is rough and hard. . . . Defeat or stalemate [are reported] in matter-of-fact tone, rather than [as] descriptions of life processes." "Biographies in Popular Magazines," in William Peterson, ed., *American Social Patterns* (Garden City, 1956), pp. 93–94.

14. Saal, p. 53; "Composer in Tartan Cap," p. 27.

15. Klapp, "Creation of Popular Heroes," p. 137.

16. [A&M Records], "Burt Bacharach (A Biography)," (mimeograph press release, Hollywood, n.d.).

17. Saal quotes Warwick: "You've practically got to be a music major to sing Bacharach"; and Polly Bergen: "I did 'A House Is Not a Home' recently —a great song. But I never did get the timing. I made them write it so I could end up with the band—regardless of how I got lost along the way, and did I ever." p. 51.

18. For the sake of convenience, all of these examples are drawn from two albums: *Burt Bacharach: Reach Out* (A&M 131) and *Burt Bacharach: Make It Easy on Yourself* (A&M SP4188). Bacharach composed, arranged, and conducted all of the music on these albums.

19. Liner notes for *Burt Bacharach: Make It Easy on Yourself*.

20. Klapp, "Creation of Popular Heroes," p. 138.

21. Quoted in Saal, p. 54.

13 FROM *Tom Gearhart*
Jesus Christ Superstar: A Turning Point in Music

The only really remarkable thing about Jesus Christ Superstar is that it was not composed before. The subject was ideal. Yet when Tommy (its lesser-known predecessor) and Jesus Christ Superstar, with its curious history of composition, was finally produced, cries of outrage and blasphemy filled the air at first. Greater familiarity, however, produced more appreciation, with the conclusion that this rock opera is truly a remarkable experience in the world of popular music.

SANNA HO SANNA HEY SUPERSTAR

I was born and reared a Roman Catholic, went to Catholic elementary and high schools, and I was told about Jesus—at Mass, in religion classes, at CYO dances. I wanted to be his friend.

SOURCE. Tom Gearhart, "Jesus Christ Superstar: A Turning Point in Music," Sec. C, pp. 1, 2, 4. Reprinted from *The Blade*, Toledo, Ohio, May 2, 1971.

In the grade school choir I sang his praises, while as a torch-bearer and acolyte I participated in the Mass itself. Along about the third or fourth grade, after long rehearsals and much praying, a great honor was bestowed upon me: I became an altar boy.

If there are cherubs here on earth, then surely I was one—a small, red-cheeked boy with a Hopalong Cassidy tie tucked under my cassock and surplice. I went to confession often, received Holy Communion daily, and cared deeply about the parish priests—mixing their incense, pouring their wine, clanging the bells at the Consecration. And doing it all gladly in the name of this Jesus they had so often told me about.

But I also remember something that my first-grade teacher had told us one morning during religion instruction, and it haunted me throughout my pristine childhood. She told us that we had better not die with a mortal sin on our souls, because if we did, at the Last Judgment our faces would turn black in fear of meeting God. Of meeting Jesus.

Those words troubled me terribly, with the result that I never could focus my feelings toward Jesus very clearly. Was my desire to please him attributable to love or wordless fear? Was he a benevolent Saviour, or was he waiting for me to trip up, just once, then snatch me away for good and abandon me in flames?

I finally gave up searching for answers to these questions, deciding instead that Jesus was, if not an ogre, then certainly not the kind of person you'd sidle up to and exchange confidences with. You're not supposed to fear a friend.

The notions of a first-grade teacher notwithstanding, it is time to resume the search. It is time to inquire into lost and long-ago relationships, to ask more questions. Was Christ on earth a sometimes reluctant Saviour who also suffered his share of uncertainty and doubt? Was he as human and in need of a friend as you and I?

That is the proposition put forth in "Jesus Christ Superstar." Two Englishmen, composer Andrew Lloyd Webber and librettist Tim Rice, have fashioned a rock opera that retells the story of the Passion with immense feeling and power, revealing Christ to be a person who, like modern man, is trapped in doubt and mortally afraid that he has no legacy to leave.

But Webber and Rice also paint him as a man with sensitivity

and the courage to believe in himself in the face of frightful odds. And in the end, Christ surfaces as a hero, as a Superstar.

RELEVANT AND IRREVERENT

Considering the sacred nature of the subject, "Superstar" could have been a colossal flop, a sophomoric rock-'n'-roll venture that would only rouse the ire of Christians everywhere crying blasphemy. That it emphatically is not is evidenced in the opera's overwhelming popularity since its release. It has racked up more than $1 million in sales, and most radio stations in the country arc playing its refrain.

But the real measure of "Superstar's" success is in the variegation of the music and the contemporary wisdom of the lyrics. Eleven characters, backed by an 85-piece orchestra and several choirs, unravel the story of Christ's last three years on earth, using a broad range of rhythmic forms, from baroque to soul, from electrifying rock to bawdy vaudeville: ya-ya girls fading into Fillmore East fading into booming overtures, etc.

If there is one thing that distinguishes Webber's score, it is melody. Whether heralding the majesty of the "King of the Jews" with lush orchestral flourishes, or pondering his grief in the Garden of Gethsemane with low choral moans, the music spins with such good, gorgeous melody that it is hard not to carry the songs with you long after hearing them.

Although Jesus occupies center stage in the two-record pop opera, the other players are well-characterized, and each has a chance to present his own point of view in Rice's brilliantly relevant, and often irreverent, libretto.

Judas is not the blank-faced betrayer of the New Testament, but a throbbing human who, while accusing Christ of having too much ambition, is tormented by odd stirring of emotion for this strange man. Solicitously Judas, transported, counsels:

> *"You'd have managed better if you had planned,*
> *Why'd you choose such a backward time and such a strange*
> *land?*

If you'd come today you would have reached a whole na-
tion,
Israel in 4 BC had no mass communication."

In a rollicking barroom ditty, Herod, the Establishment fat cat, challenges the great Jesus Christ to "walk across my swimming pool." And Pontius Pilate, an obvious victim of circumstances, tosses fitfully over the question of whether to condemn the broken King to the cross. He dreams seeing "thousands of millions crying for this man, and then I heard them mentioning my name . . . and leaving me the blame."

Such vivid description puts new faces on characters who have become all too tired and familiar, and revitalizes the gospels in a way that no updated Gideon could. In "Superstar," the apostles no longer are bearded reflections on a kitchen wall, but know the value of laughter and companionship, getting plastered at the Last Supper and singing, "Then when we retire we can write the gospels, so they'll talk about us when we've died."

Even the crowd, Jesusmaniacs all, has a personality, They are movie house popcorn-munchers, smug in their belief that Christ, like John Wayne, will "escape in the final reel," and copy-hungry sports writers asking Jesus, "Do you plan to put up a fight? Do you feel you've had the breaks? What would you say were your big mistakes?"

Aside from Ian Gillian's portrayal of Jesus, the most penetrating performance is by Yvonne Elliman as Mary Magdalene. When she sings "I Don't Know How To Love Him," the confusion of emotion which Mary Magdalene feels toward Christ—pain, bewilderment, and melancholy love—is exquisitely transmitted and touches deeply.

And there is Jesus. Jesus with beckoning eyes and a troubled brow, suddenly a human, with human instincts and foibles. "There's too little of me," he cries to the crowd begging to be healed.

His supreme agony at Gethsemane is beautifully conveyed by Gillian, baring the heart and spirit of a lamenting Redeemer. "I'm not as sure as when we started," Jesus says to God, and: "You're far too keen on where and how and not so hot on why."

Christ is capable of vanity as well, and greedy. "Would I be

more noticed than I ever was before? What will be my reward?"

As his emotions pitch and roll within him, he hesitates, and points angrily to the crowd. "I must be mad thinking I'll be remembered—yes, I must be out of my head! Look at your blank faces! My name will mean nothing 10 minutes after I'm dead!"

But finally he succumbs, in weariness and near despair. "I will drink your cup of poison, nail me to your cross and break me. Bleed me, beat me, kill me, take me now—before I change my mind."

ON RECORD

"Jesus Christ, Jesus Christ, Who are you, what have you sacrificed?"

"Superstar" is a historic occasion in music, begging to be staged and brought before live audiences.

The altar boy of years past feels a flicker of recognition in the Jesus Christ seen by Webber and Rice.

And if "Superstar" provides no answers, at the very least it assures him that many are asking the same questions.

14 FROM *Boris Nelson*
Jesus Christ Superstar

". . . in this modern piece the suffering of Christ is seen with more human insight and the figure of the Redeemer is brought even more closer to mankind than through the Holy Scriptures."

Although RAI, the Italian Broadcasting Company, has banned the hit rock opera, "Jesus Christ Superstar," as "too irreverent

SOURCE. Boris Nelson, "Jesus Christ, Superstar," Sec. C, pp. 1, 4. Reprinted from *The Blade*, Toledo, Ohio, May 2, 1971.

in tone," Vatican Radio has played excerpts from this fantastic, outrageous, sensitive, and amazingly human rock opera which is both serious and successfully contemporary.

Even more so, it is reverent in its own way, and it won't do at all to dismiss it because it uses a vernacular not yet in the dictionary nor in the musicological texts.

Already a gold disk for having sales in excess of $1 million, the very idea of taking the Passion of Jesus Christ, the very foundation of Christianity, and turning it into something less than standard and traditional musical theology has shocked a good many, well-meaning people.

But it really should not, for even Bach's Passions, with their theatricalities, were then frowned on as unorthodox, but today we admire them just for their impact however achieved.

In a like manner, "Superstar" makes an impact, shocks at first hearing.

Composer Andrew Lloyd Webber, 22, and librettist Tim Rice, 26, spent some 400 hours in English recording studios with an 85-piece orchestra, 11 rock singers, 3 choruses, an additional assortment of jazz and rock musicians, and a Moog synthesizer to put together what will undoubtedly be a turning point in the history and development of music.

It is a sophisticated collage not only of rock rhythms and ballads, but also of themes of narration, dramatic interludes, gospel blues, and even a quite obviously operatic march, "Hosanna."

What is simply good music is the composer's frank melody in 5/4 time (the Mary Magdalene theme), which is subsequently transformed and hardened up, sung in its new versions by both Jesus and Judas.

Quite ingenious is the number, "Moneylenders and Merchants."

I mention only these—there are many more instances of Webber's provocative tunes to Rice's sensitive, to-the-point lyrics. They represent without any doubt whatever a positive approach to maturity in rock music.

What concerns me most, however, after repeated listening—which admittedly I did not find easy at all—are two questions.

The range of rock is enormous. It can be sophisticated and brutally raw and romantic and gutsy. Its fans are devoted to each

with violently visceral dancing, an uninvolved social dancing that is at the same time a personalized explosion of emotions and drives and, yes, sex.

But its range of endurance, except for its communication, has been very short-lived.

To be sure, rock, as nothing else, reflects our somewhat disjointed world that teeters from fear to worry, from frenzy to chaos, and tries to cope with the strains and feelings that an ever faster pace seems to rage among us.

Is "Superstar" another passing fancy which has, like a good opera must have, its own set of theatricality?

One can only look forward with eagerness to its forthcoming presentation on stage, which might tell if all of it is as serious, as "religious," as it sounds on the splendid Decca recording.

For I feel a great disparity in the music as to what might best be called "inspiration" and the other kind, "fashioned."

In other words, in some places the seams are showing.

Traditional opera buffs who listen to "Superstar" should not be surprised to recognize quite traditional operatic practices, such as Judas, the villain—which Murray Head, incidentally, sings with "chilling effectiveness"—or the choir chanting of Judas' murderous treason, or Pilate (sung by Barry Dennen) as the epicene of the cast of historical figures, or Herod (Mike d'Abo) in a ragtime mockery of Jesus, "King of the Jews," or the finale chorus: "Jesus Christ, Jesus Christ, who are you? What have you sacrificed? Jesus Christ Superstar, do you think you're what they say you are?"

The other problem is, of course, theological, a field which no one in his right mind would argue. Yet, the lyrics—startlingly contemporary and sung with unusual clarity (hard rock in its volume usually makes the words completely incomprehensible unless you know them ahead of time)—make it mandatory that we look at their meaning.

This is not the Bible Jesus. He emerges here, doubting his own work, a superstar surrounded by manipulators, sycophants, exploiters, a modern man wondering about the possibility of faith, alone to ponder the whys of life, silent in doubt. He isn't even sure at the end if his sacrifice is worth it.

Thus this Jesus is very much human and questionably divine.

Jesus is a cool cat, but astonishingly magnetic without explanations, without answers, yet commanding the mysterious awe with which civilization has from the very beginning regarded the Jesus story. Is "Superstar," then, religious in intent? Definitely! But how many of the "older" generations will accept it as such, aside from its unusual musical score?

The program director for Vatican Radio, Jesuit Father Joseph Pelligrino, said extracts from the rock opera were aired "because in this modern piece the suffering of Christ is seen with more human insight and the figure of the Redeemer is brought even closer to mankind than through the Holy Scriptures."

(Vatican Radio broadcast portions of "Superstar" on one of its new programs which features popular music and personalities.)

And yet, with ever more rock groups and tunes appearing in churches and attracting young people, is "Superstar" any worse or better than the gyrations of a Berio or a Stockhausen, whose cosmological electronics are conproven to be?

For those who might want to catch it "live," the American Rock Opera Company will present the work in concert form— the opera will not be staged, although there will be simple choreography—at Detroit's Cobo Hall on Thursday, May 13, at 8:30 p.m. The company includes a cast and chorus of 40 members.

Like rock or not, like a contemporary version of the Jesus story or not, my frank puzzlement and frank appreciation of "Superstar" suggests this advice: Listen to the album, and not just once, and then judge for yourself. Don't deny the validity of the form, but rather feel the quality of its touch.

MOVIES

In any given year—perhaps decade—one movie stands out as the best of the time. Such a movie was Bonnie and Clyde. *Although criticized by some, it was generally praised as a fine film that somehow managed to achieve its full potential.*

How do you make a good movie in this country without being jumped on? *Bonnie and Clyde* is the most excitingly American American movie since *The Manchurian Candidate.* The audience is alive to it. Our experience as we watch it has some connection with the way we reacted to movies in childhood: with how we came to love them and to feel they were ours—not an art that we learned over the years to appreciate but simply and immediately ours. When an American movie is contemporary in feeling, like this one, it makes a different kind of contact with an American audience from the kind that is made by European films, however contemporary. Yet any movie that is contemporary in feeling is likely to go further than other movies—go too far for some tastes —and *Bonnie and Clyde* divides audiences, as *The Manchurian*

SOURCE. Pauline Kael, "Bonnie and Clyde," From *Kiss Kiss Bang Bang* by permission of Atlantic, Little, Brown & Co. Copyright © 1967 by Pauline Kael, pp. 47–63.

Candidate did, and it is being jumped on almost as hard. Though we may dismiss the attacks with "What good movie doesn't give some offense?," the fact that it is generally *only* good movies that provoke attacks by many people suggests that the innocuousness of most of our movies is accepted with such complacence that when an American movie reaches people, when it makes them react, some of them think there must be something the matter with it—perhaps a law should be passed against it. *Bonnie and Clyde* brings into the almost frighteningly public world of movies things that people have been feeling and saying and writing about. And once something is said or done on the screens of the world, once it has entered mass art, it can never again belong to a minority, never again be the private possession of an educated, or "knowing," group. But even for that group there is an excitement in hearing its own private thoughts expressed out loud and in seeing something of its own sensibility become part of our common culture.

Our best movies have always made entertainment out of the anti-heroism of American life; they bring to the surface what, in its newest forms and fashions, is always just below the surface. The romanticism in American movies lies in the cynical tough guy's independence; the sentimentality lies, traditionally, in the falsified finish when the anti-hero turns hero. In 1967, this kind of sentimentality wouldn't work with the audience, and *Bonnie and Clyde* substitutes sexual fulfillment for a change of heart. (This doesn't quite work, either; audiences sophisticated enough to enjoy a movie like this one are too sophisticated for the dramatic uplift of the triumph over impotence.)

Structurally, *Bonnie and Clyde* is a story of love on the run, like the old Clark Gable–Claudette Colbert *It Happened One Night* but turned inside out; the walls of Jericho are psychological this time, but they fall anyway. If the story of Bonnie Parker and Clyde Barrow seemed almost from the start, and even to them while they were living it, to be the material of legend, it's because robbers who are loyal to each other—like the James brothers—are a grade up from garden-variety robbers, and if they're male and female partners in crime and young and attractive they're a rare breed. The Barrow gang had both family loyalty and sex appeal working for their legend. David Newman and Robert Benton,

who wrote the script for *Bonnie and Clyde,* were able to use the knowledge that, like many of our other famous outlaws and gangsters, the real Bonnie and Clyde seemed to others to be acting out forbidden roles and to relish their roles. In contrast with secret criminals—the furtive embezzlers and other crooks who lead seemingly honest lives—the known outlaws capture the public imagination, because they take chances, and because, often, they enjoy dramatizing their lives. They know that newspaper readers want all the details they can get about the criminals who do the terrible things they themselves don't dare to do, and also want the satisfaction of reading about the punishment after feasting on the crimes. Outlaws play to this public; they show off their big guns and fancy clothes and their defiance of the law. Bonnie and Clyde established the images for their own legend in the photographs they posed for: the gunman and the gun moll. The naïve, touching doggerel ballad that Bonnie Parker wrote and had published in newspapers is about the roles they play for other people contrasted with the coming end for them. It concludes:

> *Someday they'll go down together;*
> *They'll bury them side by side;*
> *To few it'll be grief—*
> *To the law a relief—*
> *But it's death for Bonnie and Clyde.*

That they did capture the public imagination is evidenced by the many movies based on their lives. In the late forties, there were *They Live by Night,* with Farley Granger and Cathy O'Donnell, and *Gun Crazy,* with John Dall and Peggy Cummins. (Alfred Hitchcock, in the same period, cast these two Clyde Barrows, Dall and Granger, as Loeb and Leopold, in *Rope.*) And there was a cheap—in every sense—1958 exploitation film, *The Bonnie Parker Story,* starring Dorothy Provine. But the most important earlier version was Fritz Lang's *You Only Live Once,* starring Sylvia Sidney as "Joan" and Henry Fonda as "Eddie," which was made in 1937; this version, which was one of the best American films of the thirties, as *Bonnie and Clyde* is of the sixties, expressed certain feelings of its time, as this film expresses certain feelings of ours. (*They Live by Night,* produced by John Houseman under the aegis of Dore Schary, and directed by Nicholas

Ray, was a very serious and socially significant tragic melodrama, but its attitudes were already dated thirties attitudes: the lovers were very young and pure and frightened and underprivileged; the hardened criminals were sordid; the settings were committedly grim. It made no impact on the postwar audience, though it was a great success in England, where our moldy socially significant movies could pass for courageous.)

Just how contemporary in feeling *Bonnie and Clyde* is may be indicated by contrasting it with *You Only Live Once* which, though almost totally false to the historical facts, was *told* straight. It is a peculiarity of our times—perhaps it's one of the few specifically modern characteristics—that we don't take our stories straight any more. This isn't necessarily bad. *Bonnie and Clyde* is the first film demonstration that the put-on can be used for the purposes of art. *The Manchurian Candidate almost* succeeded in that, but what was implicitly wild and far-out in the material was nevertheless presented on screen as a straight thriller. *Bonnie and Clyde* keeps the audience in a kind of eager, nervous imbalance— holds our attention by throwing our disbelief back in our faces. To be put on is to be put on the spot, put on the stage, made the stooge in a comedy act. People in the audience at *Bonnie and Clyde* are laughing, demonstrating that they're not stooges—that they appreciate the joke—when they catch the first bullet right in the face. The movie keeps them off balance to the end. During the first part of the picture, a woman in my row was gleefully assuring her companions, "It's a comedy. It's a comedy." After a while, she didn't say anything. Instead of the movie spoof, which tells the audience that it doesn't need to feel or care, that it's all just in fun, that "we were only kidding," *Bonnie and Clyde* disrupts us with "And you thought we were only kidding."

This is the way the story was told in 1937. Eddie (Clyde) is a three-time loser who wants to work for a living, but nobody will give him a chance. Once you get on the wrong side of the law, "they" won't let you get back. Eddie knows it's hopeless—once a loser, always a loser. But his girl, Joan (Bonnie)—the only person who believes in him—thinks that an innocent man has nothing to fear. She marries him, and learns better. Arrested again and sentenced to death for a crime he didn't commit, Eddie asks her to smuggle a gun to him in prison, and she protests, "If I get you

a gun, you'll kill somebody." He stares at her sullenly and asks, "What do you think they're going to do to me?" He becomes a murderer while escaping from prison: "society" has made him what it thought he was all along. *You Only Live Once* was an indictment of "society," of the forces of order that will not give Eddie the outcast a chance. "We have a right to live," Joan says as they set out across the country. During the time they are on the run, they become notorious outlaws; they are blamed for a series of crimes they didn't commit. (They do commit holdups, but only to get gas or groceries or medicine.) While the press pictures them as desperadoes robbing and killing and living high on the proceeds of crime, she is having a baby in a shack in a hobo jungle, and Eddie brings her a bouquet of wild flowers. Caught in a police trap, they die in each other's arms; they have been denied the right to live.

Because *You Only Live Once* was so well done, and because the audience in the thirties shared this view of the indifference and cruelty of "society," there were no protests against the sympathetic way the outlaws were pictured—and, indeed, there was no reason for any. In 1958, in *I Want to Live!* (a very popular, though not very good, movie), Barbara Graham, a drug-addict prostitute who had been executed for her share in the bludgeoning to death of an elderly woman, was presented as gallant, wronged, morally superior to everybody else in the movie, in order to strengthen the argument against capital punishment, and the director, Robert Wise, and his associates weren't accused of glorifying criminals, because the "criminals," as in *You Only Live Once,* weren't criminals but innocent victims. Why the protests, why are so many people upset (and not just the people who enjoy indignation), about *Bonnie and Clyde,* in which the criminals *are* criminals—Clyde an ignorant, sly near psychopath who thinks his crimes are accomplishments, and Bonnie, a bored, restless waitress-slut who robs for excitement? And why so many accusations of historical inaccuracy, particularly against a work that is far more accurate historically than most and in which historical accuracy hardly matters anyway? There is always an issue of historical accuracy involved in any dramatic or literary work set in the past; indeed, it's fun to read about Richard III vs. Shakespeare's Richard III. The issue is always with us, and will always be with

us as long as artists find stimulus in historical figures and want to present their versions of them. But why didn't movie critics attack, for example, *A Man for All Seasons*—which involves material of much more historical importance—for being historically inaccurate? Why attack *Bonnie and Clyde* more than the other movies based on the same pair, or more than the movie treatments of Jesse James or Billy the Kid or Dillinger or Capone or any of our other fictionalized outlaws? I would suggest that when a movie so clearly conceived as a new version of a legend is attacked as historically inaccurate, it's because it shakes people a little. I know this is based on some pretty sneaky psychological suppositions, but I don't see how else to account for the use only against a *good* movie of arguments that could be used against almost all movies. When I asked a nineteen-year-old boy who was raging against the movie as "a cliché-ridden fraud" if he got so worked up about other movies, he informed me that that was an argument *ad hominem*. And it is indeed. To ask why people react so angrily to the best movies and have so little negative reaction to poor ones is to imply that they are so unused to the experience of art in movies that they fight it.

Audiences at *Bonnie and Clyde* are not given a simple, secure basis for identification; they are made to feel but are not told *how* to feel. *Bonnie and Clyde* is not a serious melodrama involving us in the plight of the innocent but a movie that assumes—as William Wellman did in 1931 when he made *The Public Enemy*, with James Cagney as a smart, cocky, mean little crook—that we don't need to pretend we're interested only in the falsely accused, as if real criminals had no connection with us. There wouldn't be the popular excitement there is about outlaws if we didn't all suspect that—in some cases, at least—gangsters must take pleasure in the profits and glory of a life of crime. Outlaws wouldn't become legendary figures if we didn't suspect that there's more to crime than the social workers' case studies may show. And though what we've always been told will happen to them—that they'll come to a bad end—does seem to happen, some part of us wants to believe in the tiny possibility that they can get away with it. Is that really so terrible? Yet when it comes to movies people get nervous about acknowledging that there must be some fun in crime (though the gleam in Cagney's eye told its own story).

Bonnie and Clyde shows the fun but uses it, too, making comedy out of the banality and conventionality of that fun. What looks ludicrous in this movie isn't *merely* ludicrous, and after we have laughed at ignorance and helplessness and emptiness and stupidity and idiotic deviltry, the laughs keep sticking in our throats, because what's funny isn't only funny.

In 1937, the movie-makers knew that the audience wanted to believe in the innocence of Joan and Eddie, because these two were lovers, and innocent lovers hunted down like animals made a tragic love story. In 1967, the movie-makers know that the audience wants to believe—maybe even prefers to believe—that Bonnie and Clyde were guilty of crimes, all right, but that they were innocent in general; that is, naïve and ignorant *compared with us.* The distancing of the sixties version shows the gangsters in an already legendary period, and part of what makes a legend for Americans is viewing anything that happened in the past as much simpler than what we are involved in now. We tend to find the past funny and the recent past campy-funny. The getaway cars of the early thirties are made to seem hilarious. (Imagine anyone getting away from a bank holdup in a tin lizzie like that!) In *You Only Live Once,* the outlaws existed in the same present as the audience, and there was (and still is, I'm sure) nothing funny about them; in *Bonnie and Clyde* that audience is in the movie, transformed into the poor people, the Depression people, of legend—with faces and poses out of Dorothea Lange and Walker Evans and *Let Us Now Praise Famous Men.* In 1937, the audience felt sympathy for the fugitives because they weren't allowed to lead normal lives; in 1967, the "normality" of the Barrow gang and their individual aspirations toward respectability are the craziest things about them—not just because they're killers but because thirties "normality" is in itself funny to us. The writers and the director of *Bonnie and Clyde* play upon our attitudes toward the American past by making the hats and guns and holdups look as dated as two-reel comedy; emphasizing the absurdity with banjo music, they make the period seem even farther away than it is. The Depression reminiscences are not used for purposes of social consciousness; hard times are not the reason for the Barrows' crimes, just the excuse. "We" didn't make Clyde a killer; the movie deliberately avoids easy sympathy by picking

up Clyde when he is already a cheap crook. But Clyde is not the urban sharpster of *The Public Enemy;* he is the hick as bank robber—a countrified gangster, a hillbilly killer who doesn't mean any harm. People so simple that they are alienated from the results of their actions—like the primitives who don't connect babies with copulation—provide a kind of archetypal comedy for us. It may seem like a minor point that Bonnie and Clyde are presented as not mean and sadistic, as having killed only when cornered; but in terms of legend, and particularly movie legend, it's a major one. The "classic" gangster films showed gang members betraying each other and viciously murdering the renegade who left to join another gang; the gang-leader hero no sooner got to the top than he was betrayed by someone he had trusted or someone he had double-crossed. In contrast, the Barrow gang represent family-style crime. And Newman and Benton have been acute in emphasizing this—not making them victims of society (they are never that, despite Penn's cloudy efforts along these lines) but making them absurdly "just-folks" ordinary. When Bonnie tells Clyde to pull off the road—"I want to talk to you"— they are in a getaway car, leaving the scene of a robbery, with the police right behind them, but they are absorbed in family bickering: the traditional all-American use of the family automobile. In a sense, it is the absence of sadism—it is the violence without sadism—that throws the audience off balance at *Bonnie and Clyde.* The brutality that comes out of this innocence is far more shocking than the calculated brutalities of mean killers.

Playfully posing with their guns, the real Bonnie and Clyde mocked the "Bloody Barrows" of the Hearst press. One photograph shows slim, pretty Bonnie, smiling and impeccably dressed, pointing a huge gun at Clyde's chest as he, a dimpled dude with a cigar, smiles back. The famous picture of Bonnie in the same clothes but looking ugly squinting into the sun, with a foot on the car, a gun on her hip, and a cigar in her mouth, is obviously a joke—her caricature of herself as a gun moll. Probably, since they never meant to kill, they thought the "Bloody Barrows" were a joke—a creation of the lying newspapers.

There's something new working for the Bonnie-and-Clyde legend now: our nostalgia for the thirties—the unpredictable, contrary affection of the prosperous for poverty, or at least for

the artifacts, the tokens, of poverty, for Pop culture seen in the dreariest rural settings, where it truly seems to belong. Did people in the cities listen to the Eddie Cantor show? No doubt they did, but the sound of his voice, like the sound of Ed Sullivan now, evokes a primordial, pre-urban existence—the childhood of the race. Our comic-melancholic affection for thirties Pop has become sixties Pop, and those who made *Bonnie and Clyde* are smart enough to use it that way. Being knowing is not an artist's highest gift, but it can make a hell of a lot of difference in a movie. In the American experience, the miseries of the Depression are funny in the way that the Army is funny to draftees—a shared catastrophe, a leveling, forming part of our common background. Those too young to remember the Depression have heard about it from their parents. (When I was at college, we used to top each other's stories about how our families had survived: the fathers who had committed suicide so that their wives and children could live off the insurance; the mothers trying to make a game out of the meals of potatoes cooked on an open fire.) Though the American derision of the past has many offensive aspects, it has some good ones, too, because it's a way of making fun not only of our forebears but of ourselves and our pretensions. The toughness about what we've come out of and what we've been through—the honesty to see ourselves as the Yahoo children of yokels is a good part of American popular art. There is a kind of American poetry in a stickup gang seen chasing across the bedraggled backdrop of the Depression (as true in its way as Nabokov's vision of Humbert Humbert and Lolita in the cross-country world of motels)—as if crime were the only activity in a country stupefied by poverty. But Arthur Penn doesn't quite have the toughness of mind to know it; it's not what he means by poetry. His squatters'-jungle scene is too "eloquent," like a poster making an appeal, and the Parker-family-reunion sequence is poetic in the gauzy mode. He makes the sequence a fancy lyric interlude, like a number in a musical (*Funny Face,* to be exact); it's too "imaginative"—a literal dust bowl, as thoroughly becalmed as Sleeping Beauty's garden. The movie becomes dreamy-soft where it should be hard (and hard-edged).

If there is such a thing as an American tragedy, it must be funny. O'Neill undoubtedly felt this when he had James Tyrone

get up to turn off the lights in *Long Day's Journey Into Night.*
We are bumpkins, haunted by the bottle of ketchup on the
dining table at San Simeon. We garble our foreign words and
phrases and hope that at least we've used them right. Our heroes
pick up the wrong fork, and the basic figure of fun in the Ameri-
can theatre and American movies is the man who puts on airs.
Children of peddlers and hod carriers don't feel at home in
tragedy; we are used to failure. But, because of the quality of
American life at the present time, perhaps there can be no real
comedy—nothing more than stupidity and "spoof"—without true
horror in it. Bonnie and Clyde and their partners in crime are
comically bad bank robbers, and the backdrop of poverty makes
their holdups seem pathetically tacky, yet they rob banks and
kill people; Clyde and his good-natured brother are so shallow
they never think much about anything, yet they suffer and die.

If this way of holding more than one attitude toward life is
already familiar to us—if we recognize the make-believe robbers
whose toy guns produce real blood, and the Keystone cops who
shoot them dead, from Truffaut's *Shoot the Piano Player* and
Godard's gangster pictures, *Breathless* and *Band of Outsiders*—
it's because the young French directors discovered the poetry of
crime in American life (from our movies) and showed the Ameri-
cans how to put it on the screen in a new, "existential" way.
Melodramas and gangster movies and comedies were always more
our speed than "prestigious," "distinguished" pictures; the French
directors who grew up on American pictures found poetry in our
fast action, laconic speech, plain gestures. And because they un-
derstood that you don't express your love of life by denying the
comedy or the horror of it, they brought out the poetry in our
tawdry subjects. Now Arthur Penn, working with a script heavily
influenced—one might almost say inspired—by Truffaut's *Shoot
the Piano Player,* unfortunately imitates Truffaut's artistry in-
stead of going back to its tough American sources. The French
may tenderize their American material, but we shouldn't. That
turns into another way of making "prestigious," "distinguished"
pictures.

Probably part of the discomfort that people feel about *Bonnie
and Clyde* grows out of its compromises and its failures. I wish

the script hadn't provided the upbeat of the hero's sexual success as a kind of sop to the audience. I think what makes us not believe in it is that it isn't consistent with the intelligence of the rest of the writing—that it isn't on the same level, because it's too manipulatively clever, too much of a gimmick. (The scene that shows the gnomish gang member called C.W. sleeping in the same room with Bonnie and Clyde suggests other possibilities, perhaps discarded, as does C.W.'s reference to Bonnie's liking his tattoo.) Compromises are not new to the Bonnie-and-Clyde story; *You Only Live Once* had a tacked-on coda featuring a Heavenly choir and William Gargan as a dead priest, patronizing Eddie even in the afterlife, welcoming him to Heaven with "You're free, Eddie!" The kind of people who make a movie like *You Only Live Once* are not the kind who write endings like that, and, by the same sort of internal evidence, I'd guess that Newman and Benton, whose Bonnie seems to owe so much to Catherine in *Jules and Jim,* had more interesting ideas originally about Bonnie's and Clyde's (and maybe C.W.'s) sex lives.

But people also feel uncomfortable about the violence, and here I think they're wrong. That is to say, they *should* feel uncomfortable, but this isn't an argument *against* the movie. Only a few years ago, a good director would have suggested the violence obliquely, with reaction shots (like the famous one in *The Golden Coach,* when we see a whole bullfight reflected in Anna Magnani's face), and death might have been symbolized by a light going out, or stylized, with blood and wounds kept to a minimum. In many ways, this method is more effective; we feel the violence more because so much is left to our imaginations. But the whole point of *Bonnie and Clyde* is to rub our noses in it, to make us pay our dues for laughing. The dirty reality of death—not suggestions but blood and holes—is necessary. Though I generally respect a director's skill and intelligence in inverse ratio to the violence he shows on the screen, and though I questioned even the Annie Sullivan–Helen Keller fight scenes in Arthur Penn's *The Miracle Worker,* I think that this time Penn is right. (I think he was also right when he showed violence in his first film, *The Left Handed Gun,* in 1958.) Suddenly, in the last few years, our view of the world has gone beyond "good taste." Tasteful suggestions of violence would at this point be a more grotesque form of comedy than

Bonnie and Clyde attempts. *Bonnie and Clyde* needs violence; violence is its meaning. When, during a comically botched-up getaway, a man is shot in the face, the image is obviously based on one of the most famous sequences in Eisenstein's *Potemkin,* and the startled face is used the same way it was in *Potemkin*—to convey in an instant how someone who just happens to be in the wrong place at the wrong time, the irrelevant "innocent" bystander, can get it full in the face. And at that instant the meaning of Clyde Barrow's character changes; he's still a clown, but *we've* become the butt of the joke.

It is a kind of violence that says something to us; it is something that movies must be free to use. And it is just because artists must be free to use violence—a legal right that is beginning to come under attack—that we must also defend the legal rights of those film-makers who use violence to sell tickets, for it is not the province of the law to decide that one man is an artist and another man a no-talent. The no-talent has as much right to produce works as the artist has, and not only because he has a surprising way of shifting from one category to the other but also because men have an inalienable right to be untalented, and the law should not discriminate against lousy "artists." I am not saying that the violence in *Bonnie and Clyde* is legally acceptable because the film is a work of art; I think that *Bonnie and Clyde,* though flawed, is a work of art, but I think that the violence in *The Dirty Dozen,* which isn't a work of art, and whose violence offends me *personally,* should also be legally defensible, however morally questionable. Too many people—including some movie reviewers—want the law to take over the job of movie criticism; perhaps what they really want is for their own criticisms to have the force of law. Such people see *Bonnie and Clyde* as a danger to public morality; they think an audience goes to a play or a movie and takes the actions in it as examples for imitation. They look at the world and blame the movies. But if women who are angry with their husbands take it out on the kids, I don't think we can blame *Medea* for it; if, as has been said, we are a nation of mother-lovers, I don't think we can place the blame on *Oedipus Rex.* Part of the power of art lies in showing us what we are *not* capable of. We see that killers are not a different breed but are *us* without the insight or understanding or self-control that works of

art strengthen. The tragedy of *Macbeth* is in the fall from nobility to horror; the comic tragedy of *Bonnie and Clyde* is that although you can't fall from the bottom you can reach the same horror. The movies may set styles in dress- or love-making, they may advertise cars or beverages, but art is not examples for imitation —that is not what a work of art does for us—though that is what guardians of morality *think* art is and what they want it to be and why they think a good movie is one that sets "healthy," "cheerful" examples of behavior, like a giant all-purpose commercial for the American way of life. But people don't "buy" what they see in a movie quite so simply; Louis B. Mayer did not turn us into a nation of Andy Hardys, and if, in a film, we see a frightened man wantonly take the life of another, it does not encourage us to do the same, any more than seeing an ivory hunter shoot an elephant makes us want to shoot one. It may, on the contrary, so sensitize us that we get a pang in the gut if we accidentally step on a moth.

Will we, as some people have suggested, be lured into imitating the violent crimes of Clyde and Bonnie because Warren Beatty and Faye Dunaway are "glamorous"? Do they, as some people have charged, confer glamour on violence? It's difficult to see how, since the characters they play are horrified by it and ultimately destroyed by it. Nobody in the movie gets pleasure from violence. Is the charge based on the notion that simply by their presence in the movie Warren Beatty and Faye Dunaway make crime attractive? If movie stars can't play criminals without our all wanting to be criminals, then maybe the only safe roles for them to play are movie stars—which, in this assumption, everybody wants to be anyway. After all, if they played factory workers, the economy might be dislocated by everybody's trying to become a factory worker. (Would having criminals played by dwarfs or fatties discourage crime? It seems rather doubtful.) The accusation that the beauty of movie stars makes the anti-social acts of their characters dangerously attractive is the kind of contrived argument we get from people who are bothered by something and are clutching at straws. Actors and actresses are *usually* more beautiful than ordinary people. And why not? Garbo's beauty notwithstanding, her Anna Christie did not turn us into whores, her Mata Hari did not turn us into spies, her Anna Karenina did not make us suicides. We did not want her to be ordinary looking.

Why should we be deprived of the pleasure of beauty? Garbo could be all women in love because, being more beautiful than life, she could more beautifully express emotions. It is a supreme asset for actors and actresses to be beautiful; it gives them greater range and greater possibilities for expressiveness. The handsomer they are, the more roles they can play; Oliver can be anything, but who would want to see Ralph Richardson, great as he is, play Antony? Actors and actresses who are beautiful start with an enormous advantage, because we love to look at them. The joke in the glamour charge is that Faye Dunaway has the magazine-illustration look of countless uninterestingly pretty girls, and Warren Beatty has the kind of high-school good looks that are generally lost fast. It's the roles that make *them* seem glamorous. Good roles do that for actors.

There is a story told against Beatty in a recent *Esquire*—how during the shooting of *Lilith* he "delayed a scene for three days demanding the line 'I've read *Crime and Punishment* and *The Brothers Karamazov*' be changed to 'I've read *Crime and Punishment* and *half* of *The Brothers Karamazov*.' " Considerations of professional conduct aside, what is odd is why his adversaries waited three days to give in, because, of course, he was right. That's what the character he played *should* say; the other way, the line has no point at all. But this kind of intuition isn't enough to make an actor, and in a number of roles Beatty, probably because he doesn't have the technique to make the most of his lines in the least possible time, has depended too much on intuitive non-acting—holding the screen far too long as he acted out self-preoccupied characters in a lifelike, boringly self-conscious way. He has a gift for slyness, though, as he showed in *The Roman Spring of Mrs. Stone,* and in most of his films he could hold the screen—maybe because there seemed to be something going on in his mind, some kind of calculation. There was something smart about him—something shrewdly private in those squeezed-up little non-actor's eyes—that didn't fit the clean-cut juvenile roles. Beatty was the producer of *Bonnie and Clyde,* responsible for keeping the company on schedule, and he has been quoted as saying, "There's not a scene that we have done that we couldn't do better by taking another day." This is the hell of the expensive way of making movies, but it probably helps to explain why

Beatty is more intense than he has been before and why he has picked up his pace. His business sense may have improved his timing. The role of Clyde Barrow seems to have released something in him. As Clyde, Beatty is good with his eyes and mouth and his hat, but his body is still inexpressive; he does have a trained actor's use of his body, and, watching him move, one is never for a minute convinced he's impotent. It is, however, a tribute to his performance that one singles this failure out. His slow timing works perfectly in the sequence in which he offers the dispossessed farmer his gun; there may not be another actor who would have dared to prolong the scene that way, and the prolongation until the final "We rob banks" gives the sequence its comic force. I have suggested elsewhere that one of the reasons that rules are impossible in the arts is that in movies (and in the other arts, too) the new "genius"—the genuine as well as the fraudulent or the dubious—is often the man who has enough audacity, or is simpleminded enough, to do what others had the good taste not to do. Actors before Brando did not mumble and scratch and show their sweat; dramatists before Tennessee Williams did not make explicit a particular substratum of American erotic fantasy; movie directors before Orson Welles did not dramatize the techniques of film-making; directors before Richard Lester did not lay out the whole movie as cleverly as the opening credits; actresses before Marilyn Monroe did not make an asset of their ineptitude by turning faltering misreadings into an appealing style. Each, in a large way, did something that people had always enjoyed and were often embarrassed or ashamed about enjoying. Their "bad taste" shaped a new accepted taste. Beatty's non-actor's "bad" timing may be this kind of "genius"; we seem to be watching him *think out* his next move.

It's difficult to know how Bonnie should have been played, because the character isn't worked out. Here the script seems weak. She is made too warmly sympathetic—and sympathetic in a style that antedates the style of the movie. Being frustrated and moody, she's not funny enough—neither ordinary, which, in the circumstances, would be comic, nor perverse, which might be rather funny, too. Her attitude toward her mother is too loving. There could be something funny about her wanting to run home to her mama, but, as it has been done, her heading home, running off

through the fields, is unconvincing—incompletely motivated. And because the element of the ridiculous that makes the others so individual has been left out of her character she doesn't seem to belong to the period as the others do. Faye Dunaway has a sixties look anyway—not just because her eyes are made up in a sixties way and her hair is wrong but because her personal style and her acting are sixties. (This may help to make her popular; she can seem prettier to those who don't recognize prettiness except in the latest styles.) Furthermore, in some difficult-to-define way, Faye Dunaway as Bonnie doesn't keep her distance—that is to say, an *actor's* distance—either from the role or from the audience. She doesn't hold a characterization; she's in and out of emotions all the time, and though she often hits effective ones, the emotions seem *hers*, not the character's. She has some talent, but she comes on too strong; she makes one conscious that she's a willing worker, but she doesn't seem to know what she's doing—rather like Bonnie in her attempts to overcome Clyde's sexual difficulties.

Although many daily movie reviewers judge a movie in isolation, as if the people who made it had no previous history, more serious critics now commonly attempt to judge a movie as an expressive vehicle of the director, and a working out of his personal themes. Auden has written, "Our judgment of an established author is never simply an aesthetic judgment. In addition to any literary merit it may have, a new book by him has a historic interest for us as the act of a person in whom we have long been interested. He is not only a poet . . . he is also a character in our biography." For a while, people went to the newest Bergman and the newest Fellini that way; these movies were greeted like the latest novels of a favorite author. But Arthur Penn is not a writer-director like Bergman or Fellini, both of whom began as writers, and who (even though Fellini employs several collaborators) compose their spiritual autobiographies step by step on film. Penn is far more dependent on the talents of others, and his primary material—what he starts with—does not come out of his own experience. If the popular audience is generally uninterested in the director (unless he is heavily publicized, like DeMille or Hitchcock), the audience that is interested in the art of movies has begun, with many of the critics, to think of movies as a directors'

medium to the point where they tend to ignore the contribution of the writers—and the directors may be almost obscenely content to omit mention of the writers. The history of the movies is being rewritten to disregard facts in favor of celebrating the director as the sole "creative" force. One can read Josef von Sternberg's auto-biography and the text of the latest books on his movies without ever finding the name of Jules Furthman, the writer who worked on nine of his most famous movies (including *Morocco* and *Shanghai Express*). Yet the appearance of Furthman's name in the credits of such Howard Hawks films as *Only Angels Have Wings, To Have and Have Not, The Big Sleep,* and *Rio Bravo* suggests the reason for the similar qualities of good-bad-girl glamour in the roles played by Dietrich and Bacall and in other von Sternberg and Hawks heroines, and also in the Jean Harlow and Constance Bennett roles in the movies he wrote for *them.* Furthman, who has written about half of the most entertaining movies to come out of Hollywood (Ben Hecht wrote most of the other half), isn't even listed in new encyclopedias of the film. David Newman and Robert Benton may be good enough to join this category of unmentionable men who do what the directors are glorified for. The Hollywood writer is becoming a ghostwriter. The writers who succeed in the struggle to protect their identity and their material by becoming writer-directors or writer-produc-ers soon become too rich and powerful to bother doing their own writing. And they rarely have the visual sense or the training to make good movie directors.

Anyone who goes to big American movies like *Grand Prix* and *The Sand Pebbles* recognizes that movies with scripts like those don't have a chance to be anything more than exercises in technol-ogy, and that this is what is meant by the decadence of American movies. In the past, directors used to say that they were no better than their material. (Sometimes they said it when they weren't even up to their material.) A good director can attempt to camouflage poor writing with craftsmanship and style, but ultimately no amount of director's skill can conceal a writer's failure; a poor script, even well directed, results in a stupid movie—as, un-fortunately, does a good script poorly directed. Despite the new notion that the direction is everything, Penn can't redeem bad material, nor, as one may surmise from his *Mickey One,* does he

necessarily know when it's bad. It is not fair to judge Penn by a film like *The Chase*, because he evidently did not have artistic control over the production, but what happens when he does have control and is working with a poor, pretentious mess of a script is painfully apparent in *Mickey One*—an art film in the worst sense of that term. Though one cannot say of *Bonnie and Clyde* to what degree it shows the work of Newman and Benton and to what degree they merely enabled Penn to "express himself," there are ways of making guesses. As we hear the lines, we can detect the intentions even when the intentions are not quite carried out. Penn is a little clumsy and rather too fancy; he's too much interested in being cinematically creative and artistic to know when to trust the script. *Bonnie and Clyde* could be better if it were simpler. Nevertheless, Penn is a remarkable director when he has something to work with. His most interesting previous work was in his first film, *The Left Handed Gun* (and a few bits of *The Miracle Worker,* a good movie version of the William Gibson play, which he had also directed on the stage and on television). *The Left Handed Gun,* with Paul Newman as an ignorant Billy the Kid in the sex-starved, male-dominated Old West, has the same kind of violent, legendary, nostalgic material as *Bonnie and Clyde;* its script, a rather startling one, was adapted by Leslie Stevens from a Gore Vidal television play. In interviews, Penn makes high, dull sounds—more like a politician than a movie director. But he has a gift for violence, and, despite all the violence in movies, a gift for it is rare. (Eisenstein had it, and Dovzhenko, and Buñuel, but not many others.) There are few memorable violent moments in American movies, but there is one in Penn's first film: Billy's shotgun blasts a man right out of one of his boots; the man falls in the street, but his boot remains upright; a little girl's giggle at the boot is interrupted by her mother's slapping her. The mother's slap—the seal of the awareness of horror—says that even children must learn that some things that look funny are not only funny. That slap, saying that only idiots would laugh at pain and death, that a child must develop sensibility, is the same slap that *Bonnie and Clyde* delivers to the woman saying "It's a comedy." In *The Left Handed Gun,* the slap is itself funny, and yet we suck in our breath; we do not dare to laugh.

Some of the best American movies show the seams of cuts and the confusions of compromises and still hold together, because there is enough energy and spirit to carry the audience over each of the weak episodes to the next good one. The solid intelligence of the writing and Penn's aura of sensitivity help *Bonnie and Clyde* triumph over many poorly directed scenes: Bonnie posing for the photograph with the Texas Ranger, or—the worst sequence—the Ranger getting information out of Blanche Barrow in the hospital. The attempt to make the Texas Ranger an old-time villian doesn't work. He's in the tradition of the mustachioed heavy who foreclosed mortgages and pursued heroines in turn-of-the-century plays, and this one-dimensional villainy belongs, glaringly, to spoof. In some cases, I think, the writing and the conception of the scenes are better (potentially, that is) than the way the scenes have been directed and acted. If Gene Hackman's Buck Barrow is a beautifully controlled performance, the best in the film, several of the other players—though they are very good—needed a tighter rein. They act too much. But it is in other ways that Penn's limitations show—in his excessive reliance on meaning-laden closeups, for one. And it's no wonder he wasn't able to bring out the character of Bonnie in scenes like the one showing her appreciation of the fingernails on the figurine, for in other scenes his own sense of beauty appears to be only a few rungs farther up that same cultural ladder.

The showpiece sequence, Bonnie's visit to her mother (which is a bit reminiscent of Humphrey Bogart's confrontation with his mother, Marjorie Main, in the movie version of *Dead End*), aims for an effect of alienation, but that effect is confused by all the other things attempted in the sequence: the poetic echoes of childhood (which also echo the child sliding down the hill in *Jules and Jim*) and a general attempt to create a frieze from our national past—a poetry of poverty. Penn isn't quite up to it, though he is at least good enough to communicate what he is trying to do, and it is an attempt that one can respect. In 1939, John Ford attempted a similar poetic evocation of the legendary American past in *Young Mr. Lincoln;* this kind of evocation, by getting at how we *feel* about the past, moves us far more than attempts at historical re-creation. When Ford's Western evocations fail, they become languorous; when they succeed, they are

the West of our dreams, and his Lincoln, the man so humane and so smart that he can outwit the unjust and save the innocent, is the Lincoln of our dreams, as the Depression of *Bonnie and Clyde* is the Depression of our dreams—the nation in a kind of trance, as in a dim memory. In this sense, the effect of blur is justified, is "right." Our memories *have* become hazy; this is what the Depression has faded into. But we are too conscious of the technical means used to achieve this blur, of the *attempt* at poetry. We are aware that the filtered effects already include our responses, and it's too easy; the lines are good enough so that the stylization wouldn't have been necessary if the scene had been played right. A simple frozen frame might have been more appropriate.

The editing of this movie is, however, the best editing in an American movie in a long time, and one may assume that Penn deserves credit for it along with the editor, Dede Allen. It's particularly inventive in the robberies and in the comedy sequence of Blanche running through the police barricades with her kitchen spatula in her hand. (There is, however, one bad bit of editing: the end of the hospital scene, when Blanche's voice makes an emotional shift without a corresponding change in her facial position.) The quick panic of Bonnie and Clyde looking at each other's face for the last time (is a stunning example of the art of editing).

The end of the picture, the rag-doll dance of death as the gun blasts keep the bodies of Bonnie and Clyde in motion, is brilliant. It is a horror that seems to go on for eternity, and yet it doesn't last a second beyond what it should. The audience leaving the theatre is the quietest audience imaginable.

Still, that woman near me was saying "It's a comedy" for a little too long, and although this could have been, and probably was, a demonstration of plain old-fashioned insensitivity, it suggests that those who have attuned themselves to the "total" comedy of the last few years may not know when to stop laughing. Movie audiences have been getting a steady diet of "black" comedy since 1964 and *Dr. Strangelove, Or: How I Learned to Stop Worrying and Love the Bomb.* Spoof and satire have been entertaining audiences since the two-reelers; because it is so easy to do on film things that are difficult or impossible in nature,

movies are ideally suited to exaggerations of heroic prowess and to the kind of lighthearted nonsense we used to get when even the newsreels couldn't resist the kidding finish of the speeded-up athletic competition or the diver flying up from the water. The targets have usually been social and political fads and abuses, together with the heroes and the clichés of the just preceding period of film-making. *Dr. Strangelove* opened a new movie era. It ridiculed *everything* and *everybody* it showed, but concealed its own liberal pieties, thus protecting itself from ridicule. A professor who had told me that *The Manchurian Candidate* was "irresponsible," adding, "I didn't like it—I can suspend disbelief only so far," was overwhelmed by *Dr. Strangelove:* "I've never been so involved. I had to keep reminding myself it was only a movie." *Dr. Strangelove* was clearly intended as a cautionary movie; it meant to jolt us awake to the dangers of the bomb by showing us the insanity of the course we were pursuing. But artists' warnings about war and the dangers of total annihilation never tell us how we are supposed to regain control, and *Dr. Strangelove,* chortling over madness, did not indicate any possibilities for sanity. It was experienced not as satire but as a confirmation of fears. Total laughter carried the day. A new generation enjoyed seeing the world as insane; they *literally* learned to stop worrying and love the bomb. Conceptually, we had already been living with the bomb; now the mass audience of the movies—which is the youth of America—grasped the idea that the threat of extinction can be used to devaluate everything, to turn it all into a joke. And the members of this audience do love the bomb; they love feeling that the worst has happened and the irrational are the sane, because there is the bomb as the proof that the rational are insane. They love the bomb because it intensifies their feelings of hopelessness and powerlessness and innocence. It's only three years since Lewis Mumford was widely acclaimed for saying about *Dr. Strangelove* that "unless the spectator was purged by laughter he would be paralyzed by the unendurable anxiety this policy, once it were honestly appraised, would produce." Far from being purged, the spectators are paralyzed, but they're still laughing. And how odd it is now to read, "*Dr. Strangelove* would be a silly, ineffective picture if its purpose were to ridicule the characters of our military and political leaders

by showing them as clownish monsters—stupid, psychotic, obsessed." From *Dr. Strangelove* it's a quick leap to *MacBird* and to a belief in exactly what it was said we weren't meant to find in *Dr. Strangelove*. It is not war that has been laughed to scorn but the possibility of sane action.

Once something enters mass culture, it travels fast. In the spoofs of the last few years, everything is gross, ridiculous, insane; to make sense would be to risk being square. A brutal new melodrama is called *Point Blank* and it is. So are most of the new movies. This is the context in which *Bonnie and Clyde,* an entertaining movie that has some feeling in it, upsets people—people who didn't get upset even by *Mondo Cane.* Maybe it's because *Bonnie and Clyde,* by making us care about the robber lovers, has put the sting back into death.

16 FROM *Charles D. Peavy*
Black Consciousness and the Contemporary Cinema

Blacks, as actors in movies and commercials, and as makers of movies, are so natural now that one has great difficulty understanding the great furor created in the last five years merely because in a television commercial a white girl touched the shoulder of a black man. The success of blacks in these areas is perhaps as good an example of man's growth as one can find.

Despite the sudden, almost meteoric success of Gordon Parks and the equally rapid notoriety of Melvin Van Peebles, the significance of the black film maker to contemporary American culture is still largely unnoticed. Films are now being used as vehicles for social rehabilitation, as a means of self-expression, and as weapons of propaganda in the struggle for Black Power and social change. Since America is rapidly becoming a visually

SOURCE. Charles D. Peavy, Department of English, University of Houston.

oriented society, it is only natural that young black film makers have turned to the medium of the motion picture to satisfy their own needs and aspirations. The result is that exciting examples of cinematography are now emerging from the slums of America's cities, and even Hollywood is beginning to show the impact of an expanding black consciousness. Before turning to the "slicker" and more commercially viable examples of black cinema, however, some attention should be paid to the productions of young black movie makers who, with the assistance of foundation support, have produced excellent films depicting the black experience. The Brooks Foundation of Santa Barbara, California, for example, has been extremely instrumental in the funding of film making projects among underprivileged youth in America's ghettoes. The Foundation is currently directing the National Study of the Performing Arts for Urban and Rural Youth. The Foundation has sponsored projects in New York, Philadelphia, and Watts under its general plan for film making as a special non-school related project for urban area students and dropouts.

Briefly, the philosophy behind the Brooks Foundation's project is that any effort to educate the culturally deprived teenage student must be in some degree accomplished outside the classroom, for the student who has been having serious difficulties in school for several years probably has had as many years of conditioning against the school system. He often feels that the school has nothing rewarding to offer him, a feeling which is compounded by the anti-intellectualism of his peer group, his minority group status, and the economic and cultural poverty of his environment. Separated from the negative aspects of the student's educational experience, the film making projects contribute in many ways to the personal development and socialization of the ghetto student and dropout. For instance, film making demands a serious creative effort on the student's part. This effort, directed by the student's personal interests, affords important psychological experiences of success and accomplishment. It also develops basic skills (such as writing and visual perception) and vocational skills (such as stagecraft and lighting). In its preliminary report on its film making projects, the Brooks Foundation stated its belief that the making of a movie allows the film maker to "tell something about himself, perhaps something very important that he could

tell in no other way. Once he has made his statement explicit in his film, others can respond to it, and a genuine social dialogue, perhaps the first in his life, can be pursued. The end result may be that he sees how his personality affects others. This process is a close analogue of group psychotherapy, psychodrama, and sensitivity training, and leads to similar benefits Film making provides an important aesthetic experience and prepares the student to be an intelligent consumer of movies, the national folk art, and of visually transmitted information in general."[1] The Foundation's funding of a program in film making conducted by Mobilization for Youth in New York City led to the social rehabilitation and successful career of Richard Mason, the best of the young black film makers working in America today.

A ghetto-bred, high school drop-out, Mason has come a long way from the gang rumbles and drug scene of his youth. He is presently associate producer of the WABC-TV series "Like It Is" and is also the director of two notable films, *You Dig It?* and *Ghetto*. His films reflect his experiences in the ghetto, where he was the "warlord" (or gangleader) of the Sportsmen, a black gang operating in New York's Lower East Side. Mason readily talks of these experiences, which include theft, gang-fighting, the numbers racket, and dope ("I don't think that there was much action in crime unknown to me," he says). At the age of thirteen he was running numbers and pushing dope. By the age of fifteen he was committed to a mental hospital, where he spent two years. When he left the hospital he enrolled in the training program of Mobilization for Youth ("I was painting houses for them and selling dope for me," he says, "which led to a bust and six months in the Elmira Reformatory"). When he was released from Elmira he returned to Mobilization for Youth and discovered their Drama Workshop. This was to signal the beginning of Mason's career as an actor and was also to mark a turning point in his life, for within two years after his introduction to acting he became administrative assistant for the cultural arts program at Mobilization for Youth. Mason studied with Robert Hook's Group Theatre Workshop (a tuition-free acting school for underprivileged young actors now merged with the Negro Ensemble Company), the Stella Adler Conservatory, the Marion Rich School of Voice, and the New School for Social Research. He appeared in

numerous "street plays," including *Games,* the film production of which won a Plaque of the Lion of St. Mark at the Venice Documentary and Short Film Festival. He also played the lead in a version of *Waiting for Lefty,* which was re-written as a Lower East Side rent strike, as well as other plays about the inner city, such as *The In-Crowd* (about police brutality) and *Charade on East Fourth Street* (a surreal comedy about ghetto family life).

These same themes are present in Mason's film *You Dig It?,*[2] which Mason directed when he was nineteen, and *Ghetto,*[3] directed by him at the age of twenty-one. When the Brooks Foundation gave Mobilization for Youth a ten thousand dollar grant to establish a film workshop, Mason directed (and acted in) the film *You Dig It?* He used a script written by Leon Williams, a Negro teenager whom Mason had brought to the youth organization, and who plays the role of the protagonist in the film. *You Dig It?* opens with a family scene in the ghetto (typically, the family has been deserted by the father). Leon Williams plays himself in the role of the protagonist. In the beginning of the film, he leaves his home, ostensibly to go to school, but actually to take in the neighborhood movies. He stands beneath some movie marquees which advertise girlie shows, shows in Spanish, and ultimately, the title and credits for *You Dig It?* The film is apparently a dream sequence involving the protagonist in a series of ghetto experiences. In one scene he is walking with a friend when they see three neighborhood toughs grab and attempt to rape a girl. The girl (Francene) is rescued and is later taken to the gang's clubhouse by Leon. Francene provides the love interest and the motivation for Leon to leave the gang. The action of the film concentrates on the activities of the club, gang warfare, and the deterministic aspects of ghetto life. *You Dig It?* is a truthful depiction of the importance the gang has in the life of the boy, and the terrrible isolation he feels when he is expelled from it. *You Dig It?* is good, even without apologies for its amateur cast (drawn from the students at Mobilization for Youth) and its relatively unsophisticated script (Leon Williams was sixteen when he wrote it).

Lincoln Center premiered *You Dig It?,* and WABC-TV presented a screening and discussion of it (ABC also showed *You Dig It?* three times as a part of its public affairs programs). The

film was also shown at the Chicago Film Festival, at the Youth Pavilion at Expo '67, at the 1968 Internationale Westdeutsche Kurzfilmtage at Oberhausen, Germany, and at Hemis Fair '68. *You Dig It?* has been widely acclaimed as an exciting and significant contribution to the stream of creative work now emerging from urban ghettoes.

Mason's second film, *Ghetto*, is based on a sketch written by Woodie King, Jr., the black writer and theatre founder who is currently Cultural Arts Director of Mobilization for Youth. It is a smoother, more sophisticated production than the earlier *You Dig It?* Unlike other films portraying ghetto life, Mason's *Ghetto* is transformed by its color photography and jazz score into a film of almost lyrical quality. There is a certain beauty to be seen in the ghetto, the texture of the scaling walls of a tenement room looks like an expressionistic painting, there is a surreal quality to the macrophotography of roaches, and a close up of the dark hand of the protagonist fondling the breast of a white prostitute is a masterful composition in black, white, and pink. *Ghetto* is a rapidly paced film in which the many nuances of ghetto life flash by in quick vignettes of whores, hoods, faggots, and hop-heads. In a crowded tenement room a couple makes love on a pallet while two terrified infants look on; on a dimly lit stairwell a woman tightens a belt around a man's arm as he prepares to "shoot up dope" (there is a close up of the needle as it penetrates the mainliner's vein), and in an alleyway a man is stabbed to death with a switchblade knife. There is some interesting photography (in rapid, sped-up shots, then slow motion) to indicate the protagonist's vision after he gets high, then comes down after smoking marihuana. All of these rapidly mounted vignettes are accompanied by a score played by Neal Tate, which builds to a crescendo as the action races through the denouement. There is an excellent scene in which the inebriated (or doped) protagonist runs through a litter-filled alleyway. He is running from nothing, and to nowhere, in particular. His passage is finally blocked by a brick wall on one side and a high, wire fence on the other. He rushes against the wire fence, clawing at the interstices in a symbolic action which illustrates how the narrow confines of the ghetto circumscribe the lives of its inhabitants.

Ghetto has been called a documentary film, but it might be

more properly termed an art film. It certainly should be approached as such, yet it seldom is. For instance, when *Ghetto* was screened at the Houston Film Conference in October, 1968, the most significant thing about discussion which followed the film was that it was in almost every instance approached as a social tract. Mason himself seemed to encourage this approach by saying that the film was aimed at a white middle class audience. Paradoxically, however, Mason contended that the film was not propaganda, but that it was intended to shock—that is, to shock the white middle class into an awareness of a level of life which was totally unfamiliar to them. None of the audience seemed inclined to discuss the film as *art*, but only as agitprop or social documentary. Whatever the film's value as propaganda might be, the audience's reaction was a clear indication of the persistence of the public to view the black artist as a spokesman for his race, and to judge him solely on the basis of how well he represents his people. For instance, a Negro woman in the audience objected that Mason's film did not show things peculiar to the Negro ghetto, but things which were common among all races living in tenements. A white woman felt that Mason emphasized only the differences between the Negro slum dweller and the white middle class—that he showed no traits which were shared in common by the two groups—which might give a channel of communication or understanding through empathy. She felt that something—such as humor—should have been added to give a "humanizing" effect. This line of questioning forced Mason to assume a stance which, it was clear to me, he did not wish to take.

Mason later told me his intentions in the film. When he said that the film had been directed toward a white middle class, he meant the ESTABLISHMENT, and he was not drawing racial lines. "It's not a 'black' Black film," he said, "but about conditions in the ghetto. There are no racial overtones in the film." I asked him if the scene with the couple copulating in front of the crying children was intended as a social commentary on the crowded conditions in the slum areas, i.e., families crowded into one room apartments, but Mason said that this was not his intention. Rather, he was condemning the actions of the parents—their insensitivity to the children. Both here and in another scene Mason attempts to show the brutalizing of the parent's sensitivity

by the ghetto environment (in another scene the children are allowed to play with an open pocket knife, then there is a quick shift to the scene where a man is stabbed by another with a switch blade).

Mason clearly feels that *Ghetto* is an art film. "I'm not an intellectual," he told me. "I want to share my experiences as an artist and as a film maker with the world." Many of the scenes in the film are personal. In the film a white woman looks directly into the camera and says, "you and your people are stupid." The woman represents a teacher in a situation that happens to many blacks, and has happened to Mason. Another woman looks into the camera and shouts, "You're no good! You're just like your no good father." Here again Mason is reflecting his own personal experiences—experiences that are shared by many blacks who have been faced by prejudice in the class room and a woman-dominated, fatherless home. Leon Williams' script for *You Dig It?*, and Mason's direction of that film and *Ghetto*, illustrate the autobiographical or personal vision that characterizes most of the black film makers in their attempts to "tell it like it is."

Woodie King's short story "Ghetto," which was the inspiration for Mason's film of the same name, has as a headnote a scrap of verse which reads:

> *Keep straight down*
> *this block*
> *Then turn right where*
> *you will find*
> *A peach tree blooming.*

Mason, who followed Williams' script in *You Dig It?*, improvised considerably on King's original sketch. He did, however, retain the lines of poetry in a brief scene in which a wino staggers up and repeats them to the protagonist. Mason uses the scene symbolically to indicate the frustration of the ghetto. As Mason explained it to me, "The lines mean if you go down that street you'll find a tree—you'll find what you want in the ghetto. But it's ironic —you don't. Like when they say be a good boy and study in school and you'll get what you want. The wino has been disillusioned. And Abdul (the hero) is hung up at the end of the film. He doesn't find what he wants in the ghetto; he doesn't know what

he wants. He is trapped by the ghetto and the ghetto perspective."
In the original version of the film, Mason has the protagonist
actually find a tree—a discarded Christmas tree with no gifts—a
promise unfulfilled. This scene was cut out of the final version of
the film.

Another departure from King's text is Mason's repetitive, sym-
bolic use of an atomic bomb blast. King's sketch ended with the
word "hip-doom," an expression which suggested the atom bomb
to Mason. The timing of the appearance of the bomb in the film
was to express "an immediacy, an emergency" by relating the
bomb symbolically to ghetto conditions. "If something isn't done
about the ghetto *and* the oppressed people of the world," says
Mason, "we will be blown off the earth. The film is for all ghet-
toes, not *black* ghetto, but GHETTO."

Mason's success as a film director won him the position of as-
sociate producer of ABC-TV's program "Like It Is," a news and
public affairs program aimed at the problems of minority groups.
Mason is responsible for "thinking up" program ideas, research-
ing them thoroughly and finding talent for the shows. He hopes
to bring black and Puerto Rican talent into the entire complex
of motion pictures, television, and the theatre. "And I don't mean
on a token basis," he says, "I mean that these young men and
women should be trained to assume real power over program
content."

Mason's films illustrate the autobiographical or personal vision
that characterizes most of the black film makers in their attempt
to "tell it like it is," and his rapid rise from street corner rumbles
to the executive offices of a television network at the age of twenty-
two is illustrative of how important film making projects have
been in stimulating creative, underprivileged youth to seek self-
expression.

The Brooks Foundation's funding of a film making project in
Philadelphia led to similar beneficial results, for a former black
ghetto street gang, the 12th and Oxford Street gang, is now in-
corporated under the state laws of Pennsylvania as the 12th and
Oxford Street Film Makers Corporation. The social rehabilitation
of the 147 member gang, which was largely made up of dropouts
and petty felons, was begun when the gang made their twenty
minute film *The Jungle*. The significance of the film's title is ex-

plained by a young Negro in the introductory scene. "We call it *The Jungle*," he says, "because it's a comparison where the colored fellows first come from and the gang's shooting one another . . . the fighting and the killing is like the jungle and you have to be strongest to survive."

The president of the 12th and Oxford Film Makers Corporation is twenty year old David "Bat" Williams. Williams, the fifth child of a family of twelve, was born in Philadelphia. When a young boy, Williams was harassed by the older boys in the neighborhood. Because of this, he became one of the "midgets" attached to the 12th and Oxford Street gang for protection. Beginning at the age of fourteen, Williams was arrested seven times—usually for gang warfare—until he was imprisoned for three years on a charge of highway robbery.

Twenty-one year old Jimmy "Country" Robinson, the vice president of the 12th and Oxford Film Makers, moved from a South Carolina farm to Philadelphia when he was twelve years old. He was accompanied by his mother, a sister, and two brothers; his father remained behind with seven other children. Robinson, who finished the ninth grade, was imprisoned twenty-three months for a series of robberies.

"Bat" Williams and "Country" Robinson became film makers almost by accident. They were drinking Tokay wine on a playground when they were approached by Harold Haskins, a Negro social worker. To their amazement (and derision), Haskins proposed that they make a film. After weeks of persuasion the gang agreed to participate, and the training of the group in film techniques was finally begun in November, 1966. Classes were held five times a week and each boy was paid $1 an hour for the time he spent in the classroom.

The Jungle,[4] which was funded by a $7,000 grant from the Brooks Foundation, is based on actual experiences: the friendship between Williams and Robinson, a fight with a rival gang, and the punishment meted out by a kangaroo court to a member of the gang who stayed out of a rumble in order to drink wine (he has to "run the gauntlet" with the gang). The only incident in the film which is not factual is the death of Robinson in a final rumble with a rival gang.

The Jungle, like Mason's *You Dig It?*, concentrates on the sense-

lessness of gang warfare, which until recently was an inevitable situation in the streets of America's inner cities. One of the young commentators in *The Jungle* stresses how unavoidable violence was when one obtruded into a gang's "territory": "The guys stop someone and he says, 'I'm from nowhere,' and if you say you're from nowhere, you get beat up." When *The Jungle* was shown on television several warring gangs signed peace treaties and inquired how they could make films also (currently, the 12th and Oxford Film Corporation is assisting two former rival gangs to set up operations similar to their own).

The Jungle succeeds as a documentary film. The action of the film is interspersed with brief comments from various gang members on the deterministic factors in ghetto life. Sidney Poitier was impressed when he saw it at the New York Film Festival, and decided to use Williams, Robinson, and two other boys from the film in his own film, *The Lost Man,* which was filmed in Philadelphia.

The Jungle is not only successful as a film, it also realizes the aim of the Brooks Foundation in such projects: "the personal development and socialization of the ghetto student and dropout." Some of the gang's dropouts are going back to school, and twenty members of the gang are attending special night management courses (financed by a $13,683 federal grant). With the assistance of local business firms the gang has also begun several neighborhood business ventures—such as installing laundromats and renovating houses. The corporation is also receiving $170,000 from the Office of Economic Opportunity to assist it in setting up its various projects. Significantly, however, success has not spoiled the leadership of the 12th and Oxford group. Both Williams and Robinson insist that no matter how "big" they get they will never leave the neighborhood.

Like the Mobilization for Youth organization in New York, the 12th and Oxford Film Makers Corporation prefers that members of the organization accompany the films so that they will be available to answer questions after the film is screened. Since the questions asked usually come from white middle-class audiences, there is the expected ethnic and class gap between the audience and the commentators. "We live in different worlds," says Robinson, "they don't understand. But the film helps us to communi-

cate. Some of them don't believe it happens that way." Robinson's
comment should be compared with that of Richard Mason, who
often accompanies the screening of his own film, *Ghetto*. Mason
has said that he consciously directed his film toward a white
middle-class audience and that he wanted to shock them into an
awareness of a level of life which was totally unfamiliar to them.
Both men seem to be motivated by the desire shared by many
black artists—a desire to "tell it like it is."

The 12th and Oxford Film Makers' next film, *Dropout*, is about
some of the conditions that cause ghetto children to leave school
and roam the streets: "paycheck teachers" who only work for
their money and cheat the children, teachers who do not really
teach but merely make children copy from books, and teachers
who feel they are superior to the black children they are teaching.

Besides being used as a means for the social rehabilitation of
ghetto youth, as in the case of the New York and Philadelphia
based film making projects, the medium of the motion picture
has also been utilized as an effective agent in the struggle for
Black Power and social equality. A good example of a propaganda
film is *Black Spring*,[5] a documentary film on black culture and
revolution made by LeRoi Jones, Ed Bullins, and the Black Arts
Alliance, an organization of Black Theatre groups in California.
With mediocre photography, a garbled sound track, and poor
editing, *Black Spring* is neither successful as a film nor as an
instructional or propagandistic tool.

Much more subtle and effective is the work being done by
Southern Media, an organization based in Jackson, Mississippi.
Administered by black people working to provide communica-
tion links between black communities, Southern Media has con-
sidered the special problem posed by the wide spread of illiteracy
among rural Southern Negroes. Most rural black communities are
isolated from one another, and their main contact with the out-
side world is through the television and radio sets owned by the
few families who can afford them. There are very few telephones,
and only the local white newspapers are available in the area.
These factors, together with the high illiteracy rate in the area,
have resulted in the failure of Mississippi's black communities to
build permanent, progressive, state-wide political, economic, and
social institutions. Southern Media attempts to overcome this

failure in communications through the medium of the motion picture. The problem of illiteracy is transcended by the visuals of the movies, and the self-image of the Negro, who has seen himself previously only through the eyes of the southern white, is vastly improved. The instructional potential of the movies are myriad, for the subjects of the films range from the organization of a boy-cott to the setting up of a vegetable cooperative.[6] Then, too, the production of the films opens up new avenues of expression, for Southern Media trains local blacks who not only photograph, but take part in, the movies.

Not all of the films produced by black film makers in the late 1960's are the result of efforts at the social rehabilitation of ghetto youth by large foundations, nor are they all documents of the struggle for social equality, as in the Southern Media productions. Indeed, some of the films, such as the early shorts of Melvin Van Peebles, were attempts at individual self-expression, yet even here black consciousness is inevitably present.

Melvin Van Peebles, the thirty-six year old novelist, musician and film maker, first gained importance as a black film maker because his *The Story of a Three Day Pass* was the first feature length film directed by an Afro-American. His short films, such as *Sunlight* and *Three Pickup Men for Herrick,* are rather mediocre productions. These two films are listed in Grove Press' Cinema 16 Film Library catalog as being directed by Melvin Van, but they are actually early efforts by Van Peebles. *Sunlight* (nine minutes) uses an all Negro cast (including Van Peebles as the protagonist) to illustrate the tragedy of a black man who steals in an attempt to get enough money to marry the woman he loves. He is caught and imprisoned. Years later he is released from prison and returns in time to be the silent and unobserved witness at his daughter's wedding. The surprise ending and a rather nice score played by a group of San Francisco musicians do not offset the unexceptional photography and the wooden acting, although there are some notable shots achieved during the chase scene.

Three Pickup Men for Herrick is a well-conceived, if clumsily photographed, drama about the anxiety and suspense undergone by a group of men who stand at a "pickup spot," waiting for a white contractor to select some of them for a construction job. The opening scene, in which one of the workers walks to the

"pickup spot," is almost interminable, but there are a few good moments as the camera studies the face of the contractor as *he* studies the faces of the men, trying to determine by their expressions who would be best for the job, then shifts to the faces of the men as they strain to assume the attitudes they think are expected by the contractor. There is a genuine poignancy in the closing shot, which shows the two men who have not been selected walking away, hands in pockets, looking strangely like baffled children.

The Story of a Three Day Pass[7] was directed, edited and musically scored by Van Peebles, and is based on a novel, *La Permission,* which he wrote in French and published in Europe. Until recently, Van Peebles' career paralleled that of many black artists in this country who, after a series of frustrations, sought recognition as expatriates. Van Peebles had been unsuccessful in his attempts to find distributors for his films or publishers for his books. When he took some of his short films to Hollywood, hoping to find work as an apprentice, he was told by an agent that nothing was open. Similarly, his first novel was rejected by the American publishers, one of whom said that he "didn't write enough like a Negro."

Van Peebles went to France, where at one time he partially supported himself by editing the film-like comic sequences in the French edition of *Mad* magazine. He also had various acting assignments, including one with the Dutch National Theater (he toured Holland in Brendan Behan's *The Hostage*).

In France Van Peebles discovered that a French law allowed writers to direct their own movies, and his screen treatment of his novel, *La Permission,* allowed him to get a director's permit from the French Cinema Center. *The Story of a Three Day Pass* was partially underwritten by a $60,000 subsidy from the Cinema Center, an official organization that finances films that are "artistically valuable, but not necessarily commercially viable." The film was ultimately produced by the Office de Production d'Edition et de Realisation on a $200,000 budget. It played in Paris before it was released in America, where it was brought as a result of the chance meeting between Van Peebles and a scout (also black) for the San Francisco International Film Festival. Ironi-

cally, Van Peebles entered the San Francisco Festival as a member of the French delegation.

The plot of *The Story of a Three Day Pass* involves the brief affair between an American Negro serviceman in France (played by the West Indian actor Harry Baird) and a French girl (played by Nicole Berger, who was in Truffaut's *Shoot the Piano Player*). The dialogue is in both French and English, with English subtitles. The black GI, Turner, is given a promotion and a three day pass by his bigoted commanding officer, who regards him as a model Negro (i.e., an Uncle Tom) who can be trusted.

On his furlough to Paris Turner meets the French girl, Miriam, and their subsequent affair arouses his commander's *bete noire*— fraternization between black GIs and white French nationals. The initial meeting of the two lovers in a Paris bistro is amusingly handled by Van Peebles. Turner is clad in a costume that seems quite bizarre to the French girl—a hip outfit, complete with brief-brimmed hat and wrap-around eye shades. When Turner first sees the girl he fantasies himself crossing the floor to meet her. The fantasy sequence is done in slow motion; Turner advances toward the girl as the dancing couples part to allow him to pass. He speaks to her, she responds, and they are off in a slow motion frolic through meadows and along gurgling streams—an amusing parody of the lovers and landscapes from TV cigarette commercials. When Turner actually walks up to the girl and asks her to dance, she is put off by his strange get-up and refuses. A dancing couple jostle Turner, however, knocking his glasses from his face, and when Turner and Miriam scramble under the table their eyes meet and the affair begins (this is not as incredible as it sounds; as Miriam later admits to Turner, she is in the habit of going home with men). The lovers spend a brief, idyllic weekend on the Normandy coast. The main concern of *Three Day Pass* is with attitudes toward miscegenation. For instance, every time the couple makes love each has his own private, racially oriented fantasy. Turner imagines himself as a French *grand seigneur* of the eighteenth century, making love to his white chatelaine in a Provencal chateau, while Miriam imagines herself pursued by savage warriors in a jungle, who capture and threaten to ravish her. Two unpleasant incidents mar the

lovers' weekend. A group of white GIs from Turner's barracks chance across the couple on a beach. They later report Turner's "indiscretion" to his commanding officer, who reduces him in rank and restricts him to his quarters when Turner returns to the base. And when a Flamenco dancer proposes, in Spanish, a toast to "Senor Negro" and his beautiful date, Turner takes offense and starts a fight in a nightclub. Later, Miriam explains that *negro* merely means "black" in Spanish, and that no offense had been intended, for the Spaniard had meant the toast as a compliment. Puzzled, Turner can only mutter in bewilderment that he never thought being called black could be taken as complimentary. This attitude of the film's protagonist indicates how dated the film was when it was produced in France, for at that time most black artists in America, and certainly all black militants, were proclaiming that "Black is beautiful!" The theme of *Three Day Pass,* which concentrates on the social and personal difficulties encountered by a bi-racial couple, dates back to the period of integrationist-assimilationist protest literature and illustrates the traditional white liberal stand on inter-racial courtship and marriage. This was a theme that was eschewed by the adherents of the Black Arts Movement in America. An interesting comparison is illustrated by "Ben Land's Film," a ten minute vignette inserted into National Educational Television's special film, *Color Us Black,* for it exemplifies the militant mood of black nationalists in America at that time. Directed by Benjamin Land, a twenty year old drama major at Howard University, "Ben Land's Film" concerns a black college student who must decide between a black girl friend and his white mistress. The young man apparently prefers the white girl to the militant "soul sister," who continually harangues him about "honkies." On the other hand, the white girl is very much in love with him and is anxiously trying to overcome her lover's doubt about their relationship. Finally, inspired by a speech made by Black Power advocate Ron Karenga, the black student breaks off his affair with the white girl. "I've got to fight the man," he tells her, "and I can't fight the man when I'm living with his woman." Land's film indicates that more than a generation gap existed between Land and Van Peebles. Van Peebles' *Three Day Pass* illustrates the older man's personal vision of the injustice and bigotry that

forms the basis for opposition to bi-racial mixing. Conversely, Land's film of black awareness reveals the mood of the younger, militant black man whose separatist attitudes are based on the philosophy of Black Power. The dated aspect of Van Peebles' film can be explained by the expatriate nature of his career, which would quite naturally separate him from the newest developments in American black nationalism. When *The Story of a Three Day Pass* was released, four of Van Peebles' novels (which he wrote in French) had been published in Europe: *Un Americain en Enfer, Le Chinois du Quatorzieme, Le Permission,* and *Fete d'Harlem.* Only one novel, *A Bear for the F.B.I.,* had been published in his native country. In commenting on his inability to publish his works in America, Van Peebles told me "I think it's because they want me to be obsessed with the racial problem and I'm obsessed with the human problem." None the less, his *Three Day Pass* is racially oriented, as are *Sunlight* and *Three Pickup Men for Herrick.*

Van Peebles' fourth film (the first he did for Hollywood) was *The Watermelon Man.* Van Peebles directed the film for Columbia Pictures. Starring Godfrey Cambridge as a buttoned-down white insurance agent who awakens one morning to discover that he has turned black, the film is a poor production that may be seen as belonging to the same category as the earlier films of Van Peebles, that is, the "protest" film. It was not until he produced his fifth film, *Sweet Sweetback's Baadasssss Song,* that Van Peebles made a conscious effort to produce a "revolutionary film." No longer would he depict the stoic suffering of blacks oppressed by a racist society. There would be no more losers. "I wanted a victorious film," said Van Peebles, "a film where niggers could walk out standing tall instead of avoiding each other's eyes, looking once again like they'd had it."[8]

Sweet Sweetback's Baadasssss Song offers something for almost anyone in the motion picture audience. For instance, blue movie buffs can witness total nudity (many examples), voyeurism (2 examples), transvestism (2 examples), homosexuality (2 examples), lesbianism (1 example), miscegenation (2 examples), people having bowel movements or urinating (one example each), the rape of a child by a 40 year old prostitute, and much athletic fornication by the super stud, Sweetback. For the followers of

Peckinpah and other film makers featuring violence and sadism on the screen, there is the beating of handcuffed blacks by white policemen (2 examples), the systematic destruction of a black's hearing by firing a police service revolver near his ear, the bloody bludgeoning of two white policemen, the killing of another white policeman by impaling him with a pool cue, and the death of yet another policeman in a patrol car set ablaze by a group of young blacks. For lovers of the experimental the film offers innovative visual effects, split screens, fast cutting, dizzying zooms and psychedelic effects. The sound track, filled with shrieks, sirens, and gunfire, is orchestrated like a jazz suite, an effect that is amplified by quick interpolations of rock, soul, and spiritual music and the strophe and antistrophe between Sweetback and the Colored and Black Angels.[9]

All of this explains why the film grossed more than three million dollars within four months after its release, even outdrawing *Love Story* during the same period. Van Peebles, the super cool hipster *cum* Hollywood director, produced a film that had something for everybody: a *melange* of sex, sadism, race and revolution that would appeal to the popular culture of the seventies. Yet there is more than hype and hustle in *Sweet Sweetback's Baadasssss Song*, and if there is something for everyone in the film, it is nonetheless primarily intended for black audiences. Van Peebles himself considers it to be the "first black revolutionary film,"[10] and despite arguments to the contrary made by Lerone Bennett and Don Lee in *Ebony*[11] and *Black World*,[12] the film doubtlessly serves as a vehicle for black consciousness.

Both Bennett and Lee object to the image projected by the protagonist in the film. "Nobody," they contend, "ever fucked their way to freedom." It should be remembered, however, that a supermasculinity is often characteristic of the archetypal hero of both African and Afro-American folk traditions as well as recent avatars of the white pop culture heroes, such as James Bond. Indeed, it is almost impossible to conceive of a male hero designed for the popular media of film not to have the stereotypic sexual potency demanded of pop culture icons. Van Peeble's characterization of Sweetback, however, is motivated by more than the requirements of money making movies: Sweetback's potency answers a psychic need of black audiences in that Sweetback's

cooly controlled sexuality projects a positive male model with which to identify and emulate. On one level Sweetback uses his priapic powers for survival, and on yet another his potency has revolutionary implications. Sweetback's sexual prowess provides a livelihood for him in the brothel, it helps him bribe a former lover to free him from handcuffs, it provides a camouflage from detection by the police at a rock concert, and it saves his life in a duel with the leader of a motor cycle gang. The latter incident, involving the diminutive Sweetback and the Amazonian Big Sadie, the white female leader of the gang, contains a subtle, if hilarious, statement of black power. The scene is anything but erotic. Big Sadie, who towers more than six feet tall, demonstrates her strength by lifting a motorcycle above her head, and her skill as a fighter by throwing a knife into a post. She then challenges Sweetback to choose his weapons in the duel. Sweetback's one word reply is "Fucking." Significantly, Sweetback never uses a gun in the film, always relying on his body and his native mother wit. In the scene that follows Sweetback meets the white giantess in the circle formed by the bikers and illuminated by the headlights of their motorcycles. He walks into the arena clad only in a pair of spats and a derby hat perched jauntily atop his head, resembling, as the shooting script suggests, "a refugee from an old Tarzan movie."[13] Significantly, it was the whites who dressed him in this ridiculous costume. With the lance of his phallus the black knight jousts with the white Amazon, ultimately reducing her to ecstatic, feminine bliss (the shooting script reads "Big Sadie lies there almost beautiful and suddenly shy"). Beneath the comic situation of the mock heroic tournament, however, lies the subtlety of Van Peebles' statement of Black Power. The demeaning stereotype of black manhood in the old Tarzan movies is abrogated, the pretentious, sophistical pseudo-science of Cleaver's "The Primal Mitosis" and the obsessive theorizing of special issues of *The Black Intellectual* is transcended, and the unintelligible allegory of LeRoi Jones' *Madheart* is translated into a gutsy, funky *fabliaux*. The moral of Van Peebles' bawdy vignette is not lost on the black masses who attend the film's screening. The immediacy and psychic impact of the scene is overwhelming. As the figure of Sweetback rises above the mountain of giggling white flesh he passes through the

several avatars of Shine and Stagolee to become Black Manhood
incarnate. Not since the early films of Charlie Chaplin has there
been such an apotheosis of the underdog. Yet the seriousness of
the scene is couched in a vehicle that delights and entertains as
it instructs. That this was Van Peebles' intention is indicated in
his book on the production of the film. He had no illusions, he
says, "about the attention level of people brainwashed to trivial-
ity. The film couldn't be a didactic discourse which would end
up playing . . . to an empty theater except for ten or twenty
aware brothers who would pat me on the back and say it tells
it like it is. If Brer is bored, he's bored. One of the problems we
must face squarely is that to attract the mass[es] we have to pro-
duce work that not only instructs but entertains." And, he adds,
"it must be able to sustain itself as a viable commercial product
or there is no power base."[14]

The validity of Van Peebles' conclusion is borne out by the
limited appeal of other attempts at statements of black conscious-
ness in the past, particularly those in the genre of fiction. Julian
Moreau's revolutionary novel, *The Black Commandos*,[15] enjoyed
a small success among black college students as an underground
novel in the late sixties, but the cost of having the book privately
published resulted in a very small printing that was soon ex-
hausted. John A. Williams' *Sons of Darkness, Sons of Light* and
Sam Greenlee's *The Spook Who Sat by the Door* were also
limited in mass appeal: their novels were too literary and too ex-
pensive for the essentially visually and aurally oriented black
masses. The genius of Van Peebles was that he combined his
message with a media that would result in a widely distributed
(and financially successful) product. Aesthetic considerations
aside, it is obvious that Van Peebles' film will remain a signifi-
cant part of the popular culture of the seventies. Doubtlessly
there will be sequels to *Sweet Sweetback's Baadasssss Song;* al-
ready there are the paperback of the script, the record of the
sound track, and T-shirts, sweatshirts, and nightshirts imprinted
with the slogan, "I am a Sweetback."[16]

The phenomenon of the Sweetback fad is further evidence of
Van Peebles' ability to create a popular folk or mythic hero. In
creating the character of Sweetback Van Peebles did not attempt
to transpose to the screen the introspective and fatalistic charac-

ters of John A. Williams nor the intellectualized and equally
fatalistic protagonist of Sam Greenlee's *The Spook Who Sat by
the Door.* These characters were all middle class, intelligent
blacks; college graduates who could make literary allusions or
digress on the history of the blues with equal aplomb. Con-
versely, Sweetback is the personification of Van Peebles' concept
of Brer Soul—funky, hip, and undeniably a brother off the block.
Except during his choric exchange with the Black Angels, Sweet-
back is a man of action rather than words; he speaks less than
fifty words during the entire film. This contrasts him sharply
with the glib, jive talking black brothel keeper, Beatle, who in
one scene persists in an incessant line of shuck and jive while
seated, symbolically, on a toilet. Sweetback, ever cool, looks on
in silence. Indeed, Van Peebles has suggested that he played the
role of Sweetback "as a sort of black Clint Eastwood," although
it is clear that the conceptualization of Sweetback's character is
entirely his own. *Sweet Sweetback's Baadasssss Song* is not only
an extension of Van Peebles' own ego (he wrote, directed, pro-
duced, scored the music for, and starred in the film) but it is
also a projection of his own personal vision. Van Peebles wanted
to create a revolutionary film by projecting a new image of the
black hero. "Of all the ways we've been exploited by the Man,"
he writes, "the most damaging is the way he destroyed our self-
image. The message of *Sweetback* is that if you can get it together
and stand up to the Man, you can win."[17] He told an inter-
viewer for *Life* magazine that the film "shows a nigger that busts
a white man's head and gets away with it! Now, bourgeois critics
don't like that, but black folks do. They scream and cry and
laugh and yell at the brother on the screen. For the black man,
Sweetback is a new kind of hero. For the white man, my picture
is a new kind of foreign film."[18] The last point made by Van
Peebles is significant, for the urban patois and street idiom used
by many of the film's characters are so foreign as to be almost
unintelligible to most white viewers; many subtle overtones ex-
pressive of the black life style are missed, and there can be no
identification with Van Peebles' new folk hero. This difference
in the cultural awareness of various audiences was immediately
perceivable when I viewed the film with a predominantly black
audience and then with an all white audience. For instance,

Sweetback's first real appearance in the film, after the credits, is in the scene in which he leaves the brothel with two white policemen. For this first appearance the camera begins at Sweetback's feet, then swings slowly up to reveal, in stages, Sweetback's sartorial splendor: boots, flared pants with matching vest, a form-fitting cream colored Edwardian sports jacket, a pink shirt with an enormous collar, and a copy of a banana plantation overseer's broad brimmed sombrero. Sweetback's ensemble is at once an emblem of his status and a comment on his character—unmistakable in a black audience which greeted his appearance with delighted exclamations. The same scene elicited absolutely no response in an all white audience, who viewed the splendor of Sweetback's garb in stoney silence. The shooting script for this scene notes that Sweetback's "clothes fit beautifully, but the expression on his face seems out of place. Something about him makes people uneasy. It's impossible to be sure what his stare hides. Some would say intelligence, some would say sensuality, some say stupidity, some meanness. Anyway, everyone's first thought is to try to get on his good side."[19] Any hip black in the audience would recognize in that look the sure sign of a badass cat, one you don't want to mess with. Most whites in the audience fail to perceive this, as did the two policemen in the film who were bludgeoned with their own handcuffs.

In his article in *Ebony* magazine Lerone Bennett contends that Van Peebles' film is not revolutionary, for instead of carrying the viewer forward to a new frontier of collective action it reverts back to the pre-Watts day of isolated individual acts of resistance. "The movie," says Bennett, "does not point to revolutionary questions, and it does not point to revolutionary solutions. For an individual act not articulated with a theory and an organization is not revolutionary."[20] But Bennett misses the point. Van Peebles is not concerned with a "collective revolution," but with the creation of a black mythic hero, which is in itself revolutionary. For instance, the sole purpose of Moo Moo, the young militant leader in the film, is merely to serve as a catalyst for the actions of the protagonist. When Sweetback flees from the pursuing lawmen, he crosses a desert where he "gets himself together" through a running dialogue with the Black Angels, who perhaps represent his racial consciousness. Sweet-

back's actions in the desert are avatars of his primal African origin—an indication that the survival instinct has not been bred out of him by life in the ghetto or by years of fighting the man. He exchanges his clothes with a drifter in order to throw the police off his scent, he cuts the head off a lizard and eats it raw for nourishment, he urinates in the sand to make a salve to heal the gaping gunshot wound in his side, and he kills a pursuing pack of bloodhounds with his pocket knife. At the end of the film it is clear that Van Peebles has shown more than the radicalization of an urban pimp, for Sweetback emerges as the prototype of the aware black man who will not only survive but, as the legend which flashes across the screen in the closing frames indicates, is determined to prevail.

With a few exceptions, notably Richard Mason's *Ghetto* and Melvin Van Peebles' *Sweet Sweetback's Baadasssss Song,* the newly emerging black film makers have made no important aesthetic contributions to the art of the film. Although the significance of their work is primarily sociological and political, the importance of these films as social documents cannot be overemphasized. By replacing the Hollywood stereotype with a new image of the Negro, these films have played an important role in the development of Black Pride or Black Consciousness. And because they are often directed toward the anxieties, frustrations, and aspirations of the black audience, many of the films have an immediacy that makes them powerful weapons of propaganda. And finally, these films afford white audiences valuable insights into the psyche of the Black man—insights which are perhaps necessary if a disastrous confrontation between the races is to be avoided.

NOTES

1. *Film Making as a Special Non-School Related Project for Urban Area Students and Dropouts,* Brooks Foundation, Santa Barbara, California (September 6, 1966), p. 3.
2. *You Dig It?* is available in a 16 mm black and white print from Frith Films, 1275 Lincoln Avenue, San Jose, California.
3. *Ghetto* is available in a 16 mm color print from Mobilization for Youth, 214 East 2nd Street, New York, N.Y. 10009.

4. *The Jungle* is available in a 16 mm black and white print from Churchill Films, 6662 Robertson Blvd., Los Angeles, California. The address of the 12th and Oxford Film Makers Corporation is 1550 North 7th, Philadelphia, Pa.

5. *Black Spring* is available from Jihad Productions, Box 663, Newark, New Jersey.

6. These films may be ordered directly from Southern Media, 117 West Church Street, Jackson, Mississippi 39202.

7. *The Story of a Three Day Pass (Le Permission)* is available in a 16 mm black and white print from Sigma III, Filmways Corporation, New York, N.Y.

8. Melvin Van Peebles, *Sweet Sweetback's Baadasssss Song* (New York: Lancer Books, 1971), p. 36.

9. The sound track of the film is available on both stereophonic records and tapes.

10. *Life,* Vol. 71, August 13, 1971, p. 61.

11. Lerone Bennett, "The Emancipation Orgasm: Sweetback in Wonderland," September, 1971, pp. 106 ff.

12. Don L. Lee, "The Bittersweet of Sweetback/or Shake Yo Money Maker," *Black World,* November, 1971, pp. 43–48.

13. *Sweet Sweetback's Baadasssss Song,* p. 36.

14. *Ibid.,* pp. 14–15.

15. Julian Moreau is the pseudonym of Dr. J. Dennis Jackson, a black psychiatrist in Atlanta, Georgia. His book was privately printed under the imprint of the Cultural Institute Process, Atlanta, 1967.

16. "Power to the Peebles," *Time,* August 16, 1971, p. 47.

17. *Time,* August 16, 1971, p. 47.

18. *Life,* August 13, 1971, p. 61.

19. *Sweet Sweetback's Baadasssss Song,* p. 25.

20. *Ebony,* September 1971, p. 112.